NORTH COUNTRY FOLK ART

NORTH COUNTRY FOLK ART

PETER BREARS

JOHN DONALD PUBLISHERS LTD
EDINBURGH

ISBN 0 85976 214 9

Phototypesetting by Pioneer Associates, Perthshire.
Printed in Great Britain by Bell & Bain Ltd, Glasgow.

Acknowledgements

First and foremost, I must extend my most grateful thanks to John Gall and Rosemary Allan of Beamish, not only for allowing me to share their knowledge of folk art, particularly with regard to quilting, but for the enormous amount of time and energy they have devoted to developing the North of England Open Air Museum, whose collections now provide a unique source of material for all scholars of English ethnology. I also wish to thank my colleagues in the museums at Bolton, Burnley, Calderdale, Carlisle, Douglas, Grasmere, Kendal, Pickering, Ryedale, Salford, Wakefield, Whitby, Whitehaven and York for giving me access to their collections, and providing a chair and desk-space whenever required. The incumbents of St Mary's church, Beverley, and St Stephen's church, Fylingdales, also gave considerable assistance by enabling me to study the maiden's garlands in their care. Further information has been supplied by Mrs Kate Mason of Addingham, Dr Caomhin O'Danachair of Dublin, Dr Alan Gailey of the Ulster Folk Museum, Belfast, and Mr Stephen Harrison of the Manx Museum. To all of these, I now offer my most sincere thanks for their kind help over the past years.

Peter Brears

Contents

1
Introduction

Rather surprisingly, this is the first book to be published on English regional folk art, and so it must serve as a general introduction to the whole subject.

In essence, folk art is the practical creative element in the lives of ordinary working people. It has little or no connection with the academic art nurtured in country houses and art galleries, but, along with dialect, foodways and folk music, it forms an essential component in the life of all traditional communities. From the established aesthetic viewpoint, it may appear crude, 'naive', coarse and worthless, but this is because it springs from a human reaction to the total physical and social environment, rather than the mainstream artistic culture of Western Europe. It came into being specifically to meet basic human needs, such as safety and security, for which it developed a whole series of signs and symbols which ensured that protection and good fortune sprang from Christian and pre-Christian beliefs. It provided a physical means of expressing joy, love and mourning, with its love tokens, garlands and memorials. It gave its makers an enormous source of satisfaction, allowing them to display their skill and inventiveness to the full. It enabled the time to be passed in all-absorbing activity, an extremely important function, especially for those such as shepherds who followed solitary occupations in the fields and open fells. Finally, it allowed people to make a great variety of decorative yet economical artefacts with which to enrich homes which otherwise would have remained sparse and plain.

These universal qualities appear to have motivated the production of folk art throughout vast areas of time and space, but our knowledge of its history and dispersal must now remain largely a matter of conjecture. Since it was usually made from cheap perishable everyday materials, there is no body of specimens retrieved from early archaeological contexts, anything over two hundred years old being exceedingly rare. Similarly, due to the fact that most of its makers were illiterate, and came from social groups too insignificant to attract the attention of literate commentators, there is an almost total absence of contemporary documentation. It was only with the rise of romantic nationalism in late nineteenth-century Europe that folk art began to be studied by academics

and collectors. Their aim was to define the cultural attributes which made their particular country different from all others, although we now know that the arts of any region or state all follow great international traditions, only their detailed application may vary considerably, even from one village to another.

Because England was the all-powerful centre of a robust culture, ceaselessly spreading throughout and beyond an enormous empire, it had no need for the introverted nationalism of central and northern Europe. Instead, it diverted its ethnographic research into the diverse peoples of its overseas territories, to the entire neglect of its own native population. From the opening decades of the present century, attempts to remedy this situation were actively pursued by a number of scholars such as Dr Bather and Sir Cyril Fox. In 1928, a British National Committee on Folk Art was instituted with a wide-ranging brief, including the foundation of a National Folk Museum, while two years later the British Association and the Museums Association decided, 'In view of the increasingly rapid disappearance of material relating to the popular arts and crafts of the British people, to ask His Majesty's government to put into effect the recommendations of the Royal Commission on National Museums and Galleries for the establishment of a National Open Air Folk Museum'. Subsequently a Folk Museum Committee was established, but with no real intention that it should ever produce effective results, for national funding was never proposed, and the final report, prepared by Sir Mortimer Wheeler, was suppressed in 1935 due to the financial crisis of that year. Since then, central government has continued to pour millions of pounds each year into the preservation and promotion of the arts of the establishment and aristocracy, to the entire neglect of the culture of the vast majority of its people. England is one of the very few nations in the world to have neither a national folk museum, nor legislation to prevent the export of important cultural material (unless it commands a high price in the art market).

Despite this unsatisfactory situation, many individuals, societies and local authorities have taken matters into their own hands and set up local history and folk museums to preserve the artefacts and interpret the development of their particular communities. Literally thousands of these have come into being over the past thirty to forty years, but although they are the most popular of England's museums, and are now seen as leaders in tourist promotion, in aspects of urban renewal, and of educational activity, they still have serious shortcomings. The total lack of any overall policy means that they frequently waste time, money and effort in duplicating each other's collections etc., and there are no means of drawing together and utilising their considerable attributes to promote

social history as a whole. Even more worrying is the lack of appropriate training facilities for those who are to take care of these museums, since no university offers a degree course in English material culture, and the Museums Association cancelled its curatorial courses in regional ethnology in 1978. As a result, many of today's curators have little knowledge of traditional English life, thus being unable to give the public the service they deserve, or to advance the study of this subject.

This is clearly seen in the current attitude to folk art. The majority of the magnificent collections housed in the Castle Museum at York are permanently kept in store, out of public view, while the North of England Open Air Museum at Beamish provides no gallery space for any of its considerable holdings. The same situation prevails throughout most of this country, so that it is extremely difficult for anyone to gain access to collections of English folk art, to such an extent that even its very existence has come to be in doubt.

Hopefully this book will help to remedy this situation by giving a brief introduction to the main groups of folk art produced in the six northern counties of England and in the Isle of Man, largely by people who were not professionally engaged in artistic or craft occupations. The seafaring communities will not be dealt with, however, since their ganseys, ships-in-bottles, scrimshaw etc., are part of a culture which encompassed all coastal regions and require a separate study of their own. It will also describe the methods used to create the various artefacts, the development of their styles, the social habits and customs associated with them, and the reasons for their popularity and eventual decline.

Some classes of folk art are of great antiquity, probably coming into being around the same time as our language thousands of years ago. These have an extremely wide distribution, chip-carving styles extending throughout the whole of Europe and north Africa, for example. Others are of more recent origin, starting with the decoration of useful items such as rugs, or walking sticks, or adopting the practices of the upper classes, including quilting and patchwork, continuing them for generations after they had gone out of fashionable use. By the end of the nineteenth century a wide range of folk arts flourished in many English homes, but they were about to enter a rapid phase of terminal decline as life-styles changed with increasing industrialisation and improving standards of living. As more women went out to work, they had little time or energy to follow their traditional crafts, while their growing income allowed them to buy many of the household items which earlier poverty had obliged them to make for themselves.

Similarly, as men moved from the land into the urban factories, they ceased their production of carvings etc., which had no place within their

new surroundings. The introduction of new, exciting and effortless forms of entertainment also had a profound effect on the production of folk art. Why spend time in making things when the cinema, the radio, and, more potently, the television provided an easier way of relaxing after work? Due to these growing pressures, most of the centuries-old arts and crafts of this country are now quite dead. Few of those which do survive play any real part in the life of the community, but instead they are treated almost as a branch of the fine arts, bright rag rugs now appearing at high prices in trendy craft shops, along with slipware pottery and patchwork cushion-covers. Perhaps this is where their future lies, still giving pleasure both in their making and as a means of providing attractive decoration in the home. Even so, the study of surviving examples of north country folk art enables us to fully appreciate the technical skill and ability to create beauty which was developed here over many generations, as well as giving us a unique insight into the traditional beliefs and customs of this most interesting region.

2
Signs and Symbols

Today signs and symbols play a very important part in our everyday life, for road signs, company logos, trade marks, and the insignia of numerous clubs and associations all provide potent visual messages far more effective than the printed word. Their sole disadvantage is that they can only transmit their meaning to those who already understand their significance. A red cross, for example, has nothing in its intrinsic design to connect it with medical care, yet it is for this purpose that it is instantly recognised throughout the world.

The symbols used by any society tend to reflect its needs at a particular period of time or stage in its development. In England, a whole series of popular symbols had become well established by the end of the nineteenth century, many of them being of considerable antiquity. They appeared on pieces of traditional woodcarving, pottery and metalwork, on furniture and buildings, on trade union and friendly society banners, on gravestones, and even on postcards. Since that time, however, the whole fabric of our society has changed due to the combined effects of two world wars, the development of powerful mass media, and the increase of industrialisation and modern urban life. As a result, much of the visual language readily understood by earlier generations is now virtually unintelligible to us. Why should hands appear on gravestones, for example, or birds decorate love tokens? This chapter sets out to describe the main signs and symbols used in traditional folk art, giving details of their origins wherever possible. Some, such as eggs and diagonal crosses, are probably of very early pre-Christian date, while others take their inspiration from the Bible, *Pilgrim's Progress*, or *Paradise Lost*, the great Christian epics which formed the bulk of the reading matter in most households. Others, including hearts and the serpent of eternity, were drawn from the fanciful conceits and far-fetched imagery of the emblem books published during the seventeenth-century flowering of meta-physical studies. Rather more mundane were the representations of craft tools used by craftsmen as symbols of their particular vocation. These were usually based on elements of the heraldic achievements of the appropriate London livery company. A knowledge of the symbols

developed from these diverse sources certainly helps us to appreciate and to enjoy the full significance of many pieces of traditional English folk art.

The Anchor

In the Bible, Hebrews VI.19 states that in hope 'we have . . . an anchor of the soul, both sure and steadfast'. In heraldry, the anchor signified 'succour in extremities' since, like hope, it 'doth establish and confirme our faith against all tempestuous Gusts of adverse currents'.[1] On gravestones, especially in coastal areas, it provided a potent symbol of hope, while on objects as diverse as Sunderland pottery, pub-signs and postcards it was combined with a female figure to appear as the popular 'Hope and Anchor' motif.

Birds

Of all birds, the dove probably has the greatest symbolic meaning, being used to signify the Holy Spirit, gentleness and innocence, and the coming of good news, since it was a dove which brought an olive leaf back to Noah, indicating that the flood had subsided. It is probably for this reason that doves are used as tokens of hope and promise, being carved on gravestones and modelled onto pottery cradles, lamps and money boxes.

Boots

Old boots and other cast-off footwear were popularly believed to ward off evil, many houses of sixteenth to nineteenth-century date being protected by having one placed in the roof-space. Even today old boots are tied on to the back of the bride and groom's vehicle as they depart from the wedding. Boots for good luck were carved from wood and coal, or were cut out of sheet brass and used as mantel ornaments.

Eggs

Eggs have a long and almost worldwide history as symbols of fertility, purity, sacrifice, and resurrection.[2] In Northern England throughout the

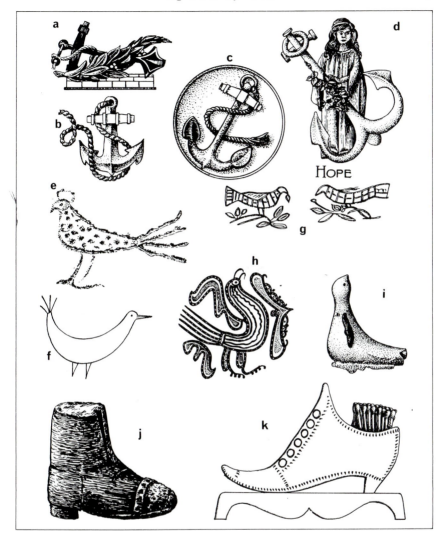

Fig.1. Anchors, Birds and Boots

The anchor symbolised faith, as seen here in (a) a trophy from the top of a Shillibeer hearse at Halifax, (b) the 1913 gravestone of James Baxter, Master Mariner, at Fylingdales, (c) the gravestone of William Cornforth, a Royal Marine killed at Zeebrugge in 1918, at Coxwold, (d) a postcard printed by Jackson & Co. of Grimsby in the early 1900s.

Birds usually indicated good luck: (e) carved on the lintel of a seventeenth-century cottage at Kettlewell and Wharfedale, (f) scratched into stonework at the Debtors' Prison, York, (g) carved on to a West Cumbrian knitting sheath of 1782, (h) the design on a late seventeenth-century Staffordshire slipware plate by Thomas Toft, (i) modelled on a cradle made in 1852 at the Cliviger pottery, Lancashire.

Boots were made in a variety of materials: (j) carved in coal in 1905 by J. Speight of Wath, (k) cut out of brass by a workman in County Durham.

post-medieval period they have continued to be associated with the great Christian festival of Easter, even though their religious significance has largely been forgotten and their continuance now relies largely on the marketing techniques of major confectionary companies. Up to the inter-war years, it was customary for children, either individually or in groups, to go around their neighbourhood to beg for 'pace eggs', this name being derived from paschal — relating to Easter. In many areas this was a formalised procedure, with groups of boys dressed in colourful costumes performing the Pace Egg Play. Its content varied from one area to another, but it usually commenced with their captain entering and singing

> Here's two or three jolly boys, all o' one mind,
> We've come a pace-egging and I hope you'll prove kind,
> I hope you'll prove kind, with your eggs and your beer,
> For we'll come no more pace-egging until the next year.

Various characters entered in turn, first Old Toss-pot, then St. George, Bold Slasher, the Black Prince of Paradine, the Doctor, etc., each shouting his lines as the dramatic sequence of fights took place, leaving St. George victorious. The request for eggs, beer or money was then repeated in verses such as:

> We're one or two jolly boys all in a row,
> The finest to act that ever you saw:
> Your money or eggs we will not refuse,
> Though we are Pace-eggers we are not to choose.

or:

> Come search up your money, be jubilant and free,
> And give us your Pace-Egg for Easter Monday . . .
> I hope you'll provide sweet eggs and strong beer,
> And we'll come no more to you until the next year . . .

Once the eggs had been collected, they were taken home where, if not used to feed the family, they were decorated in one of the following ways:

Dyeing:

This was the basic method of decoration, the eggs being boiled for about half an hour in water stained brown with the outer skins of onions, or even coffee grounds, yellow with gorse flowers, red with cochineal, or

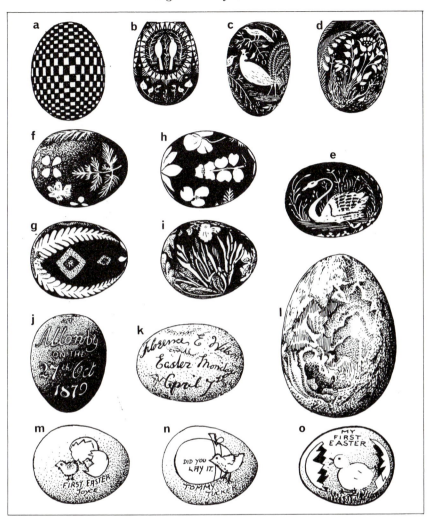

Fig.2. Eggs

(a–e) These eggs were decorated by John Dixon (1799–1878), a servant of the Wordsworths at Rydal Mount. They were first given an all-over black, royal blue, purple, or dark red-brown dye, which was then scraped away to reveal the white egg-shell beneath. (f–i) The decoration of these eggs was made by using natural foliage as a resist before dipping them into the dye. Nos. 6 & 7 are by Mrs. Herdman of Acomb, No.8. is by Mrs Cyril Thompson of Newborough, and No.9 is by Mrs Beattie Allison of Halton-Lea-Gate. (j) This Cumbrian egg was dyed and engraved with the inscription 'Fanny Mabel Foster born at Allonby on the 27th Oct. 1879', probably as an Easter present. (k) The background of this 1891 easter egg was first dyed brown with onion skins before it was inscribed with pen and ink. (l) By tying a piece of floral chintz tightly around an egg, and boiling it in salt and water, the pattern was transferred on to the surface of the egg, as in this example from Stanley, County Durham. (m–o) These eggs from County Durham were decorated in coloured penwork in the mid-1950s.

black with logwood. Rather more interesting effects were obtained by tying pieces of colourful dyed cloth around the egg, or binding onion skins in place with a piece of plain fabric before boiling it so that the colour was transferred directly on to the shell. The eggs could also be packed in the 'stony rag' lichen and boiled for an hour, to produce gold, russet, sherry and chestnut colouring.

Resist:

Before being dyed, the eggs could be dipped into hot water and then inscribed, probably with a name and the date, with a wax candle. This effectively prevented the dye from staining the egg shell, leaving the lettering clear and white against the coloured background. Alternatively, small leaves, ferns and flowers could be carefully arranged in patterns around the egg, being bound in place within pieces of coloured cloth so that the dye could only stain the exposed areas. This method gave particularly beautiful results, especially when the leaves and flowers contributed their own colouring to the eggs.

Sgraffito:

In this method, the coloured outer surface of the dyed egg was scratched away with a penknife or a steel pen. Very fine work could be achieved in this way, as may be seen in the eggs decorated between 1868 and 1878 by James Dixon, Wordsworth's gardener at Rydal Mount, for the poet's grandchildren.

Painting and penwork:

These were the least skilful methods of decoration, but had the advantage of being relatively quick and colourful, especially when inks and watercolours were used.

The finished eggs were initially used as playthings by the children, but then came the trolling, when they were rolled down a nearby hill. If they managed to reach the bottom intact, it was believed to be a sign of good luck for the coming year, but most hit stones and cracked, then being speedily peeled and eaten on the spot. Some lads, however, preferred a speedier way of either adding to their store of food, or losing their eggs

altogether. This was done by 'jauping', one egg being struck sharply against a friend's egg, until one of them broke and was forfeited to the victor.

Hands

Hands appear in a variety of contexts in English folk art, where they can symbolise a number of different concepts. On the gravestone, the hand may probably symbolise mortality, for Psalm 39 states: 'Behold, thou hast made my days as an handbreadth; and mine age is as nothing before thee'. In most examples, it is more likely to represent the Hand of God, a symbol of divine grace and favour used from the earliest periods of Christian worship. Numerous biblical references stress the power of His hand, Nehemiah 2.18 telling the people 'of the hand of my God which was good to me', while Joshua 4.24 explains that the Children of Israel's miraculous crossing of the Jordan and of the Red Sea was so ordained 'That the people of the earth might know the hand of the Lord that it is mighty'. The hand may appear with the fingers extended, with the index finger pointing symbolically to heaven, or perhaps grasping flowers and foliage.

The hand may also appear as the 'Hand-in-Hand', that *pledge of friendship* and *fidelity* which was in ancient times confirmed by the shaking of hands'.[3] Shaking hands have been recognised from the seventeenth century as symbols of true love and friendship passing even beyond the grave, since[4]

> Death is unable to divide their Hearts
> Whose Hands True-love hath tyde.

For this reason clasping male and female hands were frequently placed on the graveyard memorials of married couples. During the nineteenth century the great expansion of friendly societies, and then of trade unions, brought the shaking hands new significance as a demonstration that 'Unity is Strength', while at the height of the British Empire they received a renewed purpose as 'Hands across the Sea', appearing on postcards with lines such as

> 'From the Dear Homeland'

or

> 'Far o'er the Hills and Far across the Sea,
> Laden with Good Wishes This card now comes from me'.

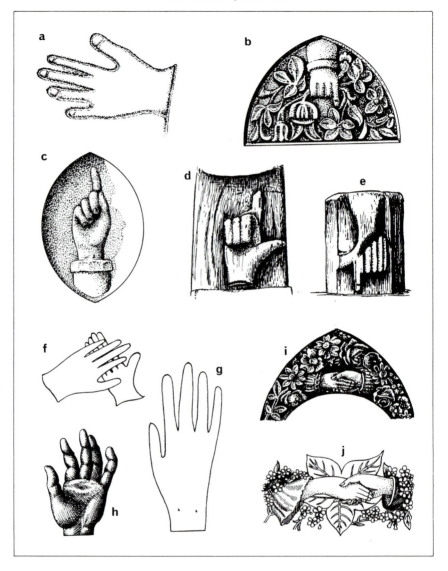

Fig.3. Hands

Hands can symbolise the Hand of God, mortality, friendship, eternal love, unity and, as gloves, virginity. (a) on the gravestone of Ann Warton, Cawthorne, 1753, (b) on the grave of Henry Bell, Dacre, 1900, (c) on the grave of Thomas Batley of Coxwold, 1916, (d) carved onto the shaft of a Cumbrian knitting sheath of 1789, (e) carved onto the handle of a Cumbrian butter marker, (f) virgin's gloves on the gravestone of Mary Oldfield, Lightcliffe, early eighteenth century, (g) virgin's paper glove from a Maiden's Garland, Fylingdales Church, (h) the hand as a symbol of faith in George Wither's *Collection of Emblemes* of 1635, p. 244, (i) clasping hands on the gravestone of John and Sarah Farrer at Coxwold, 1918, (j) clasping hands on a popular postcard of 1908.

Associated with hands, white gloves were symbols of innocence and purity, and thus of virginity. Gloves were occasionally carved on virgins' gravestones, but they formed an essential element of the maiden's garland. This ornate ribbon-hung frame was carried in front of the coffin in the funeral procession, and always included a number of cut-paper gloves inscribed with the name and age of the deceased.

Harvest

Scythes, sickles, and haycocks are carved on a number of gravestones, especially in the Lake District. At first these appear to be rather incongruous, but their significance is fully explained both in the Bible and in the emblem books of the seventeenth century. Isaiah 40.6 cries: 'All flesh is grass . . . the grass withereth . . . but the word of our God shall stand forever', while in Psalm 102 'My days are like a shadow that declineth and I am withered like grass', and in Psalm 103: 'As for man, his days are as grass, as a flower of the field so he flourisheth'. Like hay, the flesh soon withers and decays, therefore it should never take precedence over the eternal soul which will be judged at the time of 'hay harvest' or death.[5]

Similarly in Luke 3.17 St. John the Baptist likens the coming Christ to the winnower, who will gather the wheat, the elect, into his garner, while the chaff will burn with fire unquenchable, Job 5.26 predicts: 'Thou shalt come to thy grave in a full age — like as a shock of corn cometh in in his season' and, as the eighteenth-century Bible commentator John Brown stated, 'with shouts of joy, as one fully ripened for the glories of heaven'. It is for these reasons that the produce and hand tools associated with the harvest are carved in fine detail on a number of northern gravestones.

Hearts

The heart symbolises love, charity, and the soul, having been considered by early anatomists as the seat of all emotions, rather than the blood-pumping organ we now know it to be. Usually it is seen in the form of a simple shape, with pointed base and cusped top, but it may also be pierced by a dart shot by Cupid, the Roman god of love, or flame with the fire of Divine Love. In north-western England, love tokens frequently bear two hearts conjoined at the base to demonstrate the unity of the lovers, while in West Yorkshire single hearts symbolise the soul on gravestones and on funeral biscuits.[6]

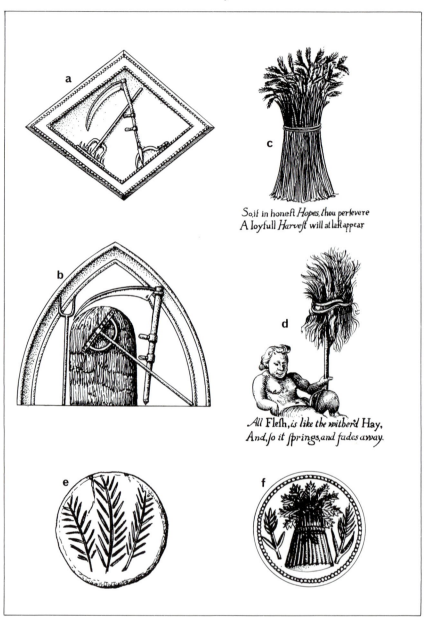

So, if in honeſt *Hopes*, thou perſevere
A Ioyfull *Harveſt* will at laſt appear

All Fleſh, *is like the wither'd* Hay,
And, ſo it ſprings, and fades away.

Fig.4. Harvest
Harvest emblems were chiefly used to represent death and the resurrection, as seen in (a & b) the gravestones of Thomas Bowe, 1830s, and George Walker, 1853, at Great Crosthwaite, near Keswick, (c & d) George Wither's *Collection of Emblemes* of 1635, pages 44 and 256, (e & f) Here ears of wheat and a sheaf of corn have been used as simple decorative elements on nineteenth-century butter prints.

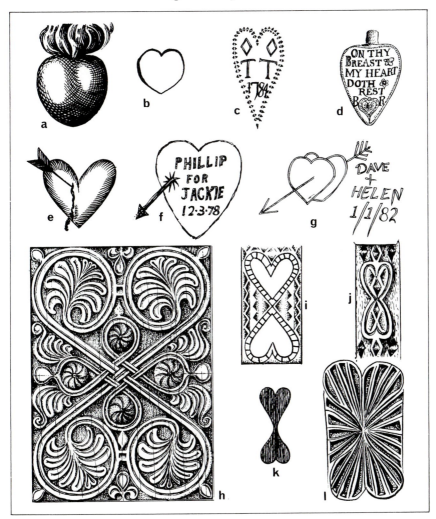

Fig.5. Hearts

The heart symbolised both love, fidelity, and charity as seen in the following examples:
(a) a flaming heart from George Wither's emblem book of 1635, (b) a heart motif embroidered on a bridal garter of 1749 from north-east Yorkshire, (c) this heart was carved on a stay-busk love token by Timothy Tarn of Middleton-in-Teesdale in 1784, (d) a West Cumbrian knitting sheath, probably late eighteenth-century date, (e) this bleeding heart, pierced with cupid's dart, appears on a printed valentine of 1807 in the Castle Museum, York, (f) graffiti on a Newcastle inter-city train, (g) the double heart cut into a bedroom window sill at the Royal York Hotel, (h) the double heart motif is particularly characteristic of north-western England, here carved on a piece of Westmorland furniture of 1696, (i) a double heart on a west Cumbrian knitting sheath of 1731, (j) carved on a north Cumbrian knitting sheath, (k) inlaid on a knitting sheath from Haydon Bridge on the South Tyne, (l) a double heart carved on a snuff box collected from Settle, North Yorkshire.

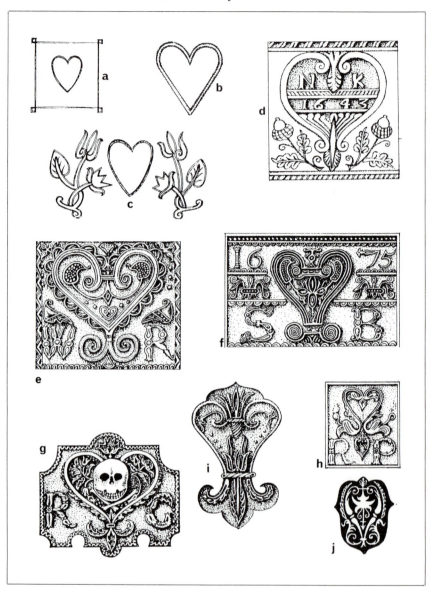

Fig.6. Heart Gravestones
The following hearts were carved on gravestones in the Calder Valley in West Yorkshire. They show how the simple heart-shaped outline was transformed into a series of increasingly complicated abstract forms between 1635 and 1747: (a) G. Reyner, Hartshead, 1635, (b) Anon., Luddenden, 1657, (c) J. Smith, Heartshead, 1660, (d) N. Kitson, Birstall, 1643, (e) W. Robinson, Morley, 1695, (f) S. Bailey, Morley, 1675, (g) R. Green, Birstall, 1702, (h) R. Pollard, Thornhill, 1712, (i) W. Lord, Hartshead, 1738, (j) H. Ramsden, Hartshead, 1747.

Hunting

Hunting the fox, deer or hare has been one of the most popular features of rural life for centuries, being enjoyed just as much for its sport and social aspects as for its practical value. It is not surprising, therefore, that hunting scenes should be found on all manner of items ranging from doorways to gravestones, from musical instruments to drinking mugs.

True Lovers' Knots

The use of a knot which has no end has been used to symbolise eternal love for centuries, its significance being described in works such as Davison's *Poetical Rhapsody* of 1611 or Gay's pastoral *The Spell.* Knots of ribbons were therefore the most appropriate decorations to be worn at weddings. M. Misson's *Travels in England* of 1696 describes how the greatest English noblemen presented these 'favours', large knots of gold, silver, carnation and white ribbons, to their wedding guests and many others, who wore them in their hats for some weeks following the event. Similarly the *Collier's Wedding* has

> The blithesome bucksome country maids,
> With knots of ribands at their heads,
> And pinners flutt'ring in the wind,
> That fan before and toss behind . . .
> Like streamers in the painted sky,
> At every breast the favours fly . . .

In the late seventeenth century the True Lovers' Knot appeared on chip-carved love tokens, while from the late eighteenth century it became increasingly popular on printed valentines and in needlework too. In northern English folk art, however, it is most frequently seen as the centrepiece of wedding quilts, although it was also used in decorative blacksmith's work, such as pierced steel fenders etc. of the Victorian period.

Roses

'As the rose is the Flower of flowers, so is this the House of houses.' Thus reads the inscription at the entrance to the magnificent thirteenth-century chapter-house of York Minster. The rose has long been recognised as an absolute standard of beauty against which all other objects may be

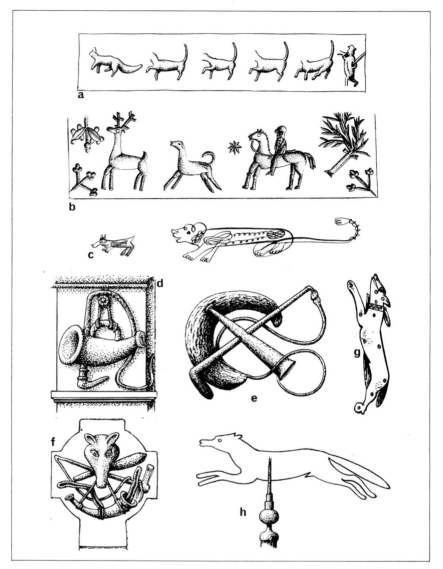

Fig.7. Hunting
Representing the most popular sport of rural England, hunting motifs occur in a wide variety of contexts: (a) stone door head at Scout Hall near Halifax, 1681, (b) sugar mould, early eighteenth century, (c) foxhunting depicted in calligraphy by William Lamb of Scawthorp, 1721, (d) the gravestone of John Peel at Caldbeck, 1854, (e) the gravestone of Tommy Dobson, master of the Eskdale and Ennerdale Foxhounds for fifty-three years up to his death in 1910, (f) the gravestone of Bobbie Dawson, whip to the Bilsdale Hounds for over sixty years up to his death in 1902, (g) foxhound pocket knife by J. & M. Rodgers of Sheffield, 1800, (h) the head of the maypole at Sinnington, where the local hunt was founded around 1700.

Fig.8. True Lovers' Knots
The large knot is taken from a late eighteenth-century panel of fabric in the Whitehaven Museum. It is printed in dark red from an engraved copper plate. The smaller knots, meanwhile, are from the centres of wedding quilts, made at West Cornforth, County Durham, around 1870 (left) and at Walbottle, Northumberland, about 1825 (right).

compared and judged. It is for this reason that we find roses appearing on valentines and other tokens of love, where it symbolises the beauty of the beloved.

In Yorkshire and Lancashire, the rose has had additional significance since the late fifteenth century. It was Shakespeare who invented the

famous scene in the Temple Gardens in which Richard Plantagenet plucked a white rose for the House of York while the Duke of Somerset plucked a red rose for the House of Lancaster. From that period, however, white and red roses have become closely associated with their respective counties, both in their official heraldic achievements, and for a whole host of semi-official and popular uses ranging from cricket club badges and archaeological society emblems through to horsebrasses and souvenir pottery.

At the end of the Wars of the Roses in 1485, Henry VII adopted the rose as the badge of the House of Tudor, and since that time it has been the accepted emblem of England. Following the Union of the Crowns in 1603, it became customary to display the rose and the thistle between the Garter encircling the royal arms and the motto 'Dieu et mon droit' enscrolled below. After the 1801 Act of Union with Ireland, the rose, thistle and shamrock, the three emblems of Great Britain, began to achieve considerable popularity as the 'Bonny Bunch of Roses' which symbolised a Britain unified against the threat of Napoleonic invasion. As a contemporary folk song about Napoleon relates:

> He took 300,000 men
> And Kings likewise to bear his train.
> He was so well provided for
> That he could sweep the world for gain,
> But when he came to Moscow,
> He was overpowered by the sleet and snow
> With Moscow all ablazing
> And he lost the Bonny Bunch of Roses O.

The 'Bunch' is found in many different circumstances, scratched on horns, moulded on to clay pipes and garden tiles, or into pottery vessels.

'Glorious beauty is a fading flower', states Isaiah 28.1, and thus the rose provides a potent symbol of the transience of human life. In Book IX of *Paradise Lost* Milton describes Eve tending roses on her own after taking leave of Adam, 'stooping to support Each flower of slender stalk, whose head . . . Hung drooping unsustained'. Later he makes her liken herself to the 'fairest unsupported flower, From her best prop so far . . .' Similarly Wordsworth uses the overgrown state of the garden outside the *Ruined Cottage*, where

> The unprofitable bindweed spreads his bells
> From side to side, and with unwieldy wreaths
> Had dragged the rose from its sustaining wall
> And bent it down to earth . . .

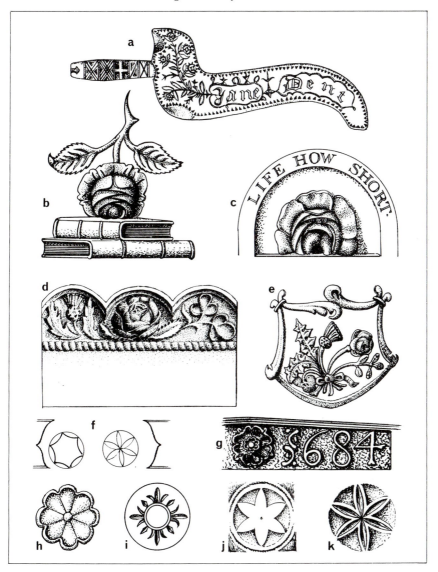

Fig.9. Roses

The rose usually symbolises beauty, but it can also represent mortality, as well as serving as England's national emblem: (a) a knitting sheath carved for Jane Dent in Baldersdale, 1855, (b–c) the gravestones of Thomas Harryman, 1862, and Joseph Fisher, 1861, at Great Crosthwaite, (d–e) the 'Bunch of Roses' on a garden edging tile from the Newcastle area, and on a saltglazed jug from the north Midlands, (f) rosettes carved on a door lintel of 1636 at Kirkby Stephen, (g) carved bedhead of George and Ellinor Browne, Townhead, Troutbeck, (h–i) gravestones of Ann Crosley, 1697, at Todmorden, and of John Halliwell, 1700, at Luddenden, (j) West Cumbrian knitting sheath, 1777, (k) knitting sheath from Middleton in Teesdale, mid-nineteenth century.

to illustrate Margaret's suffering after the death of her husband. It is for these reasons that the rose may appear on gravestones, where it indicates either mortality or widowhood.

Simple roses or rosettes, either divided into petals or formed from arcs described by the compass, are amongst the earliest and most common devices to be found in English folk art.

As the French scholar Joseph Dechelette has shown, the rosette, along with the circle, cross, star, swastika and spiral, has been used as a sun symbol ever since the Bronze Age. W. Deonna, meanwhile, has proved how the rosettes of antiquity have persisted in primitive Christian art and folk art from the Mesopotamian culture down to modern folk art, being used in the same religious and funerary contexts. In Greek and Roman antiquity the gods of light, Helios, Apollo, and Castor and Pollux, were depicted with a rosette-shaped nimbus. With the coming of Christianity, this ornament retained its significance as a protective sign throughout Europe. In northern England, they are frequently found on gravestones, on door-heads, on oak furniture from Cumbria, and on carved boxes and knitting sheaths of the seventeenth and eighteenth centuries, after which they slowly passed out of use.[7]

Royal Arms

After Henry VIII's break with Rome in 1534, he assumed the title of Supreme Head on Earth of the Church of England, and to remind the populace of his position, the Royal Arms began to appear in churches throughout the kingdom. They were always prominently placed, perhaps occupying the site of the former rood or crucifix over the chancel arch. Here, brightly coloured and richly decorated, they provided one of the major objects of interest for the congregations seated in the nave. Given this considerable exposure in church, together with their use on courthouses, shops, theatres, coinage, official papers and military insignia, it is not surprising that they provided a popular and patriotic subject for folk art. The versions of the arms which found their way on to country pottery, gingerbread moulds, samplers and snuff boxes were rarely heraldically correct, their makers usually abstracting their designs to achieve particularly robust and lively effects.

Sheep

In many aspects of English folk art the appearance of sheep in paintings, carvings, cast-iron doorstops, pottery figures, or on rag rugs etc. is simply

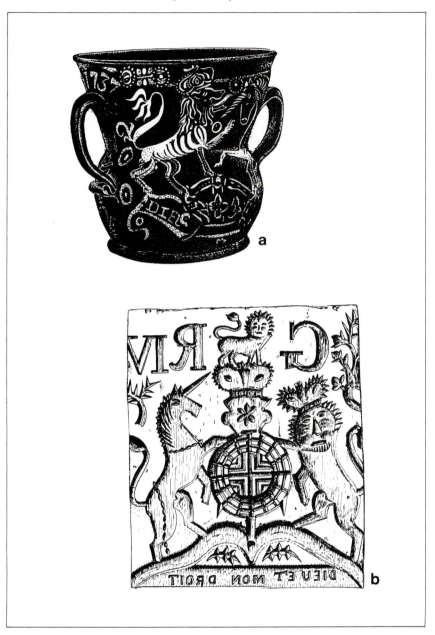

Fig.10. The Royal Arms
(a) This black lead-glazed earthenware posset pot of 1737 is decorated in coloured oil-paints. (b) Dating from the 1820s, this gingerbread mould was used by the Sonley family of bakers at Kirkbymoorside.

a reflection of their importance in local agriculture, especially in hill-farming areas. Similarly the figures of sheep on the chopping knives made by W. Scales indicate their use in preparing mint sauce, the traditional accompaniment to roast mutton and lamb.

On gravestones, single sheep are occasionally shown supporting a small flag with one of their forelegs. This is the Agnus Dei, the Lamb of God, which has been used as a heraldic device in England since the twelfth century, being adopted by bodies as diverse as the Knights Templar, merchants, the Merchant Taylors Company, military regiments, and boroughs such as Halifax, which were dependent on the wool textile industry. In other examples, single sheep or entire flocks are shown, perhaps in accurate representations of local farmyards or countryside. Here they represent the elect of God, following Matthew 25.32–3 which describes how Christ will sit in judgement 'and he shall separate them one from another, as a shepherd divideth his sheep from the goats. And he shall set his sheep on his right hand', there to enjoy life eternal.

The Snake

The snake in circular form, devouring its own tail, is a symbol of eternity.[8]

> The *circled snake* ETERNITIE declares,
> Within whose *Round* each fading Creature springs;
> Old *Sages* by the Figure of the Snake
> (Encircled thus) did oft expression make
> Of *Annuall-Resolutions*; and of all things,
> Which wheele about in *everlasting rings* – ;
> There *ending*, where they first of all *begun*,
> And, there *beginning*, where the Round was *done* . . .
> These *Roundells* helpe to shew the *Mystery*
> Of that immense and blest *Eternite*.

On gravestones, the snake usually symbolises the eternal life hereafter, although an example at Romaldkirk is combined with doves, pointing to Matthew X.16: 'Behold, I send you forth as sheep in the midst of wolves; be ye, therefore, wise as serpents and harmless as doves'. When combined with the hand, as on Cumbrian knitting sheaths, it probably indicates eternal fidelity.

Tools

Tools appear in a variety of contexts in English folk art. From the medieval period they have been seen in craftsmen's self-portraits, as on

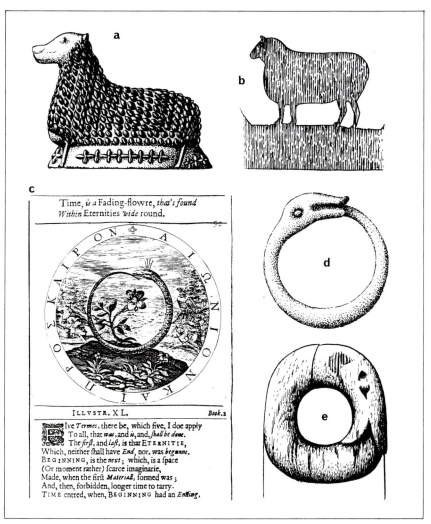

Fig.11. Sheep and Serpents
(a) print from a carved oak butter mould from York, (b) this sheep is pierced in the metal blade of a chopping knife made by W. Scales, (c) this plate, from George Wither's *Collection of Emblemes* of 1635, shows the serpent as a symbol of eternity, (d) 'eternity' carved on the gravestone of Elizabeth Richard of Osmotherley, early eighteenth century, (e) the serpent carved on the end of a Cumbrian knitting sheath of 1789.

the 1330s tomb of St. William from York Minster, or in figures representing the months of the year, each holding a scythe or axe etc. as appropriate. From the late medieval period too they have figured in the coats of arms granted to the London livery companies, the blacksmiths'

arms of 1490 having three hammers, for example, and the butchers' a pair of crossed pole-axes between two decapitated bulls' heads. The use of these devices was not restricted to London, however, for they were adopted by working craftsmen throughout the entire kingdom. The arms of the Masons Company depicted three castles and a pair of compasses, but from the early eighteenth century the modern form of freemasonry, with its ritual supposedly originating with Solomon and the building of the Temple, introduced a much richer vocabulary of symbols, ranging from the square and compasses to the sun, moon and stars.

In a period when major sections of the population might be illiterate, representations of tools provided a ready way of identifying shops and workshops. In urban environments these could be very elaborate, with gilded pestles and mortars outside chemists' shops, Indians outside tobacconists, or sugar cones outside grocers, but in rural areas they were usually much plainer, with blacksmiths' tools or a shuttle etc. carved on the lintel over the front doorway.

In their simplest form, tools were shown in the graffiti scratched by craftsmen, working men and boys on the doors, walls, or furniture of their homes or workplaces. Usually restricted to basic outlines, with minimal attention to detail, they still conveyed their author's knowledge or 'feel' for their subjects.

'X'

One of the most obvious ways of decorating a surface is to divide it up into rectangles, these being divided in turn by lines joining diagonally opposite corners. The X formed in this way is probably the most common device to be found in folk art throughout the world, especially in Africa, India, and all parts of Europe.

It would be easy to discard this motif as being pure decoration, but a considerable body of evidence from throughout Europe suggests that it also has a long history as a protective device, to ward off evil and to bring good luck. Remains of a cross of rushes have been found beneath a megalith in County Limerick, for example, while designs incorporating these diagonal crosses are incised into both ceramic beakers and chalk carvings such as the Folkton drums, which date from the early part of the second millennium B.C.[9] In early medieval times, meanwhile, the Viking inhabitants of northern England carved their bone utensils with the X, while small crosses made of silvery-barked twigs might be placed beneath bodies interred perhaps around this period.[10] From the seventeenth

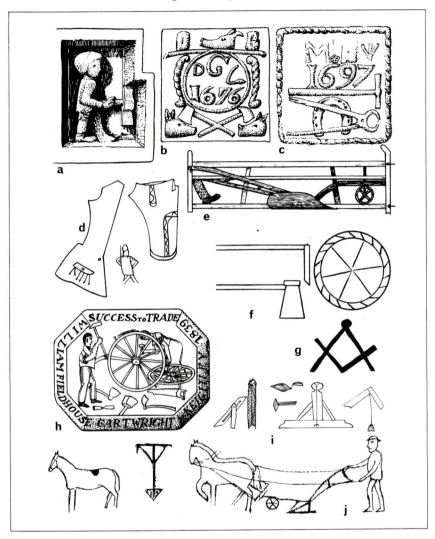

Fig.12. Tools
Representations of trade tools are a frequent motif in English folk art: (a) a mason (?) on a
stone doorstop of 1612 from Halifax, (b) this sign in the Market Place, Skipton, incorporates
crossed pole axes and bulls' heads from the arms of the Butchers' Company, (c) farriers'
tools carved as a sign at Oxen Park, High Furness, (d) eighteenth-century tailor's graffiti in
the Debtors' Prison, York, (e) wooden gate, with plough and leg, made by Mr Jack Hunter
at Plane Tree Farm, Beamish, (f) drop hammer incised on the back of a gravestone at
Dereham, Cumbria, (g) the masonic square and compass was inlaid in a Halifax pottery
money box of around 1850, (h) this iron snuff box shows the fixing of strakes and felloes
at William Fieldhouse's workshop in Keighley, 1839, (i) masonry tools scratched on a
ceremonial horn, York Castle Museum, (j) graffiti on a smithy door c. 1880, Ryedale Folk
Museum.

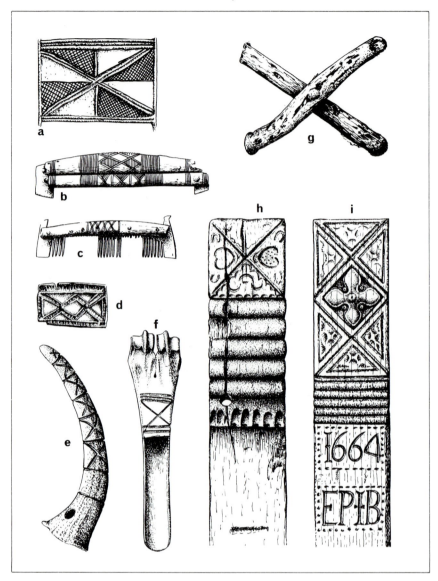

Fig.13. 'X'
The diagonal cross was believed to protect against evil, especially that intended by witchcraft:
(a) a panel from a carved chalk cylinder, c. 1880 B.C. from Folkton Wold, East Yorkshire,
(b–e) bone comb, comb case and tool, and a metal plaque from Viking York, (f) apple
scoop made from a sheep shin-bone, from Pool-in-Wharfedale, (g) a witch-cross of rowan
twigs, from Goathland, North Yorkshire, (h & i) details of witch posts from Scarborough,
and from Postgate Farm, Glaisdale, North Yorkshire. The initials probably refer to Edward
Pennock and John Breckon, the birth of J.B.'s son in 1664 providing impetus for rebuilding
in this year — see *Dalesman* (1967) XXIX, 147.

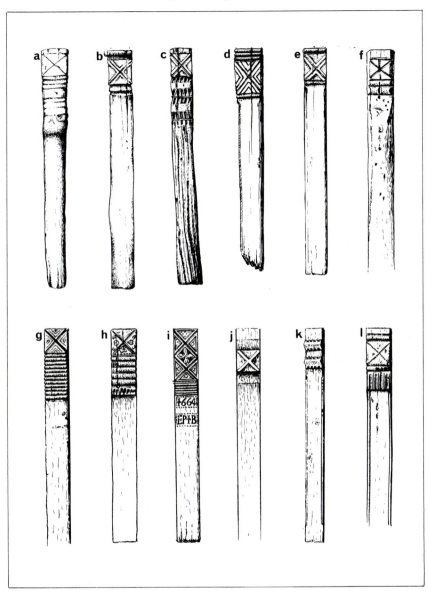

Fig.14. Witch Posts
With the exception of (1) which comes from New House Farm, Rawtenstall, Lancashire, all these posts stand by the side of hearths in the North Yorkshire Moors: (a) Oak Crag, Farndale, (b) East End Cottage, Egton, (c) Quarry Farm, Glaisdale, (d) Church View, Gillamoor, (e) Low Bell End, Rosedale, (f) Stangend, Danby, (g) Shoemaker's Shop, Danby, (h) Scarborough, (i) Postgate Farm, Glaisdale, (j) Bugle Cottage, Egton, (k) Pond Cottage, Silpho.

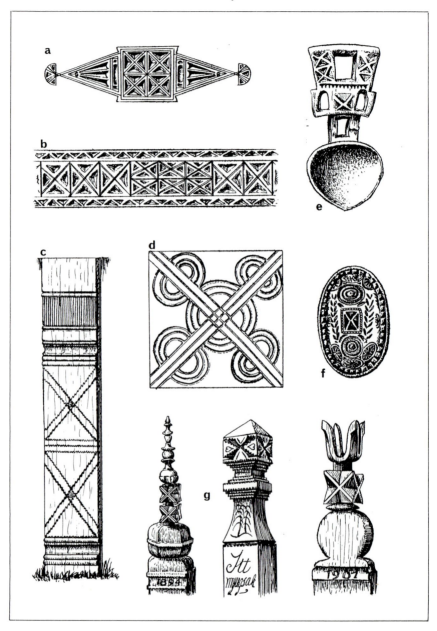

Fig.15. 'X' in Europe
The 'X' motif is found carved in wood throughout Europe, as seen in these examples: (a) from a Russian cupboard, (b) a distaff from Rumania, (c & d) a timber-framed wine store and a bridal chest from Hungary, (e) a spoon carved by a Sicilian shepherd, (f) a butter-mould from Piedmont, Italy, and (g) grave-markers from Hungary.

century, the X was carved on knitting sheaths, on sheep-bone apple-scoops, and on the witch-posts characteristic of the North Yorks Moors.

Up to the seventeenth century, it is probable that most of the single-storey houses of this region were heated by fires in the middle of the floor, similar to those of the Highland black-houses which survived in use up to the present century. It then became customary, however, to place the fire against a masonry gable or cross-wall adjacent to the entry door, the smoke being carried up a large pyramidal timber-framed smoke-hood supported on a mantel-beam at head height running across the building. To prevent draughts, a 'heck' or screen separated the doorway from the hearth itself, its inner end terminating in a vertical post morticed into the mantel-beam. This was the witch-post, carved with the X at its head. The late Mr Joe Scales, a local stonemason, has described the traditional belief in its function: 'The witch, in order to gain power over a dwelling house, must go through the house and past the hearth. The door and chimney were the only means of access, but she could not pass the witch post with its cross. Hence it was a defence at the hearth or focus . . . a crooked sixpence was kept in a hole at the centre of the post. When the butter would not turn you took a knitting needle, which was kept for the purpose in a groove at the top, and with it got out the sixpence and put it in the churn'. The post was supposed to be made of the mountain ash, or rowan, well known for its efficacy against witches, and quoted in the witch's complaint:

> Oh Master, oh Master, we can't do no good
> She's got a witch cross made o' mountain ash wood.

The belief in the purpose of witch posts was preserved in the working practices of Moors builders and masons etc. up to the present time, new examples being erected in houses rebuilt as late as the 1920s.[11]

In addition to the witch post crosses, crosses made of rowan-tree twigs were used as charms throughout the North Yorks Moors, being placed over the bed-head, or above the doors of houses and byres. In order to be effective, the rowan had to be cut on St. Helen's Day, 18th August, using a large household knife. It must come from a tree never seen before by the person concerned, and brought home by a different path from the outward one. In the 1890s twelve or thirteen such crosses were fixed to the wall of a cow-byre at Wheathill Farm, Goathland, one of them remaining in place up to 1942.[12] Even today, belief in the protective attributes of the X is still current, as we continue to cross our fingers whenever we require good fortune.

3

The Old Man's Face

Bud there is sum unlucky lads
That wants correctin' be ther dads,
They might be in sum better pleeace
Than thrawin' steans at 'aud man's face.

Writing in 1828, the North Riding stonemason-poet John Castillo was recording how the face on the keystone of the bridge he was building at Glaisdale was being 'damisht wi't lads thrawin' steeans at it' and thus attracting bad luck.[1] In this very rare, and perhaps unique reference, Castillo gives us the traditional name for the numerous carved stone heads which are still to be found in most of the stone-bearing areas of northern England. These are not the architecturally inspired faces or heads which appear on mansions, public buildings, or the terraced houses of industrial conurbations, but are the distinctive simple, crudely carved heads made by amateur or relatively unskilled masons throughout the region. Most examples, and particularly those found in flower beds and rockeries, provide little or no information regarding their original makers and locations, but fortunately it has proved possible to trace a number of north-country head carvers working during the nineteenth century.

Castillo himself was born in Ireland in 1792, but moved with his parents to Lealholm in the North Yorks Moors when only two or three years old. About 1805 he began to work with a group of local masons, a career he enjoyed up to the late 1830s, when his health began to decline until his death in 1854. Stone heads attributed to him can be seen at Post Gate Farm, Glaisdale, 1839, Lealholm Wesleyan Chapel, 1839, and perhaps at Stonebeck Gate, Fryup, 1834.[2] In the same locality Constantine Abram, a joiner from Loftus, carved a head on the gable of his farm buildings at Ellers House, Fryup, around 1850. Harry Jackson and Charles Rickaby carved heads in and around Kirkby Moorside; in 1910 Mr Dove and Mr H. Burrows carved the stone heads which decorate Houndgate, the home of Dr Kirk, founder of the York Castle Museum, while Joe Scales of Egton carved finials, bird baths, and heads, which were regularly purchased from his garden by various passing visitors. The Weatherills of Fangdale Beck and Ainthorpe, one of the major families of North

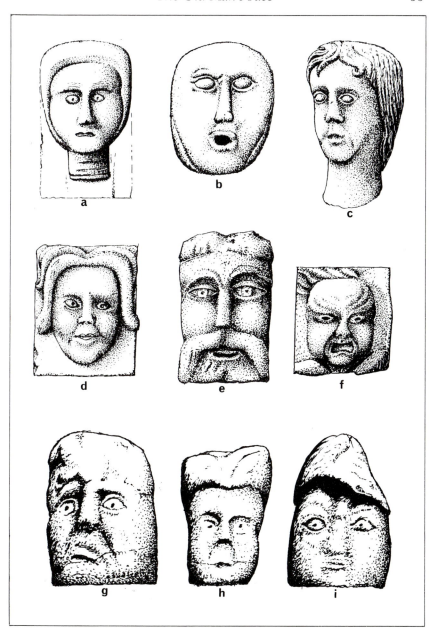

Fig.16. Nineteenth-century Faces
These faces (a) were carved by John Castillo at Postgate Farm, Glaisdale in 1839, (b & c) Sam Swift of Cawthorne in 1860? (d) Joe Scales of Egton, (e) Harry Jackson, and (f) Charles Rickaby, both of Kirkby Moorside, and (g–i) Messrs. Dove and Burrows of Pickering in 1910.

Yorkshire stone masons from at least 1810, also produced heads from time to time, these being carved almost as a joke, and sold in a similar manner to garden gnomes to decorate rockeries etc.

In South Yorkshire, Sam Swift of Cawthorne (1846–) became interested in masonry when in his late teens, attracting considerable interest with his lifesize figure of Hebe exhibited at the Wakefield Industrial and Fine Art Exhibition of 1865. A range of his delightfully naive early works, including a number of heads, are still to be found in his native village.[3] In West Yorkshire, meanwhile, William Hustwick carved the head on Well House, Addingham, around 1875, a Mr O'Calaghan carved a head found at Heaton near Bradford, and as recently as 1971 Rennie Hollings, landlord of the Sun Hotel, West Lane, Haworth, carved and erected a head over his doorway, following a local tradition that heads were put on buildings when a workman had been killed during its construction.[4]

Of the hundreds of heads carved by these and many other unrecorded masons, very few served as portraits, the busts of Robinson Gill of 1848 at Shaws Hall, High Snowden, and of Julius Dalby at Victoria Road, Eccleshill, Bradford, probably being the only examples. What, then, was their purpose? Castillo's name of 'the old man's face' suggests connections with other 'old men' such as the devil himself, or 'the old man' who was responsible for digging the disused and forgotten mine workings occasionally discovered by leadminers etc. Perhaps the heads fulfilled some protective or prophylactic function. Certainly they have been treated as objects of some importance for centuries. When the parishioners of Kirkby Malham rebuilt the arcade and clerestory of their church in the late fifteenth century, they incorporated two already old and weather-worn heads into the masonry, rather than replace them with architecturally up-to-date versions. In order to discover the probable purpose and origins of these heads, it is necessary to study a large number of examples which are still in their original locations. Rather surprisingly, they are only used in a very restricted range of circumstances.

It is likely that the heads which are cut into the sides of gritstone outcrops on the moorlands of the West Riding are amongst the oldest to be seen today. Instead of being carved with chisels, they appear to have been shaped by pecking away at the rock with a hard stone in a similar manner to that used to form the Bronze Age cup and ring marks of the region.[5]

As Castillo recorded, heads were built into the masonry of bridges, looking along the streams or rivers from the topmost part of the arch. Probably the heads on the north and south sides of the sixteenth-century Rawthey Bridge near Sedbergh are the oldest examples in this position,

but others are known on a pack-horse bridge near Lynwood House, Edgebrook Road, Sheffield, at Middleton Hall, Sedbergh, and, perhaps rather surprisingly, on the Hebden Bridge aqueduct on the 1794–1804 Rochdale Canal.

The connection of heads with water becomes even stronger when looking at spring sites. Simple carved stone heads are associated with springs, as at Dobson Bank, Summerbridge, Boston Spa and Well Head Farm, Guisburn, for example, while a roadside trough just to the west of Hebden Bridge on the A646 is surmounted by two free-standing heads, each having a face carved both on the front and on the rear, and its top hollowed out to form a shallow flat-bottomed recess. In other instances, the water actually flows through the head, dribbling out between the lips to fall into a basin or bath below, as in Rawtenstall's 'Spewing Duck' of 1835. The 'Slavering Baby' on Adel Moor was built in this way in the late eighteenth or early nineteenth century, while 'Slaverin' Sal', the local name for the Cast-a-Way or Diana's Well on the slopes of Witton Fell in Wensleydale, is perhaps associated with a nearby grotto built by the Earl of Aylesbury in 1821. The Earl, his family and guests used to drive up to the well from their seat at Jervaulx, using a two-mile carriage-road specially constructed for the purpose. Here they could sit around the large rock-slab table in the grotto, enjoying fine views, good food, and the cold, clear water of the well. The country people used the well for quite a different purpose, however, throwing pins and other articles into it for luck. As a rhyme about East Witton relates:

> Whoever eats Hammer nuts, and drinks
> Diana's water
> Will never leave Witton town while he's
> a rag or tatter.[6]

At Ilkley, the White Wells on the edge of the moor have enjoyed an excellent reputation for the curative qualities of their waters from the late seventeenth and early eighteenth centuries at least. Around 1756 the Lord of the Manor, William Middleton, converted the earliest building here into a bathing establishment by the addition of two deep, round baths.[7] The water was conducted into them by a channel flowing from the original pool to enter the baths through the mouth of a head carved on a rectangular stone block, into the top of which two shallow round recesses have been cut.

The most remarkable of these wells lies just to the south of Nappa Bridge at Eshton in upper Airedale. Climbing over a drystone wall, the visitor enters a small wooded hollow, the ground falling steeply from an iron palisade to the rim of St. Helen's well. This stone-edged pool is

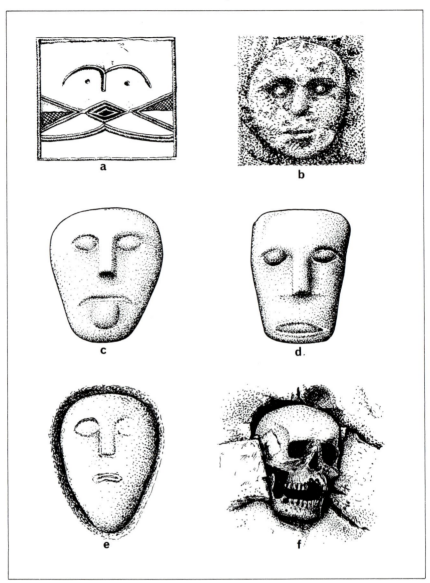

Fig.17. Early Faces

These carved faces are from (a) the stone drum-shaped chalk blocks excavated from an eighteenth-century B.C. child's grave at Folkton Wold in East Yorkshire, (b) a gritstone outcrop on Hebden Moor, Wharfdale, (c & d) from Kirkby Malham Church, where already of some age, they were incorporated into the masonry of the nave during the late fifteenth century, (e) from the late tenth-century chancel arch at Barton-on-Humber, and (f) a human skull still mounted in one of the pillars of the portico of the second-century B.C. temple at Roquepertuse, France.

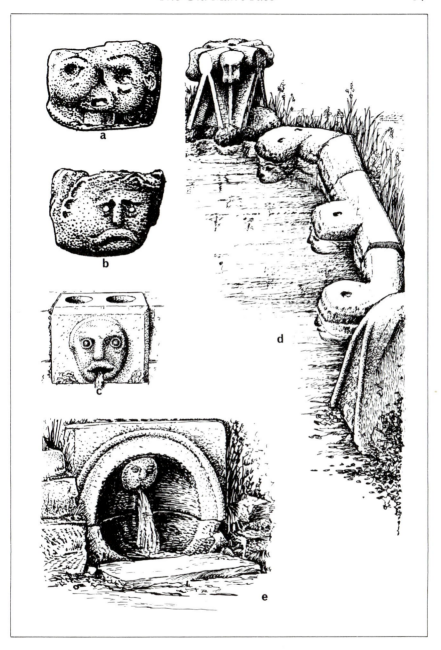

Fig.18. Faces at Springs
The 'Old Man's Face' was often associated with spring sites, these examples being at (a & b) a roadside trough at Hebden Bridge, (c) White Wells at Ilkley and (d) St Helen's Well, Eshton. (e) The Slavering Baby is on Adel Moor near Leeds.

about four yards in diameter, its fine gravel bed being maintained in a state of constant agitation due to the great upsurge of crystal-clear water issuing from the limestone beneath. The outfall from the pool takes the form of a convex masonry weir, its ends terminating in squat square pinnacles in Gothic style, while spaced equally along its length three bold semi-circular projections extend into the pool. At first these appear to be nothing more than small buttresses, but on close examination they are found to be carved in the form of human heads, their permanently submerged faces looking into the source of the water while remaining virtually invisible to those who do not already know of their presence. Unfortunately virtually nothing is known of the early history of this well, although a chapel dedicated to St. Helen stood here in 1429. This dedication to the mother of Constantine the Great, a lady long believed to be a native of Britain, could indicate that it has been a site of some significance for centuries. The style of the pinnacles, however, suggests that they are probably not medieval in date, but are more likely to be of the late eighteenth or early nineteenth century, perhaps being placed here by the Wilsons of nearby Eshton Hall who carried out great improvements to their estates around 1825. Even though the date of this group of heads is so uncertain, they remain an impressive example of the association of carved stone heads with spring sites.

On buildings, heads are most commonly placed on the gable-ends, not at the summit of the gable, but in a central position a few feet below. As early as the 1140s the masons building the church of St. John at Adel had incorporated a group of nine heads in this position. Since they have no place in Christian custom and belief, the builders were presumably using them to summon the aid and protection of some older, but still currently effective power. It is not known if similar heads were used on the domestic buildings of this and the succeeding periods for, being built of wood, they have largely decayed and been demolished. When they were replaced by permanent stone structures from the late sixteenth century onwards, however, gable-end heads were very much in evidence, some thirty being recorded on houses and barns in central Yorkshire alone. In some cases heads were also carved on the kneelers, the stones at the bottom of the gable. These may be seen at the seventeenth-century North Hall Farm, Thackley, and on No. 52 West Lane, Haworth, a cottage built in 1757.

The use of heads over or at the sides of doorways follows a similar pattern, the doors and chancel arches of Adel displaying numerous heads, for example, while one small head of uncertain date looks down from the gateway of Richmond Castle. Again, these heads are found to be fully in evidence when the first major rebuilding of domestic structures

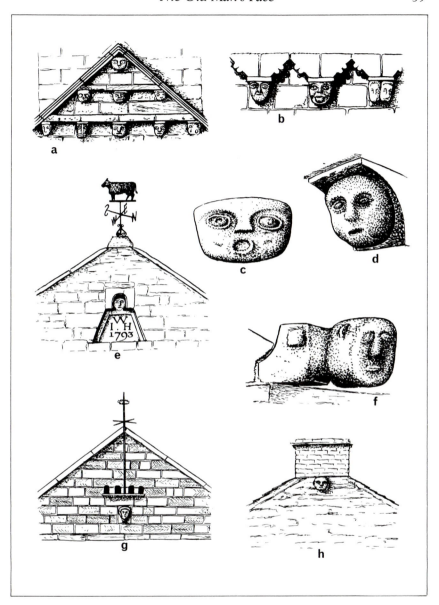

Fig.19. Faces on Gables and Eaves
Stone faces have been carved on gables and eaves of buildings for centuries, those at
(a & b) St John's Church, Adel, dating from the 1140s, (c) at Wakefield Cathedral, from the
fifteenth century, (d) at St Edmund's Church, Edmundbuyers, from the twelfth century,
(e) at Thorpe near Grassington from 1793, (f) at West Lane, Haworth, from 1757, (g) at Post
Gate Farm, Glaisdale, from 1839, and (h) at Milner Bank, Newsholme near Keighley, of the
early nineteenth century.

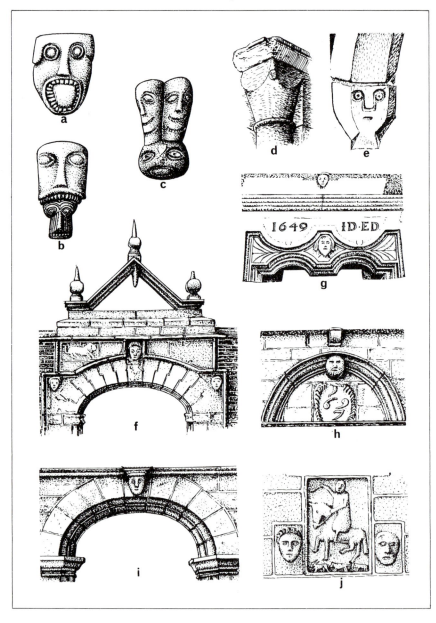

Fig.20 Faces on Doorways
Doorways and gateways might be protected with carved faces, as can be seen in these examples, (a c) at St. John's Church, Adel, (d) Richmond Castle, (e) the porch of St. Michael the Archangel, Kirkby Malham, (f) Coley Hall, (g) and Wood Lane, Sowerby, (h) both of 1649, near Halifax, Monks Hall, Appletreewick of 1697, (i) Haworth Old Hall, (j) and Oakworth Hall of 1702.

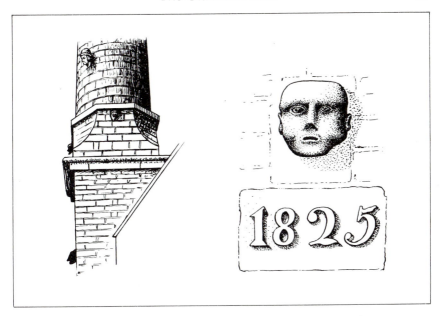

Fig.21. Faces on Chimneys
In the Keighley area a number of early nineteenth-century chimneys had stone faces built into their masonry. This chimney, which has five faces, is at Low Bridge Mills, the detail of the single face being from Smithies Mill, Birstall.

takes place in stone, numerous examples being datable between the seventeenth and twentieth centuries.

A further group of heads are found in a most unlikely situation, being built into the stacks of mill chimneys in the West Yorkshire textile area, including Smithies Mill, Birstall, of 1825,[8] Haggas' Mill at Oakworth, and T. Harrison & Sons of Queen Street, Bingley. A head on the side of the Old Corn Mill in Ingrow Lane, Keighley, is reputed to have been modelled from a Mr Feather who watched the masons erecting the buildings in 1841, while the five heads on the nearby Low Bridge Mills are said to represent the owners, all members of the Blakey family. However, the heads themselves have little of the character of portraits, and their attributions could easily have been suggested at a later date in order to explain the existence of such unusual features.

From the physical evidence given above, it can be shown that stone heads have been carved in this region since the twelfth century at least, and that they have particular associations with rivers and springs, gables and doorways. Clearly we must look back to much earlier pre-Christian beliefs and practices in order to try to explain their significance. It has

become popular to give many aspects of the pre-Christian culture of these islands the title of Celtic, as in Celtic religion and Celtic mythology, to say nothing of the Celtic Dress, Celtic Art, Celtic Music, Celtic Games and Celtic Crosses, promoted largely for nationalistic purposes during the nineteenth century.[9] Even so, it is to the practices of the Celtic peoples of central Europe that we must turn to trace the importance of the carved stone heads. It was in late Bronze Age Hungary that their culture began to take shape, with its villages, its agricultural economy, and its method of interring the cremated remains of its dead in pottery urns in large cemeteries. Between 1300 and 700 B.C. this Urnfield culture expanded to occupy most of central and western Europe, but from this time it began to change significantly, probably as a result of tribal movements westwards towards the Black Sea. An immensely wealthy aristocracy now developed, its burial rites including the construction of wooden chambers in which the chieftains were laid to rest with four-wheeled funeral wagons, together with the weapons, personal ornaments and food required in the afterlife. The weapons and tools were now of iron as well as bronze, while changing patterns of bridle fittings indicate the growing importance of the horse. This Iron Age culture, known as the Hallstatt from the major Austrian cemetery site excavated in the middle of last century, continued through to c.500 B.C.

About this time a new series of influences began to modify Celtic life, largely as a result of increasing links with the Mediterranean. The motifs found on the Greek and Etruscan, Scythian and Persian artefacts obtained through trade, combined with those of the earlier Urnfield and Hallstatt periods, provided their craftsmen with a whole new and fertile vocabulary of designs. These were exemplified in the magnificent finds of weapons, horse gear, tools, ornaments and coins excavated from the submerged domestic and industrial settlement of La Téne on the shore of Lake Neuchâtel near Berne in Switzerland, this site giving its name to the whole phase of late prehistoric Celtic Europe which ended with the coming of the Romans.

As Dr Anne Ross has shown in her excellent volume on *Pagan Celtic Britain*, 'the human head was regarded by the Celts as being symbolic of divinity and otherworld powers. The motif of the severed head figures throughout the entire field of Celtic cult practice, temporally and geographically, and it can be traced in both representational and literary contexts from the very beginning to the latter part of the tradition'. The Celts had probably absorbed these beliefs from earlier cultures, as is suggested by the use of stylised faces on three carved chalk cylinders found in an eighteenth-century B.C. child's grave at Folkton Wold in the

East Riding, and a face carved on a pebble of Borrowdale lava found in a fifteenth-century B.C. grave at Mechlin Park, Cumbria, both of which considerably pre-date the arrival of Celtic peoples in this region.

Both in Britain and in continental Europe, there is an extensive body of literary and archaeological evidence for the association of heads with both spring sites and doorways.

Within this region, this connection is proved by the discovery of human skulls in the recently excavated well of a Romano-British farmstead at Rothwell near Leeds, while a well dedicated to the goddess Conventina found in 1879 just by the Roman fort of Brocolita on Hadrian's wall near Hexham contained not only a human skull, but also a number of small bronze heads.[10] With regard to doorways and entrances, the most dramatic European evidence comes from the pre-Roman temple sites at Entremont and Roquepertuse in France, where the pillars of the porticos feature heads carved in stone, and recesses holding human skulls respectively. In northern England, Sir Mortimer Wheeler excavated a human skull near the entry into the great Brigantian fortress at Stanwick, 'The general inference is clear', he wrote; 'the skull is that of an enemy or prisoner who had been violently attacked with sword or axe and had subsequently been beheaded. The head had probably been placed on a pole at the gate, or on the gate structure itself, perhaps as part of a trophy of which an accompanying sword and scabbard may have formed a part. The chances are that the deposition occurred when the defences hereabouts were dismantled after the capture of Stanwick by the Romans in A.D. 71–74, and the slaying of the victim cannot long have preceded the event', since the skin was still intact when it was deposited.[11] Centuries later, the same custom was still being practised. In the Wars of the Roses, for example, the head of Richard, Duke of York, was spiked on York's Micklegate Bar; 'Off with his head and set it on York Gates; So York may overlook the town of York', cried Shakespeare's Queen Margaret. Even as late as 1754 the heads of traitors were still spiked over the principal entrance to this city.

It appears to be far more than mere coincidence that the carvers working in northern England during the past three hundred years should have placed their stone heads almost solely in situations which have such a long and well-established ritual significance. Archaeological evidence from this region shows that the head had acquired cult status almost four thousand years ago, and it is quite feasible that practices established from this period survived, even in the most vestigial forms, through to recent times. Since long periods of the intervening centuries were characterised by the use of perishable timber and clay building materials, it is extremely unlikely that conclusive proof of this suggested continuity will ever

become available for study. It is significant, however, that the first permanent stone structures feature these heads in comparatively large numbers, especially in areas such as West Yorkshire and the northern borders of England where the survival of British culture was particularly strong, and where a number of British place-names are still in use today.

As in other aspects of folk art, the 'Old Man's Face' provides us with an interesting example of the long continuity of custom and belief in both local and European contexts, a continuity which was only interrupted by the great social changes and population movements brought about by nineteenth-century industrialisation.

4

Traditional Woodcarving

Up to the closing years of the nineteenth century, almost within the period of popular living memory, a traditional form of woodcarving was still being practised in northern England, just as it had been over many preceding centuries. It was not a sculptural form of carving, involved in making representations of human figures or animals, but was a crisp geometric form of surface decoration composed of minute incised triangles cut with a pocket knife, these being arranged to form zig-zag lines, rosettes, hearts, and Xs. This was essentially an art of the pastoral regions of the north, flowering in the dales of Yorkshire, County Durham and Northumberland, and the hills and mountains of Cumbria, where life was based on raising sheep and cattle in these vast open landscapes.

'To decorate a piece of wood with notches and carvings is a shepherd's pastime, and not so long ago every inhabitant of certain districts was a shepherd . . . They are the strangest and at the same time the most attractive people one can meet. The shepherd spends his whole life wandering from the snow-clad mountain . . . to the plains. These shepherds, the dogs and the sheep, form a numerous silent, slow-moving community in which all is mild and gentle. Remote from every other human being, far from their wives and sweethearts, their thoughts wander aimlessly, they come round to the loved one on whom they dwell with affection. But time drags on slowly when there is nothing to do. And so they pick up a piece of wood; unclasp the knives which hang on their belts. After a while they become oblivious of time and space, they dream, talk to the dog, whilst the hand is cutting skilfully drawn lines, crossing them, interlacing them, adding a figure, a date, possibly initials. There is no hurry, the shepherd has well-nigh an eternity of time before him; he does the work well, arranges and finishes everything with loving care, all for the beloved.'[1]

Although this passage perfectly describes the mental and physical environment in which traditional northern English woodcarving was created, it relates to the Wallachian shepherding communities who led their flocks throughout Rumania, into Poland, Czechoslovakia, Hungary, Yugoslavia, Greece, and the Russian Steppes. These men, together with their counterparts in every pastoral region of Europe, shared a common

carving tradition unified by its techniques, its designs, and its practice of giving carved wooden utensils as love tokens. In England, men carved knitting sheaths for their women; in Wales and Brittany they carved love spoons; in Switzerland, distaff handles and caskets; in Italy and Sicily, stay-busks; in Scandinavia, scutching knives and mangle-boards; in Hungary and Lithuania, distaffs; and in the Austrian Tyrol, milking stools, salt boxes, knife handles, forks and spoons.[2] The actual purpose of the utensil was determined by local circumstances, but its true value was as a love token. For this reason, the richness and delicacy of its decoration might make it totally useless for all practical purposes. It was impossible to use most love spoons for eating, for example, while the fineness of the carving on some knitting sheaths made them unfit for anything except to be hung up on the living-room wall as decoration.

In every case, the repertoire of designs was largely restricted to rosettes, the X motif, and zig-zag lines, 'creations which are to be numbered among the most interesting and the oldest of European Art', being found on artefacts ranging from ceramic beakers made early in the second millennium B.C. through to the products of the traditional European wood-carvers of the nineteenth century A.D.[3] Considering the recorded antiquity of these carved motifs, their widespread distribution, their association with love tokens, and their close relationship with pastoral peoples from the Urals to West Wales, it appears that they must spring from one common source. It was some four thousand years ago that a dynamic community of cattle-herding nomads burst out from Russia to spread their 'beaker' culture with its crucially important contributions throughout Western Europe. To them is generally attributed the spread of the Indo-European languages which unify this continent, and it is to them too that we may owe the origins of our traditional woodcarving skills. That this tradition is of considerable antiquity in the north of England is beyond doubt, for among the artefacts recently excavated from the Viking site at Coppergate in York was a wooden saddle-bow, its entire surface being covered with magnificent chip-carving, presumably executed in this woodworking suburb around one thousand years ago.

Knitting Sheaths

The international folk-art of woodcarving is chiefly represented in northern England by the knitting sheath.[4] Introduced into this country in the sixteenth century, knitting quickly moved away from urban centres such as York and Lincoln to become a major craft industry in Cumbria and the Yorkshire Dales where it provided a sizeable income to the

Fig.22. Knitting Sheaths
Chiefly carved as love tokens throughout the north of England, knitting sheaths change their shape from one locality to another, as may be seen in this map which shows the distribution of each type: (a) Airedale tinplate hearts, (b) West Cumbrian hearts (c) Clapham sheaths, (d) Durham sheaths, (e) Eden sheaths, (f) West Cumbrian sheaths, (g) Dent sheaths, (i) Eskdale sheaths, j) 'Triangle' sheaths, (n) North Yorkshire brass hearts, (s) 'Stepped' sheaths, (t) Teesdale sheaths, (w) Weardale sheaths, Spindle sheaths.

inhabitants. By the 1820s, for example, the stockings from Wensleydale and Swaledale alone produced some £40,000 each year. In this region knitting was carried out on a number of curved metal needles, one of which was held rigidly between the right hand and a purposely made wooden support or sheath secured at the side of the body between the waist and the armpit by means of a ribbon or belt. Then, as William Howitt reported in 1844: 'their knitting goes on with unremitting speed, they sit rocking to and fro like so many wierd wizards. And this rocking motion is connected with a mode of knitting . . . called swaving [using] a

single uniform tossing motion of both hands at once, and the body accompanying it with a sort of sympathetic action. They knit with crooked pins called pricks; and use a knitting-sheath consisting commonly of a hollow piece of wood, as large as the sheath of a dagger, curved to the side [of the knitter] and fixed by a belt called a cowband. The women of the north, in fact, often sport very curious knitting sheaths [which] are often presented from their lovers to the young women'.

Since knitting sheaths were only introduced in the sixteenth century, it is probable that they replaced some earlier variety of carved love token, such as the spoon. However, sheaths carved in the traditional manner soon became accepted as the major love token of northern England, each major dale or region adopting its own particular shape of sheath. The major groups of sheaths may be defined as follows:

Durham Sheaths

These are rectangular in section, their slightly curving shafts tapering in thickness from head to foot, while maintaining the same width across the face. Their feet terminate either with a straight-cut edge, or with a neat scroll to the front, while a deep diagonal slot for the cowband runs diagonally across the face. Many sheaths are quite plain, while others have simple chip-carved designs and inscriptions. When County Durham became much more urbanised from the mid-nineteenth century, the traditional form of carving on native wood gradually disappeared, being replaced by the cabinet-maker's techniques of inlay and French polishing on imported mahogany, ripple-grained maple, etc. These later sheaths are frequently decorated with inlaid panels of glass which cover slips of paper bearing either handwritten inscriptions or painted scenes, the paper itself often being pierced with diamonds or hearts to reveal a backing of coloured cloth or paper. On these examples the inlay is of the highest quality, the panels being framed with mahogany, ebony and harewood crossbanded between fine boxwood strips, the shafts being further inlaid with fine woods, bone, or coloured waxes rubbed into incised designs.

Stepped Sheaths

Similar to the Durham sheaths, but with a raised step running diagonally across the upper part of the face, these sheaths come from the area between Upper Nidderdale and the Tees in North Yorkshire. From

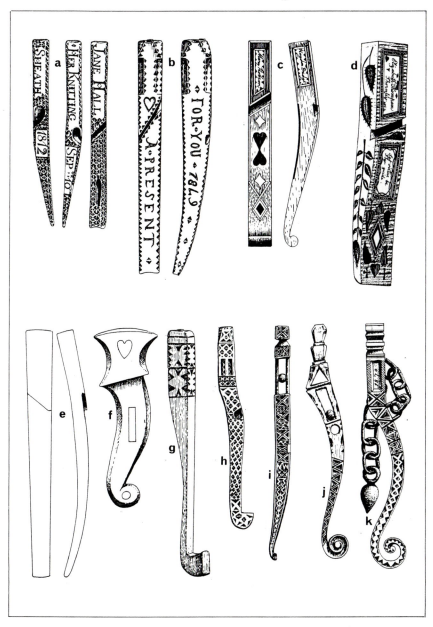

Fig.23. Knitting Sheaths
Durham sheaths: (a) from Consett, County Durham, 1812 (b) from North Shields, 1849 (c) from Haydon Bridge, (d) from Thornley, 1854 Stepped sheaths: (e) from Gayles, Richmond (f) from Scorton, Richmond. Weardale sheaths: (g) from Nenthead, (h) from West Blackdean, (i) from Weardale, (j) from Nenthead, (k) from Alston, 1870.

around the 1850s, they too began to be made in finer imported woods, their heads developing concave sides, and their shafts a serpentine form with pronounced scrolling at the foot. Usually quite plain, these later sheaths were occasionally inlaid with small diamond- or heart-shaped pieces of bone or light-coloured wood.

Weardale Sheaths

The Weardale sheaths are normally square in section, the upper third being straight-sided and decorated either with chip carving, a ball-cage carved from the solid wood, an imitation ball cage, inlaid glass panels, or even with a carved chain pendant. The lower part of the sheath has a gently curving outline, frequently being chip-carved and having an arrow-shaped, spiral or violin-scroll terminal. Where a slot for the cow-band is provided, it runs diagonally across the upper face of the sheath. This group originates in the hill country to the north of Cross Fell, including the upper valleys of the South Tyne, the East Allen, and the Wear.

Cumbrian Hand Sheaths

Straight-sided and rectangular in section, this type of sheath has a diagonal cut across its face to receive the cowband, six separate needle holes bored into its head, and a terminal formed of a hand pointing to an encircled serpent, the symbol of immortality. Most examples date from the last quarter of the eighteenth century, being so alike that they probably represent the work of a single maker.

West Cumbrian Sheaths

Similar in shape to the Durham sheaths, those made around the foot of Eskdale and the coastal areas of western Cumbria are characterised by having an L-shaped slot cut back into the sheath to take the cowband, and a head which is either square-cut, or has a square terminal knob, and includes a ball-cage. The carved decoration includes the usual chip-carved motifs together with hearts, flowers, birds, and the initials or name of the owner.

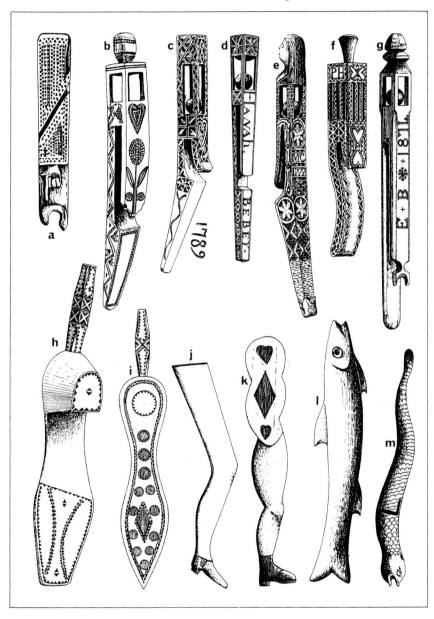

Fig.24. Knitting Sheaths
Cumbrian 'Hand' sheaths: (a) Cumberland, 1773. West Cumbrian sheaths: (b) from Calderbridge, 1782 (c) from Eskdale, 1789 (d) from Eskdale, c.1825 (e) Unprovenanced, 1777 (f) from Cumberland, 1831. Clapham sheaths: (g) from Clapham, 1871. Representational sheaths: (h) shoe from Teesdale, (i) shoe from Muker, (j) leg from Newsham, (k) leg from Weardale, (l) fish from Stanhope, (m) snake from Blanchland?

Clapham Sheaths

These north-west Yorkshire sheaths have a long straight shaft, square in section, their heads terminating in a carved knob and a ball-cage. The lower part of the shaft, meanwhile, is divided into a long forked form, the back prong having a rounded end, and the slightly shorter front prong a round or Y-shaped finial. The decoration is restricted to simple X motifs or rosettes, together with the date and the initials of the owner.

Eskdale Sheaths

The sheaths used in the valley of the Yorkshire Esk, which runs westwards from Whitby deep into the North Yorkshire Moors, are square in section, the lower part of their shafts being divided into a fork which can be hooked on to the cowband. The simplest of initials, patterns cut in V-sectioned grooves, and the occasional ball-cage complete their decoration.

Chain Sheaths

This most elaborate group presented the greatest opportunity for the display of technical skill and ingenuity, each sheath having a long chain terminating in a hook intended to support the weight of the knitting, all carved from a single block of wood. The technique of carving wooden chains was already fully developed by the fifteenth century, although the earliest chain sheaths date from the 1680s. In northern Cumbria, around Carlisle, most chain sheaths have square-sectioned shafts with elaborate terminal knobs and perhaps ball-cages too. Chip carving, including double hearts, initials, or the date, covers their surfaces, while their single or even double chains may be further enriched with ball-cages or a number of swivels. One example from this area, carved with a pocket knife by Francis Mitchinson, a quarryman at Garthpool, Castle Carrock, about 1870, is much simpler in form, relying on the intricacy of its surface decoration for its effect. The other centre for making chain sheaths was upper Teesdale. Here the shafts were carved into a spiral form with rectangular terminals, their finely carved chains finishing in two- or four-pronged hooks carved from square-sectioned blocks. Unlike most other sheaths, they are frequently covered either with varnish or with black paint, the latter being rubbed into the carving to make it stand out in contrast to the light-coloured wood. Probably the finest makers in this area were the Tarn family, Timothy Tarn's work of the 1890s being particularly notable.

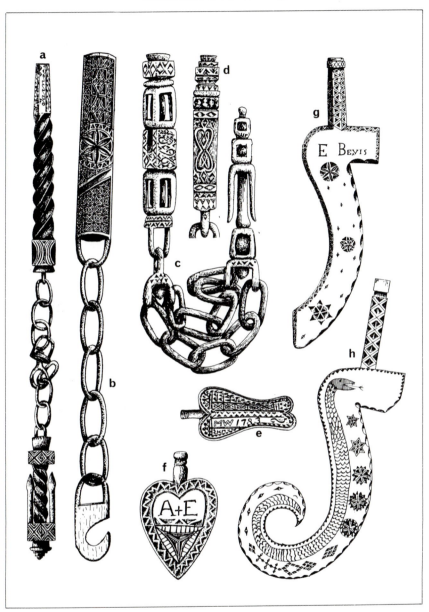

Fig.25. Knitting Sheaths
Chain sheaths: (a) by Timothy Tarn, Middleton-in-Teesdale, 1892 (b) by Francis Mitchinson, Castle Carrock, Cumbria, c.1870 (c) from north Cumbria, 1896 (d) from north Cumbria. Heart sheaths: (e) from West Cumberland, (f) unprovenanced, probably West Cumberland. Teesdale sheaths: (g) from Middleton-in-Teesdale, (h) from Teesdale.

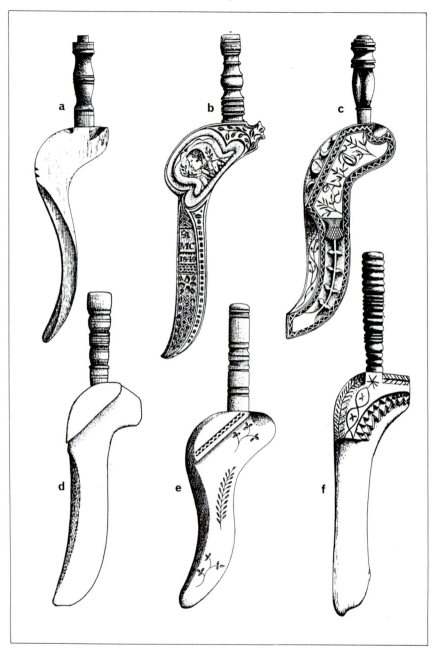

Fig.26. Knitting Sheaths
Eden Vale sheaths: (a) from Warcop, (b) from Wigton, (c) from Eden Vale. Dent sheaths: (d) from Dent, (e) from Dent. 'Triangle' sheaths: (f) from Castle Bolton, 1830.

Teesdale Sheaths

Made exclusively of native woods, this group of sheaths has flat-faced blades, almost uniform in width, with simple curved outlines enriched with borders of small curved triangles around the back and top edges, this often being replaced by a scalloped border along the front edge. Both the head and foot tend to have straight vertical edges, although these may be chamfered or scrolled respectively in some examples. The haft is normally carved to a square section, often tapering towards the ends, or given an octagonal section. Their decoration includes carved rosettes, lozenges, X and plant motifs, incised snakes, names or initials, and inlaid glass panels covering printed paper inscriptions. These sheaths were made almost solely around Middleton-in-Teesdale.

Eden Vale Sheaths

The blades of the Eden Vale sheaths have flat faces, broad at the head and tapering in a graceful curve towards the foot, this being emphasised by a broad chamfer along the back edge. The top edges are decorated with chamfers or scallops, with deep grooves in front of the haft to receive the cowbands. The hafts are either lathe-turned (or carved to resemble lathe turning) to a variety of complex baluster forms which are frequently enhanced by additional carving. The plainer sheaths may be decorated with pricked geometric designs, or with floral motifs or initials shallowly incised across the upper section of the face. Further examples have either initials or a name incised diagonally across the face within an ornamental frame. The finest sheaths in this group have their faces covered in carving of the highest quality, with elaborate initials, floral and geometric motifs, and even applied panels of bone carved with portrait busts picked out in black ink. These sheaths originate from the upper Eden valley, from Appleby towards Kirkby Stephen, then along its tributary, the Scandal Beck to Ravenstonedale.

Dentdale Sheaths

The chief characteristic of the Dentdale sheaths is the pronounced step or ledge which runs diagonally across the broad upper section of the face. In comparison with the Eden Vale sheaths, their blades are short and broad, ranging from smoothly modelled serpentine outlines to severe almost straight forms. In the finer examples the hafts are lathe-turned

balusters, but many are either carved to give a similar appearance to lathe-turning or are given a simple cylindrical or slightly conical shape. Their decoration is limited to notching along the upper edge of the step, or incised floral motifs and borders of incised triangles, although the majority are quite plain and of mediocre workmanship. These sheaths originate from Dentdale, Garsdale, and the adjacent areas of the Lune valley and upper Ribblesdale.

'Triangle' Sheaths

Similar to the Eden Vale and Dent sheaths in overall shape, the lower right-hand area of the upper section of their hafts is recessed to reveal either a parallel series of gouge-cut grooves, or a number of curved steps carved as a series of triangles. The remainder of this area is decorated with chamfers and simple incised designs. They come from the northern part of the Yorkshire Dales, from Darlington in Teesdale to Leyburn and Castle Bolton in Wensleydale.

West Cumbrian Heart Sheaths

These sheaths take the form of small heart-shaped pieces of wood which were secured back to a tape or other textile foundation by which they could be pinned in place on the clothing. They are decorated with simple chip carving and perhaps initials etc.

Stay Busks

The word 'busk' appears to have been applied at first to any stiffened form of bodice or stays. Thus William Warner in his *Albions England* of 1589 could describe a lady whose 'face was Maskt . . . her body pent with buske', while John Marston's 1599 *Scourge of Villainie* stated that:

> Her long slit sleeves, stiff buske,
> ruffs, verdingall,
> Is all that makes her thus angelicall.

From the mid-seventeenth to early nineteenth centuries, however, the term became restricted to the long, triangular-sectioned shaft of wood which passed down the front of the stays, being inserted into a V-shaped

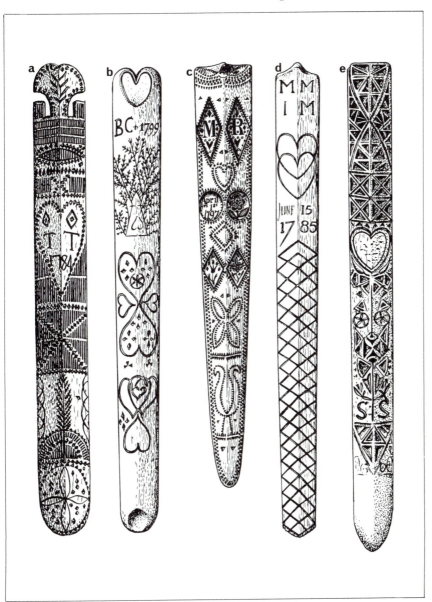

Fig.27. Stay Busks

Like knitting sheaths, stay busks were carved as love tokens, most being eighteenth century or earlier in date: (a) carved by Thomas Tarn of Middleton-in-Teesdale, 1784 (b) made in 1799 for 'Barbra Cowse' who lived in the Bassenthwaite area, (c) probably from County Durham (d) from Thormanby, North Yorkshire (e) from Skelton, probably North Yorkshire.

opening in the corset bodice, stiffening it, and permitting the body to be tightly laced into the fashionable tight-waisted silhouette.

Along with English knitting sheaths and Welsh love-spoons, the wooden stay busks provided an excellent opportunity for men to demonstrate their carving skills in providing presents and love tokens for their womenfolk. This is clearly indicated by some of the inscriptions carved on the busks. These include the following, taken from the earliest dated example:

> As a ring is round and hath no end,
> So is my love to the[e] my fri[e]nd
> Agnes Battie, 1660

or, from a busk of 1783:

> When This You See
> Pray Think on Me
> Tho Many Miles
> We Distant Be
> all Tho We are a Great Way Apart
> I wish You Well With all My Heart

or, simply:

> The gift is small but Love is All

Similar evidence is provided in the following lament of Bridget in William Carr's *Dialect of Craven* of 1828:

> but what grieved me more than all were,
> I lost my hollin busk, finely flowered, 'at my husband
> gave me 'fore I were wed.

Since stay busks went out of popular use almost a century before they started to be collected by antiquarians, very few of them have any detailed history or provenance. Even so, it is possible to attribute certain busks to particular people and places in northern England, where there was a well-established tradition of carving love tokens.

From Middleton-in-Teesdale, a high Pennine village on the border of Yorkshire and County Durham, comes a busk made by Timothy Tarn in 1784. It was preserved in his family up until the 1950s, when Mr O. R. Whitehead of Bradford purchased it for presentation to the York Castle Museum. The whole of its convex face is covered with chip-carved and incised decoration, including X motifs, roundels, and a heart bearing the

inscription 'T.T. 1784'. Its chief characteristic, however, is the treatment of the upper end, where slots have been cut into each side to produce a wide, shaped finial. Perhaps this provided a convenient place for tying a lace around the top of the busk, thus keeping it securely in position within the stays. Although differing in their style of carving, it is possible that a small group of busks with similar finials, all dating between 1784 and 1794, may be attributed to this area.

The Carlisle Museum collection includes a busk made for Barbara Cowse in the Bassenthwaite area of the Lake District in 1799. Although quite simple in its overall shape, it has a number of decorative elements cut in outline into its curved front face, the most notable being a pair of hearts joined by their bases, the typical love-token motif found throughout north-western England.

The inscription 'M.M. – I.M. June 15, 1785/This and the giver are yours forever, Thormanby, June 15', recorded on a busk in the Pinto collection at Birmingham Museum, enables it to be firmly provenanced to the village of Thormanby, midway between Easingwold and Thirsk in North Yorkshire. It is extremely plain, its almost parallel shaft of mulberry wood being simply incised with two interlaced hearts and an area of widely spaced diagonal cross hatching, quite unlike the decoration found on busks from any other area.

Another example in the Pinto collection is inscribed 'E.K. Skelton, April 10, 1762'. Here the place of origin is rather more difficult to determine, since there are some six villages of this name in the north of England, but as four of them are in the North Riding of Yorkshire, it is most probable that the busk comes from within this county. Like the example from Thormanby, it is long, narrow, and parallel-sided, but here the similarity ends, for its face is covered with deeply-cut chip carving, including X motifs, roundels, and a heart.

A further group of busks, all dated to the late 1790s, and so closely identical that they can certainly be identified as the work of a single maker, probably come from County Durham. Their long, tapering shafts have square-cut tops neatly chamfered to produce a simple yet ornamental finish, while a heart, a diamond, a quatrefoil and a 'tulip' motif are all chip-carved in outline within a zig-zag border on the face of the busk. Their chief characteristic, however, is the use of small glazed panels inlaid into wood. Near the top, a pair of diamond-shaped panels reveal the owner's initials neatly penned in coloured inks on small pieces of white paper which are further decorated by being pierced with diamonds, hearts and crosses to show an underlying layer of dark-coloured material. Two roundels below show the exact date and a five-petal flower respectively, while lower down there might also be a further

Fig.28 Carved Boxes
This group of finely carved boxes appear to have originated in this region, probably in the area between the Lake District and the Yorkshire Dales, c, for example, being collected in Settle, and having the double-heart motif of the north-west carved on its lid. In each example, the lid has a broad dove-tail section and a gradual taper along its length to ensure a perfectly tight fit.

pair of diamond panels decorated with lively floral motifs. As this particular technique of decoration is entirely restricted to the traditional woodcarving of County Durham, it is reasonable to assume that this delightful group of busks originated from this area.

Unfortunately it is not possible to identify either the makers or the provenance of most other busks, but even so, they remain a vibrant reminder of the high quality of traditional English folk-art. By 1900 the

Fig.29. Carved box and Funeral biscuit moulds
The tradition of chip-carving love tokens had already achieved spectacularly high standards of inventiveness and craftsmanship by the mid-seventeenth century, as illustrated in (a) this box of 1650, with its heart, lover's knot and rosette motifs. Funeral biscuits of caraway-flavoured shortbread were made in specially carved moulds from the seventeenth to the nineteenth centuries; (b) carved in stone in 1666, and stating that the day of death is the birth of life eternal, was used in the city of York, while the biscuit (c) was stamped with a wooden mould used by Mrs. Nelson at Longber Farm, Burton-in-Lonsdale.

practice of carving love tokens had been dead for some years, and this centuries-old tradition was now totally redundant. As Romilly Allen commented: 'Imagine a masher of to-day laying a stay-busk at the ungainly feet of a new woman. She would probably use it as a golf club or a hockey stick!'

Boxes

Small carved boxes form a significant element in European folk art. They were made by taking a rectangular block of solid wood, digging out the core to leave a thin outer shell, and providing a sliding lid broadly dovetailed in section and gently tapered along its length to ensure a perfect fit. The edges of the lids were thoroughly disguised once the carved decoration had been completed, thus making it very difficult to detect in the finer examples. Although the mirror-cases carved in Hungary are made on this principle, the boxes originating in the area between the Yorkshire Dales and the Lake District are virtually identical to those made in France, especially around Saint-Veran, Switzerland and the Tyrol. Like them, their decoration usually includes rosettes within borders of simple zig-zags, but the English examples may also bear the X motif, have their corners cut in concave quadrants, or have one edge rounded in imitation of the spine of a small book.[5]

The European tradition of carving small plank-built boxes or caskets as love tokens has been virtually unknown in England for over two hundred years. A number of examples survive from the 1640–70 period, however, most of them being either the name of a girl or an inscription such as 'WIL THIS PLEAS YOU'. Their carving is of the highest standard of inventiveness and technical excellence, especially in the execution of their elaborate rosettes and lovers' knots.[6]

5

Splintwork

Splintwork was a very effective method of jointing thin, flat strips of wood together to form three-dimensional structures. To make each joint, six of the strips or splints were carefully notched and tapered so that they could be snapped together, each splint being held rigidly in place by its neighbours, without the use of nails, screws, glue or wedges. Although this technique is known in North America, it appears to be virtually unknown in continental Europe, while in England every provenanced example has been found in the northern counties.

It is very difficult to establish the origin of splintwork, the two earliest examples coming from early eighteenth-century north-east Yorkshire. Made from over 120 splints and incorporating some eighty joints, they are built in the form of extremely complex rectangular frameworks symmetrical about a vertical central shaft. The example housed in the Pannett Park Museum, Whitby, was collected from a farm on the North Yorks Moors, where it was called a 'Roman candle', one end of the central shaft being charred, presumably from its use as a candlestick, perhaps suggesting that it had some ritualistic purpose. The Castle Museum in York obtained its example from the eighteenth-century Kirkleatham School Museum near Redcar. Very similar in shape, it has the bottom of its central shaft rounded, as if it was intended to fit into a handle or stand, while a piece of lead shot is enclosed within each joint so that it rattles with the slightest movement. Faint traces of handwriting can also be seen on a number of the splints, an ultra-violet lamp enabling a series of inscriptions to be read with difficulty. These include:

> *There is no Sweet within our power, but it*
> *is saused with some Sower*

> *. . . in thy Youth least . . . should find thee*
> *poor, for when times pass . . .*

> *. . . well to thy self every degree according*
> *to thy (?) etting, let . . .*

> *Cum recte . . .*

and, more revealingly:

> *Gwielmus Watson fecit & dedit Willm. Richardson,*
> *1733*

It therefore appears that it was made by William Watson for William Richardson in 1733. Its design and the nature of the inscriptions indicate that it was probably intended for use as a charm. Assuming that it was

Fig.30. Splintwork Charms
Splintwork charms, such as this example in the Pannett Park Museum, Whitby, (a) were probably used by the early eighteenth-century wise-men of north-east Yorkshire. They are made from narrow strips or splints of pine, carefully notched and interlocked together to form a rigid structure, lead shot enclosed within each joint making them rattle with the slightest movement; (b) detail of a splintwork charm at the York Castle Museum which was made by William Watson for William Richardson in 1733. Many of the splints bear similar lines inscribed in faded brown ink.

made in north-east Yorkshire, where belief in the supernatural continued to play a major part in everyday life through into the mid to late nineteenth century, it might well have formed part of the equipage of one of the local wise-men. In his classic *Forty Years in a Moorland Parish* Canon Atkinson gives a full account of their activities and their use of 'the accustomed paraphernalia of the character assumed and its pretensions — a skull, a globe, some mysterious-looking preparations, dried herbs, etc., etc.' to counteract witchcraft, trace stolen goods and solve the problems of the local people.

During the nineteenth and early twentieth centuries splintwork was used as a hobby or pastime, numerous frames for pictures, photographs and mirrors being made in this way in cottages and small farmhouses throughout the North. In many cases the splints were quite robust, measuring perhaps three-quarters of an inch by three-sixteenths, their broad surfaces being enriched with simple chip carving. For real demonstrations of skill far finer work was undertaken using splints only three-sixteenths by one-sixteenth, their miniature scale making accurate measuring, cutting and jointing absolutely essential. A single modest picture frame made in this way could easily take over 1,320 splints, 460 joints, and hours of careful work, a sturdy under-frame then being required to support the splintwork and hold the picture or glass in place.

Model chairs also provided suitable subjects for splintwork, the rectangular arrangement of their posts and rails being readily reproduced by relatively thick, narrow splints. Most examples have their splints carefully smoothed, with chip-carved corners so as to present an interesting if rather spiky silhouette, the whole then being coated in a golden-brown copal varnish to keep them clean and bright. For added reality and colour, their seats might be upholstered with padded velvet, etc. or have miniature wool-work or embroidered cushions carefully made especially for this purpose. Since the whole assemblage would be spoiled by an accumulation of dust, which lodged irremovably in the intricacies of the splintwork, the most elaborate examples were enclosed within a glass dome and placed on the sideboard for display to family and friends.

In Lancashire, chairs were sometimes made in a very distinctive form of splintwork in which short, almost square-sectioned splints were notched across one face, pointed at their ends, and interlocked with one another along the length of two long, narrow splints. Using this method, it was possible to produce curving strips of splintwork, one of the best examples, made from a piece of railway sleeper by a retired railwayman in Rochdale just before the First World War, having a balloon back which would have been impossible to make by the usual techniques.

Fig.31. Splintwork Frames
(a) This splintwork photo frame was made in West Yorkshire towards the end of the nineteenth century. Note the chip-carving along the front surfaces of the splints; (b) Measuring only four and a half inches (11 cm) wide, this detail of one corner of a mirror frame demonstrates a high level of splintwork craftsmanship. Note the notched ends of the splints, and the projecting joints around its upper edge. It was collected from the Ingleton area of North Yorkshire.

In addition to picture frames and chairs, splintwork could be used to make many small yet decorative items for the home, the practice of inserting panels of thin board between the splints converting the open framework into an enclosed space so that it could be used as a money box, watch pocket, or holder for other useful items.

Along with many other traditional crafts, jointed splintwork failed to

Fig.32. Splintwork Chair
Chairs formed a popular subject for the splintworker, as may be seen on this late nineteenth-century example from West Yorkshire.

survive the social changes which took place during the early twentieth century, the latest example I have found to date having been made from an old cigar box by a man from Cumbria while a prisoner of the Japanese during the 1939–45 war. Since that time a variety of splintwork has continued to be made using mass-produced components. Of these, the

Fig.33. Splintwork Chair
This chair, made from a piece of railway sleeper by a retired railwayman in Rochdale, shows a variety of Lancashire splintwork in which short sharp-pointed splints are interlocked around a pair of long, flexible splints. This method enables curved sections to be completed.

Fig.34. Splintwork
Collected in Keswick, this money box (a) was brought home by a local man who had made it from an old cigar box while a prisoner of the Japanese in the 1939–45 war. The money can be extracted by sliding one of the wooden panels to one side within its splintwork frame. To make this baby's rattle, (b) a craftsman from north-eastern England has enclosed a number of small stones or lead shot within a complex arrangement of square splints. In recent years a crude variety of splintwork has been made by gluing together either the jaws of spring-loaded clothes pegs or the used sticks collected from ice lollipops. (c & d) The chair and box shown here are typical examples of this work.

wooden jaws of spring-loaded beechwood clothes pegs are glued together
to make small rocking chairs, while the flat, round-ended sticks saved
from ice lollipops are similarly assembled as square or polygonal baskets
or dishes. However neatly these are made, they entirely lack the quality
of the early splintwork.

God-in-the-Bottle

As England has a strong Protestant and Non-conformist culture, it is not
surprising that this country never established a popular tradition of
making religious paintings and carvings. Throughout continental Europe,
however, the influence of the Roman Catholic church maintained a
vigorous religious folk art, with the crucifixion, saints and martyrs depicted
in a wide range of colourful media. The crucifixion theme was particularly
strong, since it represented the very essence of Christian belief. In France
and Germany, for example, elaborate crucifixes were constructed from
small pieces of wood, their basic crosses being festooned with numerous
miniatures of hammers, pincers, spears, ladders, and other relevant
implements. In other countries the crucifixion models were built entirely
within glass bottles.

The tradition of making ships and architectural models in upright
bottles was well established in maritime Europe by the early nineteenth
century. In 1860 Swedish craftsmen such as Edvin Johansson were also
producing crucifixion tableaux in bottles, features such as the figures of
Christ and the two thieves, the hammers, pincers, and the dice used to
cast lots for His garments all being included. In Ireland a similar tradition
was established about this time, many examples now being housed in
public collections.

The crudest examples might have only a rough-hewn cross and a
ladder inserted into an old spirit or mineral-water bottle, but these were
in the minority. Most were made from carefully smoothed and accurately
cut sections of pine, neatly carved and jointed together. First two short
horizontal rails were cross-halved into each other in the bottom of the
bottle to form a foundation for the crucifix. The vertical shaft of the cross
was then morticed into the centre of this foundation, and the arms of the
cross were added to hold it in position against the inner walls of the
bottle. It was then possible to add the instruments of the crucifixion,
usually including a ladder leaning against the back of the cross, and
carved hammers, pincers and spears slotted into holes already drilled in
the main framework. In most cases the surfaces of the wood were left

quite plain, but rare examples had black cord tightly wrapped around each section to give a richer and more decorative finish.

Once the crucifix had been completed, the bottle was filled with plain water and tightly corked to prevent evaporation and spillage. It was sometimes claimed that this water gained strong medicinal powers after

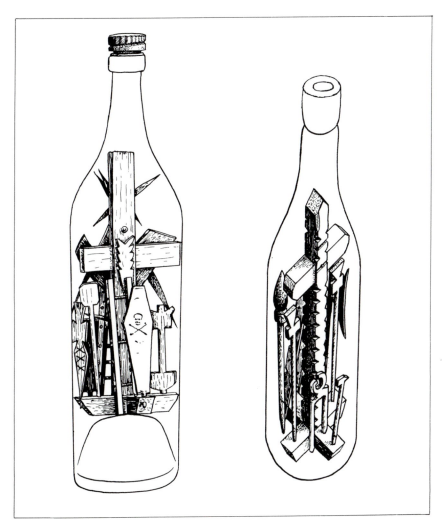

Fig.35. 'God-in-the-Bottle'
Made from strips of wood carefully assembled within a bottle to represent the crucifixion, the 'God-in-the-bottle' could also include working tools, Orange, or Masonic elements. In the first bottle, from Manorhamilton, Ireland, the cross is surrounded by a ladder, together with the key, compass, star and coffin of the Masonic order. The second bottle with the spear, pincers, hammer, and the crosses of the thieves is in Abbey House Museum, Leeds.

being kept for seven years, or, as recorded from an informant in County Roscommon, that it was Lourdes water — even though the salesman had just been seen filling the bottles from a nearby pump! Some makers, such as Mr Herrity from Donegal, used to put a spoonful of mercury in the

Fig.36. 'God-in-the-Bottle'
These examples of 'God-in-the-bottle' were collected from (left) the home of the Misses Gibb of the Grove, Ramsey, on the Isle of Man and (right) from the Newcastle area. The Newcastle example is quite unusual in the form of its decoration, each splint being bound in black cord.

bottle, so that when shaken a number of tiny bright globules spun around the objects inside, while others added fine white sand to give a snowstorm effect.

Fig.37. 'God-in-the-Bottle'
As the label around the neck of this bottle states, *These tools are a replica of those used in making Dore and Chinley R(ailwa)y Tunnel* running between Sheffield and Manchester in the late 1880s. Its maker was probably an Irishman employed during the construction works.

From the mid-nineteenth century up to the 1960s at least, crucifixes in bottles were made in Ireland either by individuals as a hobby, or, more commonly, by itinerant traders or pedlars who offered them for sale along with the remainder of their wares. One of these men even acquired the nickname of 'God-in-the-Bottle' as a result of his activities in this field.

From the famine years of the 1840s thousands of Irishmen and their families moved across to England, where their skills made a significant contribution to the unparalleled expansion of the Workshop of the World. Here they continued to make crucifixes in bottles, to the extent that in some areas, such as Tyneside, these models became quite as numerous as the locally made ships in bottles.

Some examples were made as a pastime by the navvies building the railways, where a sharp knife, a few pieces of pine and a supply of empty spirit bottles were always readily available. Instead of showing the instruments of the Passion, however, the navvies might choose to incorporate models of the hand-tools they used every day in the course of their work. One fine example bears a label inscribed 'THESE-TOOLS-ARE-A-REPLICA-OF-THOSE-USED-IN-MAKING-DORE-AND-CHINLEY-RY-TUNNEL-GIFT-OF-HARRY-' These tunnels, measuring over 3½ and 2 miles in length, were some of the longest in Britain, and were cut during the construction of the railway between Manchester and Sheffield in the late 1880s, therefore allowing the bottle to be accurately dated to this period. In addition to including the axes, picks and shovels used in tunnelling, it also has saws for cutting the sleepers, crowbars and huge tongs for heaving the lines into position, a track gauge which ensured that the lines were running exactly the same distance apart, and a range of hammers for spiking down the iron chairs on to the sleepers and driving home the wooden blocks which held the lines in place. For decoration, the maker has also added a beautiful, delicate fan, its circular form being built up of individual leaves cut from wafer-thin shavings of pine.

Work of this quality and close provenance is exceptionally rare, but even so, the majority of the 'God-in-the-bottle' makers demonstrate considerable skill and patience in their work. To construct a neatly carved crucifix with its attendant range of instruments of the Passion is no easy matter, but to assemble the whole group within a small, narrow-necked bottle is quite a remarkable achievement.

6

Carving and Modelling

All the previous chapters have dealt with folk arts which were ancient in origin and which were essentially localised variations created within a great international tradition of carving incorporating its own range of symbols, customs and beliefs. In contrast, the sculptural aspects of folk art were predominantly the field of the individual, dependent on his own motivation, imagination, techniques and choice of materials. There was never any stylistic 'school' of north country folk sculpture, but instead each person made his or her own statement in wood, stone, clay, metal, textiles and paint. Similarly there was no restriction to the uses to which the sculptures might be put. They could have some definite utilitarian purpose, or perhaps serve as presents for friends and relatives, but they were just as likely to be made solely for their own sake, providing their makers with an absorbing, enjoyable and rewarding pastime.

In most cases, the finished works were displayed in the home, occupying prominent positions over the fireplace, on the sideboard, or on top of the cupboard, where they could be fully appreciated by family and visitors alike. Alternatively they might be made for use in the local church, chapel, public house, village hall or local museum, where, since they originated from within the community, they were particularly effective in reflecting its chief interests and values. Take, for example, the head of a miner carved from a paste of coal and the accompanying crocheted panel displayed in the entrance to the Outwood Memorial Hall. These are amongst the most appropriate and poignant memorials to the men who lost their lives when water from old workings broke through into the coalface at the nearby Lofthouse Colliery a few years ago. Similarly the nativity group carved in oak by Michael Doyle of Lambton Colliery, with its local shepherd and sheepdog, its pit pony, and its kneeling pitman with his safety lamp, has a unique relevance to the communities worshipping in Durham Cathedral, a relevance which no other figures, however beautifully carved, could ever achieve.

As in all fields of creativity, the quality of craftsmanship, of technique, and of artistic expression, varied greatly from one individual to another. Unlike the works of professional sculptors, however, those made by the

untutored amateur generally lack a high degree of surface finish or of overall accuracy with regard to their shape and proportion. Instead, they tend to exhibit a close observation of constructional detail, especially where the maker is representing something of which he already possesses a sound working knowledge. But their main quality is that of directness, even boldness, in their execution, full-blooded renderings of form and colour always being preferred to the muted subtleties and contrived effects of academic art.

The range of subjects and media available for carving or modelling was extremely wide, but in some instances the choice was restricted by practical considerations, especially where the finished item had to fulfil a definite function. Duck decoys, for example, had to be accurately carved from a block of wood and then painted in realistic colours if they were to be effective in luring wild ducks to join them on stretches of water within range of the hunter's gun. Similarly, scarecrows were made as realistic as possible to keep birds off the crops, their clothing and headgear usually being cast-offs from the farmhouse mounted on a light wooden framework filled out with sacks of straw. Considerable ingenuity was displayed in their construction, sticks being placed under the arms to represent guns, for example, or single legs left swinging in the breeze to give a more lifelike appearance. When W. B. Redmayne carried out a survey of Cumbrian farmers to discover the practical value of scarecrows in keeping birds off the growing crops, he found that 46% thought them to be really effective. Even so, their painted faces, straw hats, police uniforms, or even clothes painted with the broad arrows of Victorian convicts, surely reflect the inventiveness and humour of the farmers, rather than any true agricultural purpose.

As early as the 1580s, Michael Drayton's *Pastorals* described a shepherd by an old tree 'and by the same, his sheep-hook, one of price, That had been carved with many a rare device'.

The sticks and crooks used by the north country shepherds both to catch sheep and as an aid to climbing the steep fells were almost entirely home-made, their crooked heads being made from wood or sheep horn in contrast to the blacksmith-made wrought iron used in the southern counties. As David Dippie Dixon noted in *Upper Coquetdale*: 'The hill shepherd always possesses a goodly choice of walking sticks, besides those in everyday use; his long hill stick, a sort of alpenstock; his smarter Sunday and 'mart' stick; he generally has a dozen or so laid up in store on the 'latts' between the beams of his kitchen ceiling. These sticks are mostly made of hazel saplings, cut with a block of the root attached to form the head; bundles of these are carried from the low country, for hazels are scarce in the uplands. The shepherds dress their own sticks at

Fig.38. Crooks and sticks
Shepherds' crooks and walking sticks have been cut and carved in the north for centuries. These examples include: (a) a hazel crook used in the Wakefield area; (b–d) sheep-horn crooks by Norman Tulip; (e & f) walking sticks made in the 1880s by John Boucher, estate joiner at Ripley Castle, the twisted example being formed by a tendril of growing ivy; (g–i) are all carved walking stick handles from around Leeds.

their own firesides during the long winter nights with a pocket knife. Some of these sticks are very tastefully ornamented, and are really excellent specimens of home handicraft — one of the points being to produce a handy stick, that is, a neatly turned 'gib' or crook to fit the hand of the 'wearer'. At its simplest, the head of a traditional northern shepherd's crook was cut from a block of the root or main stem from which the long shank had sprouted. For high-quality work, however, the crook was made either from a separate block of fine wood, such as burr elm, or from a sheep, goat, cow or buffalo horn carefully moulded into shape and attached to the shank by a secure dowel or bolted joint. By means of careful sawing, filing and polishing, the crook had already been worked up into its finished form, strong, practical, and comfortable in use, but retaining a real elegance and displaying to the full the natural beauty of its figured wood or translucent horn. Sometimes a personal name might be cut into the crook, or decorative elements such as a scroll, or a thistle worked into its tip, but, especially from the early years of the present century, stick-dressers have also made a great variety of fancy crooks. For some designs the horn of the crook is moulded, carved, finely textured and painted to give a realistic representation of a trout or pheasant's head, for example, while for others the crook retains its traditional form except that the surplus horn is used for three-dimensional carved decoration instead of being sawn off as waste. Using this method, skilled makers such as Norman Tulip can produce crooks bearing delightful miniature figures of pitmen and pit ponies, gypsies, carters, plovers, or even lobsters. However beautiful and sensitive these carvings might be, they are never allowed to detract from the basic function of the crook, which must always retain its essential qualities of strength and comfort in practical use.

Although horn might be used for making the handles of walking sticks in shepherding areas, most countrymen cut their sticks from suitable lengths of hazel, cherry, holly or blackthorn etc., which they found growing in the hedgerows. Their handles were either cut from the root, shaped as a ball to fit into the palm of the hand; formed from a small branch projecting at right-angles from the shank, or, for light canes, made by bending the end of the shank into a semi-circle while the wood was still green. Any outstanding natural features which would make the stick more interesting were carefully retained. John Boucher, the estate joiner on the Ripley Castle estates, used to purposely wind ivy around growing shank in order to produce sticks showing a characteristic spiral, for example, while others would round off the stubs of projecting side-shoots to give an interesting knobbly outline. Blocks of root, burrs, side

Fig.39. Scarecrows
These scarecrows, including a gamekeeper and a convict, were all made and used in north-
west Cumberland in the 1930s.

branches and knots also provided scope for imaginative carvings of faces, figures, animals or vegetation, and Wordsworth's Robert in the *Ruined Cottage* of 1797–8

> . . . whistled many a snatch of merry tunes
> That had no mirth in them, or with his knife
> Carved uncouth figures on the heads of sticks . . .

Representations of human figures formed one of the major themes in north country folk art. At their simplest and crudest, they were made by stuffing cast-off clothing with straw and adding a head made from a piece of light-coloured cloth padded roughly into shape and painted with eyes, nose and mouth. Besides serving as scarecrows, they also played the central role in a variety of popular customs and celebrations, appearing as Guy Fawkes on the top of the November 5th bonfire, or as Bartle, whose huge effigy, made for many years by Mr George Stockdale, was carried in a night-time procession around the Wensleydale village of West Witton before being burnt. Similar figures were made for occasions such as V.E. Day, when the crowds in central Leeds tossed around an effigy of Hitler, his arm raised in Fascist salute, a painted swastika for his arm band, and his chest decorated with a large cardboard Iron Cross inscribed 'FOR LYING, MURDERING, RUNNING'.

Carved figures were made for a great variety of purposes. On gravestones and on the datestones of vernacular buildings, they were probably intended to portray their respective occupants, while on knitting sheaths they represented either the lover or his beloved. The ladies and gentlemen who frequently appear on gingerbread moulds from the seventeenth to the nineteenth centuries, always dressed in the height of current fashion, were designed to give an air of prestige to this most popular feast- and Christmas-time delicacy and thus help to promote the hawker's sale returns just as in today's commercial advertising. Sometimes figures were carved simply as household ornaments, or as toys for the children, but for the best entertainment they were always articulated. Up to a few years ago a visit to the allotments in any of the north's industrial conurbations would have been made much more interesting by the sight of numerous small wooden figures. In some instances home-made windmill-powered tableaux showed men pumping water from a well, chopping logs, or sawing, while in others single figures mounted on an upright pole jerked this way and that, with arms wildly flailing in the wind. As in America, these whirligigs were frequently based on military characters, their uniforms being painted in realistic colours. For indoor entertainment, the dancing doll had all its limbs loosely jointed, one or

Fig.40. Human Figures
Fashionably dressed figures were used to decorate a variety of vernacular buildings, furniture and other artefacts from the seventeenth century. Here are: (a) the so-called 'Naked Man' of 1663 in Settle market place; (b) a warrior on the earpiece of the West Yorkshire armchair of the 1660s; (c) a fashionable couple on a late seventeenth-century carved chalk gingerbread mould from Flamborough; and (d) the figures of Henry and Elizabeth Foster on their new house of 1736 at Heptonstall.

two sockets in the back of its body being provided for the long light rods by which it was held upright. The performer sat sideways on a table or chair, one end of a thin plank of springy wood which projected before him being gripped against the seat by means of his own body weight. Then, holding the doll with its feet just above the far end of the plank with one hand, he used the other to beat the near end of the plank, causing it to vibrate and transfer its motion to the doll. This rhythmic beating, accompanied by mouth-music from the performer and the staccato clack of the wooden feet against the plank, sets the whole doll dancing in the liveliest manner, different steps and arm movements being readily achieved when in the hands of skilful performers such as Renee Pickles.

The occupation of the carver was occasionally reflected in the making of figures wearing the appropriate costume, miners wearing their shorts and helmets, for example, but usually occupational interests were shown by models of the tools and equipment used in their everyday work. In farming areas, model ploughs and farm carts were made, in industrial areas it might be locomotives, drop-hammers or pit-heads, while men serving in the forces would make tanks, aeroplanes or guns.

Models of buildings provided a further source of interesting subjects. In their most dramatic form, they were built as permanent masonry structures within their own miniature landscapes. One front garden at Black Hill, Queensbury, near Bradford, has a castle, a public house, a lighthouse and a church with a nine-foot spire all meticulously cut and jointed from the fine Yorkshire stone for which this area was famous. This was the work of a local mason who lived here around the turn of the century. Also in West Yorkshire, at Netherton between Wakefield and Huddersfield, an amazing assemblage of buildings was constructed by Mr Leonard Ibbotson, a retired miner from Artley Bank Colliery. Working mainly between 1968 and 1980, he made wooden moulds into which concrete was poured to produce two- to three-foot high models of York Minster, Fountains Abbey, Ripon and Wakefield Cathedrals, Chesterfield Parish Church, Caernarvon and Conway castles, cottages, high-rise flats, and even the nearby Emley Moor television mast. Garden sculpture of this type and scale was always quite unusual, however, most modellers preferring to work in wood, card and paint. The subjects could range from local historic buildings, such as abbeys, parish churches, town halls, etc., to workplaces, public houses, or their own homes. Many of these models were made to serve such practical functions as birdcages, weather houses, or money boxes, while others incorporated secret compartments, musical boxes or battery-powered internal lighting. Particular ingenuity was required to make one of the most popular of the amateur modeller's

Fig.41. Animated Figures
The dancing doll (a) was made by Mr. Wright of Eales Farm, Bellingham, around 1930, and performed in his dance band. The legs were operated by a springy wooden board, while the arms could be raised by pulling the loop of string which emerged from his back. The two whirligigs were designed to twist their arms in the wind, (b) coming from Walton near Carlisle and (c) from a greenhouse at Park View, Shotley Bridge.

Fig.42. Industrial Themes
Models and sculptures frequently drew their inspiration from their maker's industrial
experience. (a) Alfred Arundel, who worked at the railway workshops at Ardsley near
Leeds, made the G.W.R. locomotive in 1940; (b) the miner's head was modelled in a paste
of coal dust, oil and water to serve as a memorial to those who lost their lives in the
Lofthouse Colliery disaster; while (c) the lifesize figure of a pitman with his safety lamp was
carved from affromosia by Mr. J. C. Higginson of Whitburn, Sunderland, around 1960.

themes — the traditional travelling fairground. Many of these have now found their way into folk museums, since they tend to be far too large and awkward to house in most homes, once their maker has no further use for them. A typical example, now in Leeds City Museums, was made by Mr Billy King of Holbeck Moor between the late 1920s and the 1950s. Some idea of its scale is given by its three-foot square Grand Scenic Railway of 1928, to which were added a chairplane, a speedway, swing

Fig.43. Fairground Models
Many modellers chose fairgrounds as the theme for their work, this group of rides etc., being made by Mr Billy King of Holbeck Moor, Leeds, between the 1920s and the 1950s.

boats, coconut shy, big wheel, three-abreast horse carousel, fairground engine and trailers, all the rides etc., being fully operational and completed with bright paintwork and lights carefully copied from the full-sized versions seen at local fairs.

Most carvings and models were either based on observation and a

Fig.44 Model Houses
Models of houses often include hidden or unexpected features. The upper house, from Bolton, shows a fashionable Victorian villa made to serve as a birdcage, while the lower house, made by an elderly man in the Helmsley area as a wedding anniversary present for his wife, has windows which light up, in addition to a musical box which plays the Anniversary Waltz!

close working relationship with their subject, or on suitable drawings and photographs. Those who wished to aspire to something rather more aesthetic turned to the numerous illustrations of literary or artistic subjects which nineteenth-century improvements in printing and papermaking technology now brought into almost every home. Here they could be readily transformed into carvings cut in low relief into panels of wood or stone. Perhaps the most notable carver to work in this way was Thomas Tweedie, born in 1816 at Newcastle upon Tyne where he later became established as a carver and gilder in Grainger Street.[1] During the course of a visit to the Great Exhibition in 1851 he was greatly impressed by the magnificent displays of English, Irish, and Continental woodcarving and so decided that he too should become an 'artistic carver', embellishing his furniture with well-known scenes taken from Shakespeare, *Robinson Crusoe*, or *Tam O'Shanter*. Contemporaries commended his work for its northern vigour which, it was felt, excused the lack of refinement found in the products of the south-country carvers. Even so, his carvings are remarkable for their close attention to detail, for their convincing rendering of perspective, and for the lively quality of their portraiture which, if anything, excels that of the prints on which his work was based. The exceptional quality of Tweedie's carvings is reflected in the success they achieved when exhibited at the international exhibitions held in Paris in 1855 and in London in 1862, but it should be remembered that he was only one of a great number of carvers working throughout the north during this period. The majority were entirely amateur and self-taught, their efforts being largely restricted either to individual panels, or to figures and decoration cut into the surfaces of their own family furniture, which might already be fifty or a hundred years old before it was thus 'enriched'. Although not appreciated by antique dealers and auction houses, early north country furniture naively recarved during the mid-nineteenth century is still to be found in many houses and museums today.

Instead of decorating furniture, James Edward Elwell of Beverley decided to decorate the exterior of his house in North Bar Without in the 1880s, with carved wooden panels.[2] One over the door, entitled 'The Political Cheap Jack', shows Disraeli electioneering from the back of a covered wagon, this obviously being copied from one of the numerous political cartoons of the period. Meanwhile, 'The Doll's Eye-Maker' was taken from a scene in *Dot*, the stage version of Dickens's *Cricket on the Hearth*, in which Elwell's comedian friend J. L. Toole had played the part of Caleb Plummer, using the line 'We like to go as near nature as we can for sixpence'. Further figures of knights, monks, musicians and dragons appear around the house at first-floor level, their inspiration apparently

being drawn from popular illustrated books of the third quarter of the nineteenth century.

The use of paintings as models for carved panels is perhaps best seen in the work of Sam Swift of Cawthorne. Born in 1846, he produced

Fig.45 Pub Models
In the 1950s Mr H. Gladstone made a series of low-relief plywood models of individual public houses, their surfaces being painted in accurately-observed colour. Mounted within a rectangular gallows framework, they stood on the shelves at the back of the bar, where they attracted the attention of the customers. These examples show (top) the Borough Arms Hotel, Morley and (bottom) the Queen's Hotel, Outwood, near Wakefield.

many of his most interesting sculptures when still in his late teens, as may be seen by the examples built into the walls of Taylor Hill in the 1950s. A mounted knight in medieval armour brandishing a banner, taken from a popular print of the period, is entitled 'Godfrey of Boillon'; a kennel

Fig.46. Stone Carving
This massive carving, one of the largest and most intriguing pieces of English folk art, stands in the grounds of Nun Monkton Hall between York and Knaresborough. Probably dating from the early nineteenth century, it shows a wealth of detail — churches, windmills, towers, archways, dancers, fauns, amorous couples, a carriage and pair etc. — but unfortunately its origins are as yet quite unknown.

D

Fig.47. Carvings

The lion, carved by Samuel Swift of Cawthorne, shows how the nature of the local stone has caused the sculptor to transform the lively lion of British heraldry into a massive, ponderous beast of enormous strength. In contrast, the carver who transformed McLean's lithograph 'Grimaces' into a relief was able to faithfully transpose every detail into his slab of fine-grained wood.

THE FEED. from the Painting by
J. F. HERRING. SEN? ESQ. F.R.A.

THE POLITICAL CHEAP JACK

Fig.48. Carvings from Paintings
A number of carvers took their designs directly from popular paintings etc., rather than from the everyday objects they saw around them. Here are two of Sam Swift's stone panels based on paintings by J. F. Herring and by Landseer. Disraeli, 'The Political Cheap Jack', was carved by James Elwell of Beverley from a late nineteenth-century political cartoon. It still stands above his doorway in North Bar Without, Beverley.

scene with three dogs is derived from the work of Landseer or one of his contemporaries, while a couple of horses with their grooms are taken directly from 'THE FEED. from the Painting by J. F. HERRING SENR. ESQ. F.R.A.'. In contrast to these reliefs, his three-dimensional work is much more lively and robust, his interpretation of the British lion showing an empathy with the local stone fully worthy of Henry Moore. Following the award of a silver medal for his life-size figure of Hebe shown at the Wakefield Industrial and Fine Arts Exhibition of 1865, the eighteen-year-old Sam Swift decided to gain further training and experience, joining the firm of Farmer and Brinleys in London. Here his style was brought into line with the established standards of the day, as shown by the conventional figures of Paulinus and of John Wesley he later carved for the church and chapel of his native village.

7

Traditional Brassware

Today brassware is as popular as ever. Enter most public houses, hotels and homes both in the country and in the inner city, and shining brass candlesticks, horsebrasses, wall plaques, and numerous other items will be found decorating the mantelpiece or beams. Almost without exception, these pieces will have been mass-produced, but in contrast, the brassware described here was all individually designed and then made by hand by a wide range of colliery engineers, shipbuilders and brass fettlers etc., much of it being made for sheer enjoyment during their brief leisure hours or during slack periods at work.

Their basic material, brass, is one of the most beautiful and useful of all base metals. Its fine golden colour, its ability to take a rich, deep polish, and the variety of ways in which it can be shaped and decorated, have brought it into widespread use both in the home and in engineering for many generations. Made from copper and zinc, this yellow alloy was first produced in England in the late sixteenth century following the incorporation of the Mines Royal Company and the Mineral and Battery Works in 1568. Over the following years the industry slowly but surely expanded, so that by the late eighteenth century Britain had become the greatest brass manufactury in the world. The extensive works at Birmingham and at Bristol were now making thousands of tons of finished domestic brassware every year. Candlesticks, chandeliers, mortars, door knockers, clock cases, furniture mounts and cooking vessels were being mass-produced by pouring the molten metal into moulds, while clocks, coffee pots, tankards, goblets, warming pans and lanterns were being fabricated from sheet brass.

Throughout the nineteenth century, brass played an increasingly important role in most branches of the rapidly developing engineering industry. It was used extensively for bearings and fittings on locomotives and stationary steam engines, in the manufacture of machinery of all kinds, and in the production of scientific instruments, weights and measures, etc. In virtually every industrial enterprise, from textile mills and coalmines to factories and shipyards, craftsmen were engaged to work brass into the various artefacts required for their particular purposes.

The sheet brass used in industry appears to have been supplied in two

basic forms. In the coarser variety, measuring 1/16" or more in thickness, it frequently shows signs of having been cast on sand, the back faces being deeply pitted, with a rather granular texture if it has not been filed or scraped down to a level surface. Often the front face also shows clear evidence of being scraped smooth before being polished, the resulting sheet varying considerably in thickness. This form of brass is usually quite rigid, requiring considerable force to bend it into shape. The finer variety, seldom measuring more than 1/32" in thickness, was produced by being passed through rolling-mills. Both its front and back faces are therefore quite smooth, and it is of uniform thickness throughout its entire area. Brass sheet of this quality was ideal for making three-dimensional objects, since it could easily be bent into any required form, it could be finished with fine rolled edges and its joints could be formed into folded seams in a similar manner to working tinplate. Much of this work was carried out by hand, tinsnips, saws and drills being used to carry out the initial shaping of brass sheet, which could then have its edges filed to a smooth finish. After being bent into shape, various elements might be joined together either by rivetting or by soldering. The areas to be joined having been cleaned, and placed in position, they were coated with a thin layer of flux. A soft solder composed of lead and tin, melting at around 350°C, was then applied from the tip of a hot copper soldering iron to produce a neat and secure joint.

A number of simple but effective methods of decoration enabled the brassware to be given an attractive appearance. Designs could be pierced through the metal, for example, using small drills and fine-bladed saws in a similar manner to fretwork. One layer of brass sheet could also be mounted on another, throwing the decoration into low relief. This was particularly effective for representing the raised mouldings on model fireplaces, etc., or for picking out details on miniature shoes and boots. The smooth surface of the brass could be impressed with ornamental punches to indicate either particular features, or to build up overall textures, while highly polished dome-topped rivet heads of various sizes provided reflective highlights to enrich a design. The opportunity might also be taken to introduce details in contrasting non-ferrous metals, red copper and silvery aluminium being used to considerable effect in the form of strips or rivets applied on to the basic brass shape. In exceptional pieces, small sections of copper and brass might even be carefully cut to shape and filed up so that they could be assembled in elaborate parquet designs.

Perhaps the finest decoration of all was executed with the graver. This tool had a narrow hardened steel blade of diamond or V-shaped section measuring about four inches in length mounted in a short wooden

handle much resembling half a small mushroom. By enclosing the graver in the hand, with the handle cushioned in the palm and the pointed tip held firmly beneath the extended forefinger, it was possible to cut a wide variety of lines into the surface of the brass. Straight or curving lines graduating in width and depth could be used to outline the main features of a design, while further areas of hatching and cross-hatching could build up either three-dimensional effects, or represent different textures such as hair, fur, or feathers. Not everyone had access to a graver, however, and many pieces were decorated quite effectively by the use of a scriber. This simple pointed piece of iron or steel was held like a pen, and enabled shallow inscriptions etc., to be cut with relative ease even by unskilled hands.

Some items of brassware were decorated in wrigglework, a technique which first achieved popularity in England in the mid-seventeenth century, when it was used to mark out designs on pewter plates. It involved the cutting of narrow zig-zag lines with a blunt chisel-like tool applied with a rocking or walking movement, and can most often be found in the form of inscriptions on the lids of small brass snuff boxes.

By using these basic techniques it was possible to build up quite beautiful, well-designed, and structurally complex objects, giving the workman both wide scope for self-expression, and the opportunity to display his manual dexterity. It is not surprising that he often decided to use some of the tools and materials placed in his care at work to make ornaments or utensils either for his own use or to give away as small presents. Odd pieces of scrap and offcuts of brass sheet provided an ideal starting point for the creation of thousands of interesting and useful objects.

Brass in the Home

In most houses the life centred around the cooking range in the kitchen or living room, its shining black-leaded ironwork, burnished steel fittings and spotless scoured hearth forming a source of deep satisfaction for the housewife. Since one characteristic of human activity is that things which are highly valued are carefully tended and decorated to reflect their owner's pride, it is not surprising that the fireplace, mantelpiece and entire chimney breast were often richly ornamented. As Jagger Johnson of Runswick Bay recalled: 'around the cottage fireplace and on top of the drawers one could hardly find enough space to place a box of matches, because of the number of small and large brass pieces all gleaming and making a wonderful sight'. Such items as steel fenders and fire irons,

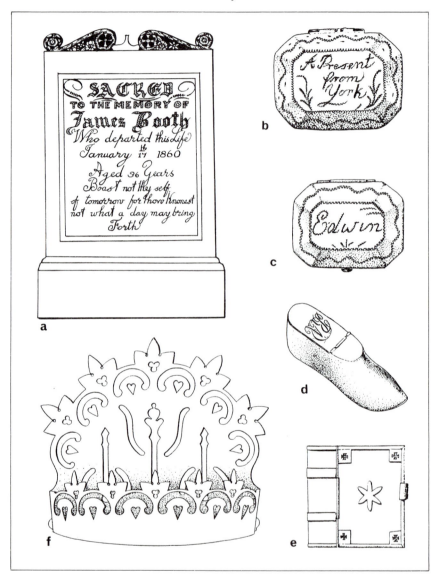

Fig.49. Brassware Memorials, Boxes and Tidies
(a) Personal memorials, including elaborately framed funeral cards, formed a significant element in the furnishing of many Victorian homes. Made of thin rolled brass sheet, this engraved memorial collected in Leeds probably copies an original churchyard gravestone.
(b & c) The snuffboxes, with their wriggle-work inscriptions, were both made in York. (d) Engraved with the owner's initials 'R.A.', this matchbox was obtained in York. (e) The decoration of this book-shaped snuff box from Newcastle is executed in copper details soldered back onto the brass base. (f) Hung near the fireplace, tidies provided a useful receptacle for combs, brushes, papers, pencils, and other paraphernalia.

clocks, vases, pot dogs, numerous candlesticks and horse brasses were all mass-produced and could be purchased from local stores, but many other utensils and fittings might be made by members of the family who had access to the necessary resources.

Along the northern boundaries of North Yorkshire, for example, narrow strips of scallop-edged bright brass sheet were made to decorate both the edge of the mantelpiece and the junction of the range with the hearth. In the industrial regions of Tyne and Wear, and in Yorkshire, meanwhile, long brass airing-rails were mounted beneath the mantelpiece on elaborate brackets. Made by the local engineering workers and shipbuilders, they were frequently constructed from two sections of 'scrap' brass tube joined by a large central boss. This feature was essential, since it was relatively easy to remove three-foot lengths of tube from the works by hiding them inside the trouser-leg, whereas a single six- or seven-foot length would have been far too obvious!

The designs of some pieces of handmade brassware were taken directly from mass-produced originals. This was certainly true of numerous match-holders, spill-holders, and the large wall-mounted 'tidies' which provided a convenient home for hair brushes, combs, pencils and loose papers. Their robust scrolled outlines and simple form of construction were copied from papier-mâché wares made from the mid-nineteenth century in the West Midlands, but instead of having a black japanned finish picked out with sprays of painted flowers, they relied entirely on their golden colour and bright polish for their decorative effect. Stands for hot smoothing irons were similarly copies from mass-produced examples, their three short legs being intended both to keep the face of the iron clean, and to prevent damage to working surfaces. However, it is likely that many were made for show rather than for practical use, their thin sheet brass being far too weak to support a heavy iron, but their broad triangular faces did provide an ideal area to show off neat piercing with complex scrolls, and geometric or floral motifs.

Some of the most remarkable handmade domestic brassware of last century originated on the Isle of Man. Instead of being made in thin sheet, it was massively constructed from 1/8" and 3/16" plate, but even so it was pierced, filed and polished to the highest standards. The Manx Museum at Douglas possesses a splendid rectangular trivet designed to stand on the hearth, its four cabriole legs and richly scrolled frame supporting an elaborate top-plate decorated with the three legs of Man surrounded by stars and hearts. This was the work of Jack the Nailer, who worked at his craft in Port St. Mary to the south of the island. A similar example is still in the possession of an old-established Manx family, one of their ancestors, a stoker on a ferry serving the island,

Fig.50. Brassware Utensils
Utensils for use around the home formed one of the most popular products of the amateur brassworker, as may be seen in the following examples: (a) match holders from Hexham, (b) Leeds, and (c) Darlington, (d) a pipe rack, and (e) a watch-pocket from Leeds, and (f & g) shoe-horns from the Newcastle area. The brass matchbox holders also come from Newcastle, the first (h) being made by a Mr Clegg, and the second (i) by Mr Billy Larner, while the iron stands (j & l) were collected in the same area, the central stand (k) coming from Barnard Castle.

making it during periods of slack time during his numerous cross-channel voyages.

Pipe racks, watch pockets, matchbox holders, tin-lined snuff boxes, serviette rings and shoehorns could add further colour and interest around the fireside, but other pieces of brassware were of much greater personal interest. These might be memorial tablets for the dead, for example, or even love tokens.

Love Tokens

In the northern counties small heart-shaped brass plates were fitted with a socket to hold the narrow double-ended wire knitting needles against the wearer's side when knitting in the traditional manner. They were usually made by young men for their loved ones, those of North Yorkshire having broad, convex hearts pierced with scrolls and a row of small holes drilled around their edges. The West Cumbrian knitting sheaths were much smaller, relying on finely engraved names, monograms and dates for their ornament.

In the farming region of East Yorkshire, meanwhile, it was customary for most labourers to live-in, eating communally in the farm kitchen and spending their evenings in the harness room or a spartan dormitory. The Rev. Collier recorded that the farm lads used to spend some of their spare time in making seal fobs which could be mounted at the end of a watch chain or cord and worn in the waistcoat. Often given as a token of friendship, they were usually kept by the recipient throughout all the succeeding years. They took the form of a polished octagonal cone built up from layers of brass, bone, bronze cut from coins, and any other hard material which came to hand, all sandwiched together and secured by a central rivet. At the top, a flat knob was pierced for suspension, while the broad base of the 'seal' was either criss-crossed with sawcuts or textured with punch marks so that it could leave an impression in hot wax — even though it probably never got the opportunity. As with so many aspects of English folk art, these seals were made in imitation of those of the gentry, and were never intended for practical use. Even so, they provide a poignant reminder of a past way of life and of past friendships.

From the second quarter of the eighteenth century through to the late Victorian period, coins of the realm were frequently adapted to serve either as love tokens or as memorials of some particular event. To do this their obverse and/or reverse were first carefully ground down to a perfectly flat, smooth surface into which the appropriate initials, inscriptions or illustrations could be engraved or punched, although in

Fig.51. Love and Friendship Tokens
(a — e) This group of typical late eighteenth and early nineteenth-century love tokens in the
Hull Museum collection are all engraved on halfpennies which have been carefully ground
down to a smooth surface before being decorated: (f) A farm servant's seal made by John
Duke of Mere Farm, Burton Agnes, East Yorkshire. (g) Made in East Yorkshire in 1923,
this farm servant's seal incorporates layers of brass, horn, and both red and white
plastic. (h — j) Brass knitting sheaths from County Durham and the adjacent parts of North
Yorkshire.

Fig.52 Brassware
(a) Made by Jack the Nailer of Port St. Mary on the Isle of Man, this magnificent highly-finished 'footman' trivet displays the triskelion, or three legs of Man at the centre of its elaborately pierced top plate. (b) An elaborate piece of traditional brassware, this late nineteenth-century Yorkshire range from Harrogate is quite accurately observed, the hinged door opening to reveal its removable baking sheets, for example.

some instances the decoration was carried out directly on the original surface of the coin.[1]

Sometimes the engraving consisted solely of the initials of the man and woman who were about to be married, while at others their names were given in full, perhaps with the date or with symbolic representations of love such as interlocking hearts, a heart pierced by two arrows, a pair of clasped hands, a lover's knot, Cupid, or a bunch of flowers. Similar tokens were made by farm lads who meant to be friends for life, each lad scratching both his own name and that of his friend upon it, the friend doing the same, after which the tokens were exchanged and kept as permanent mementos. One example in the York Castle Museum was found in the pocket of an old man who died at Gransmoor in the East Riding. Made from a piece of an old sundial, it still records the names of the two friends 'Robert Winship' and 'James Barnes'.

Other tokens might bear mottoes, inscriptions, messages, or scenery, houses, ships, birds, dogs, trees and flowers, or the figures of men, women and children. These were often made to commemorate births, deaths, etc., one example in the Hull museums recording 'THE GIFT OF MY FATHER W. JOINER BEING THE ONLY PENNY HE EARNED ON THE DAY OF MY BIRTH AUG. 24. 1852'.

Tokens were also engraved in minute detail to demonstrate the maker's considerable manual dexterity, Peter Crosthwaite, curator of the Keswick Museum from the 1780s, proudly displaying a silver penny on which he had cut the entire text of the Lord's Prayer.

Coins were occasionally adapted for use as carpenter's marks, being nailed on to roof timbers or floor joists either by a single nail driven through a pierced hole, or by four or more clout nails hammered in around the rim. In some instances, a new coin was fastened up in this way, its date indicating the completion of the project, while the workmen's initials were carved into the adjacent timber. It was more usual, however, to inscribe or stamp the initials and a suitable motif on to the coin itself, typical examples collected from Selby bearing the marks 'RH' 'HO' and augurs, 'D' 'A' with chisels and tools, or 'John R., L. Edwin, W.' respectively on Georgian copper pennies and halfpennies.[2]

Models

In northern England, particularly in County Durham and the north-eastern coastal towns, miniature pieces of domestic equipment formed a major topic of interest for the brass-worker. Of these, the most remarkable were complete kitchen ranges measuring only a few inches in height.

This choice of subject was quite understandable, for the range was the family's great provider, giving both radiant heat for the whole living room and facilities for boiling, baking, roasting and drying clothes, in addition to heating gallons of water for washing and bathing. It was therefore treated almost as a household shrine, great pride being taken in its maintenance and decoration. Some of the model ranges were made from thin rolled brass, but the finest were fabricated from thick plate, meticulously filed, chamfered and polished. Perfectly observed in every detail, complete with hinged doors, fitted ovens and sideboilers, they form some of the most magnificent examples of English folk art.

Hearth fittings similarly provided a fertile source for the modeller, the most common being the fenders which were often made in pairs to stand symmetrically to each side of the mantelshelf. Imitating the heavy polished steel kitchen fenders of the late nineteenth century, their broad top-plates are usually pierced in a variety of scrolled designs. Fire shovels and rakes, coal buckets, trivets, girdles or 'bakstones' and the 'blazers' or 'draw-tins' placed in front of the fire to give it an increased draught, were all produced in large numbers. There were even miniature versions of the brassworkers' own wares, including tiny iron-stands and tidies.

Other models were based on long-standing local traditions. From the early nineteenth century the glass-blowers of Sunderland had been making hollow glass rolling pins, their surfaces gaily decorated with transfer-printed pictures and texts, along with painted floral motifs. These traditional keepsakes or love tokens were presented by sailors to their girlfriends, often being filled with tea or rum to make the gift even more acceptable. Later in the century brass rolling pins were made for similar purposes. Although they were of no practical use, and could not even conceal interesting presents, they made an impressive addition to the fireside display. They were often hung from the picture-rail by means of the ornate machine-stamped brass chains which were then being made for pendant oil-lamps.

Footwear provided a popular subject too, being a well-known symbol of good luck. Houses had been protected from evil for centuries by inserting old shoes in their roofs, for example, while shoes and boots still appear at weddings, small and silvered on the cake, or worn out and tied at the back of the couple's car. Every variety of clog, shoe or boot, workaday or high fashion, was modelled in brass, either singly or in pairs. Some were mounted on plinths and some were free-standing, while others concealed holders for matches or spills. They even formed the basis of elaborate watch-pocket centrepieces which occupied pride of place on the mantelshelf, the watch being mounted in an elaborate cartouche supported by two elegant ladies' button boots.

Sheet aluminium boots numbered 'L15 1.4-16' were also made. These came from the Zeppelin L15 which set out to bomb London on March 31st, 1916. She failed to reach her target, however, for having been damaged by gunfire over Purfleet and subsequently attacked by aircraft, she came down in the sea off the north coast of Kent at 12.15 a.m. Most of her crew were rescued, but the airship disintegrated during the

Fig.53. Model Yorkshire Range
Made by a shipbuilder on Tyneside towards the end of the nineteenth-century, this model is probably the finest example of traditional English brassware. The standard of its design and workmanship, its high finish, and the use of copper parquetry across the hearth all demonstrate its exceptional quality.

Fig.54. Brass Models
Miniature pieces of hearth equipment formed popular subjects for the brassworker, as may be seen in this selection from north-eastern England (except g, which was made in Chester): (a) fender; (b) iron stand; (c) footman; (d) tidy; (e) 'tidy Betty' to cover the ashpit beneath the fire; (f) girdle or backstone; (g) tidy Betty; (h) cradle; (i–l) fifty years of practical experience as an engineer are reflected in the fine quality of workmanship seen in this group of models made by Joe Ward of Hull. Each piece is carefully finished and buffed up to achieve a high polish, while inside they all conceal musical box movements operated by a variety of hidden levers.

Fig.55. Brass Footwear
Shoes were probably the most popular mantelpiece ornaments made by the north-eastern brassworkers, examples here coming from: (b) Ovington, (c) Newcastle, (e) Durham, and (f) Leeds. The central boot (d) was made from aluminium salvaged from the Zeppelin L15, the first airship to be brought down in England during the First World War. The detailed origin of (a) is unknown.

attempt to tow her back to Westgate. The boots made from her frames were extremely popular as souvenirs, for L15 was the first Zeppelin ever to be brought down in Britain.

Other models were taken directly from the modeller's own imagination or observation. One of the finest brass model makers of recent years was Mr Joe Ward of Hull. After retiring as a machine-shop superintendent, he established a workshop at the bottom of his garden so that he could begin to make an incredible number of beautifully finished pieces, ranging from musical instruments to churches and stoves. Some concealed musical-box movements, or other mechanical features, such as revolving lights on lighthouses, or displays on the screens of model televisions. Mr Ward gained most of his ideas from items seen in local museums or in the streets of his home town, always working from memory, rather than from drawings. In this way he made over 300 models, all displaying a close observation of detail skilfully translated into brightly polished brassware of truly delightful quality.

Animals

In late Georgian England, a number of the major brassfounders began to produce finely detailed figures for use as ornaments on fashionable chimney pieces. Companies such as R. Day of Pope Street, Birmingham, charged about seven shillings a dozen for these low-relief castings, which were mounted vertically on brass plinths from around 1815 to the 1830s, when cast-iron bases became more popular. The subjects depicted on these ornaments were taken from popular engravings and book illustrations of the day: Robinson Crusoe and Man Friday, for example, or goddesses such as Ceres, appropriate for the dining room.

By the mid-nineteenth century, the use of brass chimney ornaments was rapidly moving down the social scale. Instead of literary and classical subjects, however, they now featured horses, plough teams or even locomotives robustly modelled in high relief, with their plinths probably forming part of the same casting. It was brassware of this type that provided the inspiration for the many sheet-brass animals made by workers in late Victorian Northumberland and County Durham.

In nearly every example, the animals were cut from rigid sheet brass before being fitted on to flat or shaped brass bases. Sometimes the joints were simply soft-soldered, but it was more usual to cut and pierce the brass to form a series of mortice and tenon joints which were then secured with soft solder, this being a far stronger method. With the exception of the limited use of dome-headed rivets to represent eyes, or

Fig.56. Brass Horses
These sheet-brass horses all come from the north of England: (a) coming from Durham City, (c) made from an old brass door-plate, from Carlisle, (d) from Bedale, and (e) from Sunderland. Both (b) and (f) are unprovenanced.

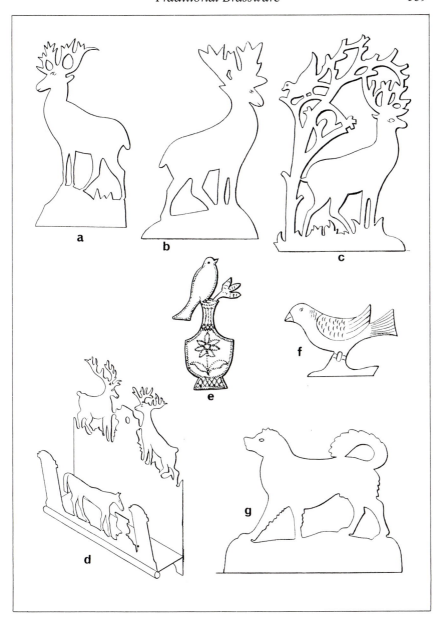

Fig.57. Brass Stags, Birds and Dogs
The popularity of stag ornaments of the north-east might be due to the influence of a Bewick woodcut, or to the numerous mid-Victorian reproductions of Landseer's 'Monarch of the Glen'. These examples come from (a) Newcastle, (b) Pelton Fell Colliery, where it was made by the colliery engineer, (c) Leadgate, and (d) Boldon. Both birds were found in County Durham, while the dog came from a house at Bedale in North Yorkshire.

simple chased or engraved lines to clarify the position of limbs etc., the animals were usually left entirely plain. They relied solely on their silhouette for their visual effect. Almost without exception, they exhibit an excellent quality of line, giving each animal a sense of life and movement.

Horses provided the most popular subject, being made either singly or in pairs to ornament each end of the mantelpiece. Occasionally a horse is shown tethered to a pillar, but the majority either trot, with two legs raised from the ground, or, more rarely, proceed at a full gallop. They all have great individuality and a quality of observation which suggests that their makers had a close working knowledge of horses. Even so they could have been copied from book or magazine illustrations, or from contemporary advertisements.

Stags were almost certainly copied from illustrations, for there were virtually no parks within the industrial regions at which the makers could gain first-hand experience of deer. The most likely source of inspiration was the wealth of full-colour reprints of famous paintings of the Scottish Highlands, particularly Sir Edwin Landseer's 'Monarch of the Glen' which hung in many front parlours. Certainly the majority of brass stage are depicted in the classic 'Stag at Bay' pose, standing with head erect on a low mound. In addition to being made both singly and in pairs, stags also appeared on useful articles ranging from magazine racks to desk-top stands, where the points of the antlers made admirable pen-holders!

Animals other than horses and stags were made from time to time, but were by no means as popular. Birds, cats and dogs are found, however, the latter always having a particularly lively appearance, probably because they were modelled directly from a well-known family pet. One example in the farmhouse of the North of England Open Air Museum at Beamish even has a series of narrow closely-spaced sawcuts around its outline, these representing the dog's long coat in a unique but effective manner. Of all groups of traditional English brassware, animals such as these are among the most beautiful and appealing.

8

Pottery and Glassware

The craft of shaping and firing raw clay to produce hard and durable pottery vessels for domestic use has been carried out in England for some five thousand years, each generation modifying the form and techniques of its wares to meet its changing requirements. Development has not been continuous, however, but has proceeded through a whole series of fits and starts. In the Viking period, for example, little pottery was used in many northern communities, the bulk of their utensils being of wood, leather or various metals. Throughout the medieval period the potters concentrated on the production of jugs and cooking pots, but from the late fifteenth century they began to expand their range of wares considerably by taking over shapes such as cups, and plates which had formerly been the virtual monopoly of the wood turners and pewterers. This significant advance, coupled with the great improvement in technology and transport facilities generated by the industrial revolution in the eighteenth century, effectively split the potter's craft in two. One branch, led by Wedgwood and his contemporaries, developed the expensive factory-made wares whose elegant design and technical excellence established a worldwide reputation for English ceramics, while the other, the 'country potters', continued to make cheap practical wares for everyday use in the homes of the agricultural and industrial working class.

The majority of the country potteries working in the north of England were established on the coal measures of Lancashire, western Yorkshire, West Cumberland, the lower Tyne and Wear valleys, and around Ingleton in north-west Yorkshire. Here they enjoyed the advantages of a ready supply of coal and suitable clays, together with easy access to the vast new urban populations now gathering around the world's greatest steelworking, engineering, coal-mining, wool and cotton textile centres. The bulk of their products were the handmade cups, mugs, mixing bowls, baking dishes, brewing jars, bread pots, jam jars and storage vessels all made in red earthenware and coated with a brown or glossy black glaze to serve the basic culinary needs of their customers. In addition, the potters made a variety of decorative wares, some being for speculative sale when hawking the ordinary wares around the streets and

Fig.58. Pottery Figures

It was in the early sixteenth-century that the pottery cup-makers of northern England began to make pottery figures. Most of them appear to have served as salts on the banquetting table, miniature figures dressed in the height of fashion holding a bowl full of salt before them. The figures, (a) were excavated in York; (b) at Sandal Castle, and (c) probably from the north, from Southampton. The man and woman (d) were both made at the Burton-in-Lonsdale potteries around 1830.

hamlets on a horse and cart, while others were made to order, perhaps to celebrate an event such as a wedding or a Christening. It is these decorative wares which form such an interesting aspect of north country folk art.[1]

Probably the earliest examples of this type of pottery are the salt cellars made at the Potovens potteries near Wakefield in the mid-sixteenth century. Measuring about seven inches in height, they usually took the form of a lady standing with her arms before her carrying a wide bowl, in which the salt was served. Her wide dress, arms and bowl were all in red clay over which her head, hands, and the fashionable details of skirt, bodice and bonnet were all neatly modelled in red and white clays covered with a golden yellow transparent glaze. Examples have been excavated from Castle Mills Bridge in York, from Sandal Castle near Wakefield, and from Addlethorpe near Skegness, while it is possible that a magnificent salt featuring two ladies and two gentlemen recently found in Southampton also originates from one of the northern potteries of this period.[2] Over the succeeding centuries very few potters modelled human figures, except for the crude unglazed red clay busts occasionally made as toys for children, such as my brickmaker grandfather made for me forty years ago. At the Burton-in-Lonsdale potteries in the 1830s a few figures were modelled, however, their simple body shapes being clad in coats, collars and hats made from separate pieces of clay deftly pressed in place and finished with buttons, pockets and belts as required.

Birds provided by far the most popular subject for modelling in pottery, their compact shape enabling them to be produced with relatively little trouble, while their reputation as symbols of hope and promise for the future made them additionally attractive. In their most impressive form, they appear as cuckoos modelled in brick-red clay and perched on a horizontal branch mounted at the summit of a tall conical base, both the branch and the base bearing gnarled knots of clay and miniature cuckoos. Details such as beaks, eyes, wings, spotted breast feathers and the sawn-off tips of shoots and branches are represented in slip-trailing. This is a method of decoration in which white clay dissolved to a creamy consistency is piped on to the unfired pottery through a hand-held funnel made by inserting a hollow goose-quill into the bored-out tip of a pointed cow's horn. These pieces are capable of producing a very loud and realistic cuckoo call, the two notes being made by blowing up a slot in the tip of the tail and alternately opening and covering a round hole pierced through the hollow breast. Cuckoos of this type were made in the potteries around the Halifax area of West Yorkshire, at Burton-in-Lonsdale, and at Buckley near Chester, while others having the same shape but a light buff clay and a glaze splashed with manganese brown

Fig.59. Bird Whistles
Each of these birds could produce a realistic cuckoo-call when air was blown up its tail, the
two notes being made by opening or closing the holes in its breast; (a) in red and white
marbled pottery, comes from the Tyne or Wearside potteries; (b) was made by John
Bradshaw at the Bridge End Pottery, Burton-in-Lonsdale; while (c & d) probably come
from the Halifax area.

Fig.60. Money Boxes
Hens and chickens decorate many north-country money boxes such as these examples
from the Burton-in-Lonsdale potteries; (a) was made by John Bateson at Town End
Pottery; (c) was made for James Whitaker, headmaster of the Kendal Bluecoat School in
1838, while (b & d) are by unknown makers.

probably originate in one of the Castleford potteries. Smaller versions of the cuckoos were also made in the Tyne and Wear district from what was known as solid agate ware, red and white clays being partly kneaded together to produce a swirled marble effect which passed completely through the pottery of the finished model.

Good fortune was certainly required when dealing with financial matters, and so it is not surprising to find birds associated with pottery money boxes. The simplest of the 'hen and chickens' money boxes made in Yorkshire has the globular onion-shaped body characteristic of this type of vessel ever since the sixteenth century. On top, a large bird sits amid five smaller chickens, while beneath a slot for the coins the initials 'J.B.' are neatly pricked through the clay, these probably standing for John Bateson who made it at the Town End Pottery, Burton-in-Lonsdale, in 1830. This group of potteries was responsible for some of the finest English money boxes, their bodies being surmounted by cylindrical cages and tall conical roofs from which spring eight ornamental loops to form an ornate terminal crown. Within the cage sits a perfectly modelled bird, further birds peering in through the bars, while another sits on top of the entire vessel. Inscriptions such as 'This His a Save All 1815+', 'Dorothy. Ann. French', or 'T:L: Mill of Millom Cumberland 1841' in neat slip trailing around their bases give the names of the customers for whom they were made. One money box inscribed 'James. Whitaker 1838' was ordered by the master of the Kendal Bluecoat School from a Burton-in-Lonsdale potter attending the Kendal Fair in that year. It must have proved extremely satisfactory, for a little later the same potter provided an identical example, this time bearing the inscription 'Anne. Whitaker. 1841' for James's wife.

Birds were also used to decorate salt-kits. These vessels, introduced into the northern potter's repertoire in the late eighteenth century, usually took the form of a tall bulbous bottle, except that what would normally be the neck was completely sealed over to form a finial knob. Access to the inside was provided by cutting a hand-size circular hole into the shoulder of the pot, this then being finished with a rounded canopy formed from a section of another thrown pot luted in place before the kit was decorated and placed in the kiln. This design was specially adapted to keep cooking salt dry and crisp in the steamy atmosphere of the kitchen, the domed interior effectively preventing the build-up of condensation, in addition to keeping the salt free from dust and smuts of soot from the fire. In the potteries of the Halifax and Tyne and Wear district, the kits were decorated with slip-trailed designs, often incorporating initials, dates, or the word 'salt' in the space beneath the hand-hole, but the finest slip-trailed examples were made at the

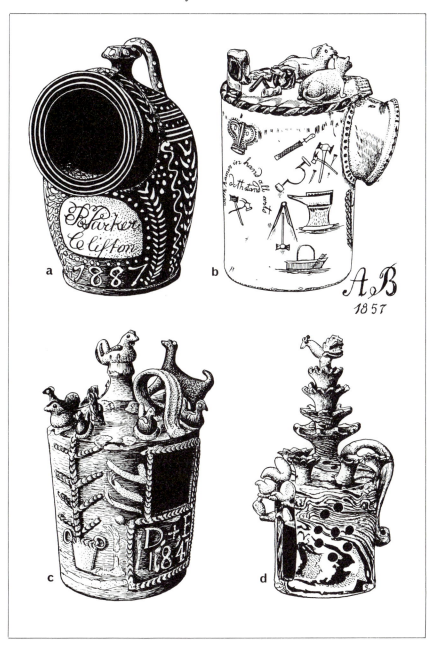

Fig.61. Salt Kits and Lantern
These salt kits were made: (a) at Weatheriggs Pottery, Penrith in 1887; (b) probably from Weatheriggs in 1857; and (c) by the Kitson family at Ainley Top Pottery near Halifax. The lantern was made in solid agate ware by John Kitchin at Whitehaven in the 1850s.

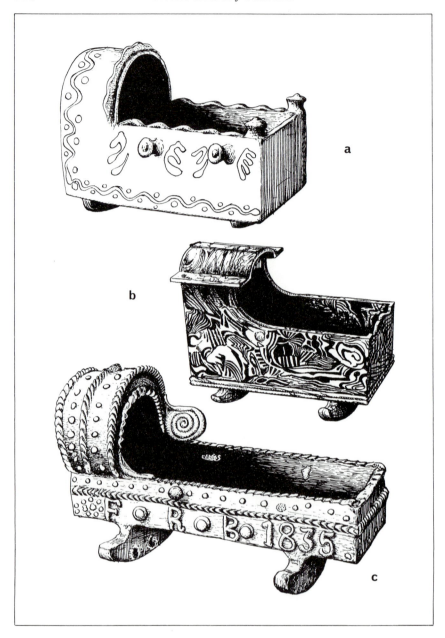

Fig.62. Cradles
Miniature pottery cradles appear to have been made to commemorate weddings or Christenings, frequently bearing appropriate initials and dates: (a) dated 1802, and (b) come from the Halliday's Howcans Pottery and (c) from the Kitson's Ainley Top Pottery, both near Halifax.

Weatheriggs pottery near Penrith, between the 1880s and 1920s. These had concentric slip-trailed bands applied when the pot was still on the potter's wheel and vertical bands of zig-zag and dot motifs, as well as panels of white slip through which, when dry, the customer's name and address were scratched to reveal the colour of the clay beneath. This technique is known as 'sgraffito'. For special orders the potters added three-dimensional modelled figures on to the top of the kit, one example made for a blacksmith in the Brampton area near Carlisle having a cat, a dog, an anvil and a set of tools modelled in brown and white clays, while another, probably made by a member of the Kitson family at Ainley Top pottery near Halifax, has a whole group of hens and chickens — and a dog — clustered around it.

Birds, usually described as doves or pigeons, may also be associated with model cradles. The custom of making these first became popular in the mid-seventeenth century slipware potteries of North Staffordshire, examples measuring between six and sixteen inches in length being copied from contemporary oak cradles, with long bodies mounted on shallow rockers, their foot-boards and hoods rising up to curved, gabled or square outlines, while small knobs usually extend to each side to enable a muslin cat-cover to be secured over their open tops. Motifs including the monarch's head, scrolls, and abstract floral patterns are frequently trailed around their exteriors, the finer ones having their date and owner's name boldly added in 'jewelled' slip. Others are elaborately decorated with applied figures, with heads and the figure of a lively fiddler sitting gaily on top, probably representing the musician employed to entertain the wedding or Christening party for which the cradle had been made. One of the north country potteries to make cradles was Howcans, clinging to the side of a steep Pennine hillside just to the north of Halifax. Here, from around 1800, the Halliday family built up cradles from thin sheets of red clay, their deep rectangular bodies having a semi-cylindrical hood and four cat-cover knobs all decorated in simple but extremely competent slip trailing. By the 1870s the cradles made here had altered greatly in style, their early simplicity being replaced by much more precise and accurately observed modelling. They were made in the manner of wood, slices of leather-hard agate ware being cut to shape and stuck together with slip, just as the joiner would use planks and glue. Even the mouldings across the top of the canopy and all around the base are reproduced exactly.

This mechanical quality is entirely absent from the work of the Kitson family of Ainley Top pottery. Their cradles have long narrow bodies, tapering towards the base, while their hoods are formed from short cylindrical vessels thrown on the wheel. As with all the finer Kitson

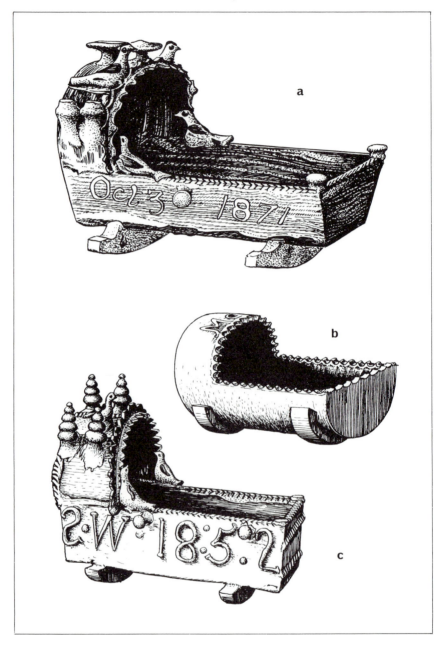

Fig.63. Cradles
These examples come from: (a) one of the potteries of the Tyne or Wear; (b) John Bradshaw's Bridge End Pottery, Burton-in-Lonsdale; and (c) from one of the Cliviger potteries.

pieces, much of the decoration is executed with white clay motifs applied over the red clay body. In addition, the applied mouldings and the edges of these cradles are impressed with a series of V-shaped notches made either with a modelling tool, or perhaps even by the use of a small incised roller. Very similar cradles were made at other northern potteries. At Cliviger, near Burnley, the hoods were decorated with deeply cut notches, tall thrown pinnacles, and six small white doves with brown wings. By the 1850s, this pottery had closed down, but since almost identical cradles dated to the 1870s have been found in the Newcastle area, it is tempting to consider the possibility of their having been made in one of the potteries in the Tyne and Wear district by a former Cliviger employee. Cradles of quite a different design were made at the Bridge End Pottery, Burton-in-Lonsdale, by John Bradshaw. He first threw a tall cylindrical pot, allowed it to become leather-hard, then laid it on its side, cut out two-thirds of the top and added a foot and rockers before trailing initials over the hood to complete a very simple yet effective cradle.

Miniature children's rocking chairs, copying the oak or elm plank-built examples used in many northern homes, were produced in the potteries of the Tyne and Wear district and around Halifax during the latter half of the nineteenth century. Occasionally made to match a pottery cradle, they might bear the same date, perhaps commemorating a Christening or wedding.

The most interesting wares of this type, however, were models of chests of drawers or dressers, representing some of the greatest status symbols of working-class households. Some of the finest examples were made either by Elizabeth Kitson or perhaps by other members of her family working at the Ainley Top pottery from the 1850s. Their materials and workmanship are very distinctive, enabling them to be recognised fairly easily. In every case the basic construction of the piece is carried out in the usual red-firing coal-measure clay which can range from a pale brown colour to a near-black beneath its lead glaze. Decoration is in the form of narrow strips of white clay with V-shaped notches stamped at regular intervals along their length. Most stand about six inches high, stand on four or six slightly conical feet, and have two drawers set to each side of a central round-topped cupboard. The drawers are fully operational, a border of white clay around the face of each one helping to disguise the unavoidable irregularities in the surrounding pottery. Further enrichment could include slip-trailed designs, white slip inlaid into the red clay, or the addition of three-dimensional figures such as pigeons or long-skirted ladies. Other Halifax potters made chests of drawers too, the slabs forming their front panels being pressed down into specially-made moulds which reproduced the drawer fronts and turned half-column

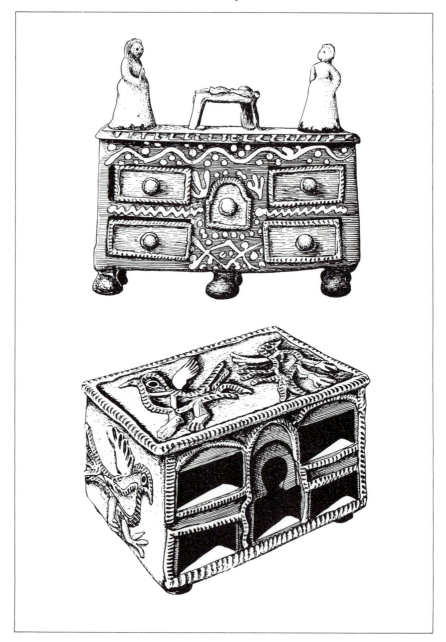

Fig.64. Modelled Chests of Drawers
These chests of drawers were probably made by the Kitson family at Ainley Top Pottery near Halifax from the mid-nineteenth century. Some of the finest were made by their daughter Elizabeth.

Fig.65. Moulded Chests of Drawers
The fronts of these chest of drawers money boxes were formed by squeezing a slab of clay into a specially-made mould. The top example was made in agate ware with an inlaid inscription at one of the Halifax potteries, while the lower example probably originates from Burton-in-Lonsdale.

Fig.66. Pottery Models
This fine chest of drawers, from the Canny Hill Pottery near Bishop Auckland, was
reputedly made as an apprentice piece in 1862. The agate ware top hat, made for George
Ratcliffe in 1881, and the whistle in the form of an animal's head also come from one of the
north-eastern potteries.

decorations in exact miniature detail. The finer examples, dating from the 1840s, were made in solid agate ware, the remainder being in plain red clay. In the north-east, the only pottery known to have made chests of drawers was at Canny Hill, near Bishop Auckland. One fine example, reputedly made here as an apprentice piece in 1862, is now in the collection of the North of England Open Air Museum at Beamish. Neatly built up from slabs of red clay, its surfaces are covered with parallel rows of S-scroll and dots in slip trailing, while each of its five fully functional drawers has dotted borders and round handles tipped in white slip.

One of the potter's most amusing uses of modelled decoration was the production of frog mugs, drinking vessels of quite normal and innocent appearance which concealed a slimy frog which only became visible as the drinker drained his pot. As the earliest surviving frog mugs are all factory-made pieces of the 1775–80 period, it is probable that the coarse earthenware examples are derived from these, for none is dated before the mid-nineteenth century. The Halifax potteries, and especially that at Howcans, appear to have been the main centres of production, the relatively uniform style of the frogs suggesting that they nearly all originate from a common source. The mugs are characterised by cylindrical redware bodies finished with two looped handles down the sides, while inside one or more frogs squat around the base and walls. One of the earliest examples, inscribed 'J + R + C.S. 1861', is now in the collections of the Yorkshire Museum, at York, while perhaps the latest is in Shibden Hall, Halifax. A note in pencil across its base reads 'Last kiln at Howcans, 1889'.

Simple slip trailing and small modelled details were used to decorate many of the potter's everyday products, mugs, jugs, jars, drink pots, and containers for candles, tobacco or cutlery having the most basic initials or dates added whenever there was a need to give them some individual identity, or to make them commemorate some specific occasion. This was particularly important for ceremonial vessels such as the posset pots used at wedding breakfasts in the Pennine hills between industrial West Yorkshire and Lancashire. Here it was customary to order one of these large vessels from a local pottery, the date and the initials of the bridal couple being trailed around its sides. Then, on the morning of the wedding, the whole of the party 'met at the residence of the bridegroom. Before breakfast proper commenced, or rather it ought to be called the first course of the breakfast, a large pot that would hold two or three quarts, with two, three, and sometimes four handles on, called a posset pot, filled with hot ale and rum posset, would be handed round the party from one to another. Into this posset pot the bride would drop a wedding ring, and it was the object of each one of the party by taking three or four tablespoonsful of the posset at a time to fish up the wedding ring, for it

Fig.67. Pottery Models
Miniature versions of the traditional plank-built potty-chairs used by small children were probably made to celebrate Christenings. These examples come from (a) Halifax, and (b) one of the potteries of the Tyne and Wear district. Frog mugs were designed to give a fright to the unsuspecting drinker, the frog slowly emerging out of the liquid as he drained his pot. These frogs come from the Howcans pottery at Halifax, the base of (d) being inscribed in pencil 'Last kiln at Howcans, 1889'.

Fig.68. Posset Pots
In the Pennine hills between the industrial conurbations of Yorkshire and Lancashire, the
wedding breakfast took place in the morning at the bridegroom's house. It commenced
with a hot posset made of ale and rum served in a specially-made two-handled posset
pot; (a, b and c) all come from Halifax, a being decorated with oil paint rather than the
more usual slip trailing; (d) comes from the Cliviger Pottery in eastern Lancashire.

was firmly believed that the one who fished it up, whether male or female, would be the next of that party to be married. Then followed tea with a liberal proportion of rum in it. By the time the breakfast was over the company got quite lively, and their faces, normally quite rosy from living in the bracing atmosphere of the hills, 1,200 feet above the level of the sea, became glowing red, the perspiration standing in drops. Breakfast over, the party would prepare for a journey of six or seven miles to the parish church, headed by the indispensable fiddler'.[3] After the return from church, the same pot was probably used for the bride-ale served to all the company, then remaining in the house of the newly-weds as a memento of their wedding day.

As the nineteenth century progressed, there was a fall in demand for the traditional household wares made by the country potters. Changing lifestyles, increasing mechanisation in the great Staffordshire pottery industry, the introduction of new glass, enamel and galvanised vessels, and the new, cheap transport facilities provided by the expanding railway system all exerted economic pressure on these small potteries. Fortunately they were able to delay their demise by turning their attention to a variety of horticultural wares. Many, such as field-drain pipes, rhubarb, seakale, and plant-pots were purely utilitarian, but for the ferns, aspidistras and other plants displayed everywhere from the smaller cottage window sills to the great conservatories of the industrialists, rather more decorative pots were required. From the 1850s, 'rustic wares' proved extremely popular, this range of bouquet holders, trellis-work flower-pot holders, wall pots, epergnes and fern pots all being made in red-firing clay coarsely incised with the prongs of a dining fork to give a realistic bark-like finish, often enlivened by the addition of a few slip-decorated 'knots'. Other items, such as picture frames or tobacco boxes, were also produced in rustic ware up to around the time of the First World War, but then the great social and economic changes sweeping the country began to take effect. Dozens of the smaller potteries closed in the 1920s, this decline continuing so that by 1945 there were less than a dozen, and today only two of these remain in production, horticultural wares and the tourist market forming the bulk of their trade.

Glassware

In contrast to the country potteries, the glassworks operating in northern England were major industrial concerns. From their origin as small rural workshops in the late sixteenth and early seventeenth centuries they rapidly developed into large urban factories requiring substantial capital

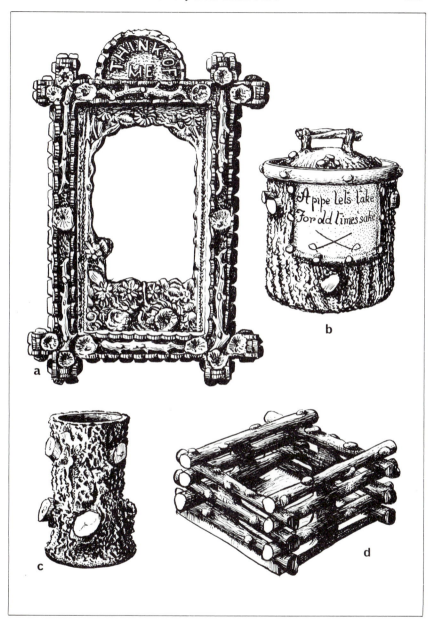

Fig.69. Rustic Ware

Rustic wares are characterised by their imitation of natural rough-barked wood, seen here in (b) a tobacco jar made by the Leeds Fireclay Company at Hipperholme early this century; (c) a spill holder from the Halifax area; and (d) a twig basket made at the Salendine Nook pottery, Lindley Moor. The picture frame, a pottery copy of a cut-cork and twig example, was made at Denholme Pottery around 1855.

investment in the form of buildings and plant, in addition to sufficient resources to pay for a skilled workforce and large supplies of fuel and raw materials. Their usual output might include bottles, drinking glasses, and window glass, together with more specialised products such as plate glass, scientific apparatus, or high-quality tableware decorated by being enamelled, engraved, etched, or stained with metallic oxides. According to many writers, the glassblowers used the surplus glass left in their pots at the end of the day's work to make ornate models both for their own satisfaction, and as a means of earning extra money from private sales. It is probable, however, that these 'friggers', which took the form of blown glass walking sticks, smoking pipes, witch balls, bellows and rolling pins etc., were produced as part of the commercial operation of the glassworks too, being sold through glass-dealers' shops in the market towns and the itinerant traders who attended all the local fairgrounds. The more ornate friggers, such as sailing ships, harps, fountains, birds and animals did not even require access to the technical facilities provided at the glassworks, for they could be readily made from rods of clear and coloured glass heated by a portable lamp. Thus it was possible for them to be created by glassworkers who gave demonstrations and offered direct sales of their work at feasts and fairs. Similar activities are still carried on today in many seaside resorts.

Even though the majority of the friggers found in museums, galleries and antique shops today were made by craftsmen who specialised in their production, a more limited number were made by glassblowers for their own amusement. Perhaps the earliest documented examples of this type are 'Rupert's Tears', or 'Rupert's Drops', which owe their origin to Charles I's nephew, Prince Rupert of the Rhine. Around 1661 he discovered that tear-shaped drops of toughened glass could be made by dropping the molten 'metal' into cold water. The tension built up in this way gave them a remarkable property, for they were extremely robust at their rounded ends, and extremely fragile at their points. Generations of glassblowers used them to play tricks on their visitors: 'they would just gather a few ounces of melted glass at the end of a punty stick and drop a portion of it into a kettle of water. When cold enough he would fish it up with his fingers and offer you the thick end of it, bidding you hold tight! As soon as he found you had a grasp of it, he would give the thin end a twist, when hey presto! you would find yourself with a handful of glass dust after a loud explosion, with a tingling sensation in your fingers and thumb which would last some time . . .'[4] They were also made as toys for children, Miss M. Moore of York remembering them coming from the glassworks in that city.

Other friggers might include walking sticks, top hats, swans etc. At the

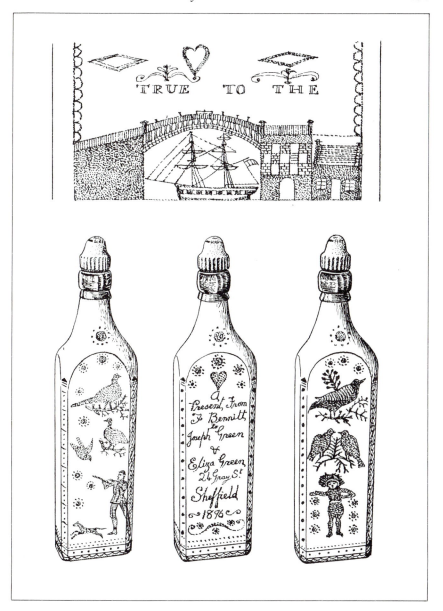

Fig.70. Glass Decoration
Articles of ordinary domestic glassware were occasionally decorated by being stippled with a sharp-pointed tool. The upper design comes from a black glass rolling pin made at Sunderland in the mid-nineteenth century. As a love token, it bears the inscription 'TRUE TO THE [E]'.
The bottles, meanwhile, were decorated by F. Bennitt for Joseph and Eliza Green in Sheffield in 1896.

annual Glassmakers' Procession in Newcastle upon Tyne these were carried through the streets, as recorded in the following account dated September 12th, 1823: 'the workmen employed in several of the glass-houses [of Newcastle, Gateshead and the neighbouring towns, walked through the principal streets] each bearing in his hand a specimen of the art, remarkable either for its curious construction or its beauty and elegance . . . The sky was clear and the rays of the sun falling upon the glittering column, gave it a richness and grandeur in appearance to defy description. The hat of almost every person in it was decorated with a glass feather, while a glass star sparkled on their breasts, and a chain or collar of variegated glass hung round the neck; some of them also wore sashes around their waist. Each man carried in his hand a staff, on a cross-piece on the top of which was displayed one or more beautiful specimens of their art. As these were carried above the heads of the crowd, a full view of them was afforded to every one, and the procession was relieved from the inconvenience which might otherwise have been experienced from the populace crowding round it to obtain a sight of the different vessels. These consisted not only of a profusion of decanters, glasses, goblets, jugs, bowls, dishes &c. which may be called the staple articles of the trade, and which exhibited endless variety of elegant shape and exquisite workmanship, but also several others, remarkable either for their grandeur and excellence of work, or for the curious nature of their construction; amongst the latter were two elegant bird cages, containing birds, which sang at periods during the procession, a salute was fired several times from a fort mounted with glass cannon, to the astonishment of the spectators; and a glass bugle, which sounded halts and played several marches, was much admired for its sweetness and correctness of tone. Several elegant specimens of stained glass were exhibited, and many of the men wore glass hats and carried glass swords Exhibitions of this kind are highly commendable not being a mere unmeaning show calculated for caricature, but exhibiting to public view some of the finest efforts of human industry and genius'.[5] Regrettably only a few pieces of glassware carried at these events have survived through to the present day, but the Shipley Art Gallery, Gateshead, houses a top hat, a fish, a bell, a pistol, bellows, a violin, green and blue glass walking sticks, a drum major's baton, and a pipe, all of which were used in this way, and the Laing Art Gallery, Newcastle, has the sword carried by John Miller of Lemington Glassworks in the procession of 1867.

Outside the industry, the everyday products of the glassmaker's craft provided a useful medium for decoration by ordinary people. A diamond ring could be used to scratch an inscription onto a quarry of glass in a

leaded window light, for example. Rather more common was the practice of tapping a sharp steel point against the surface of the glass in a stippling motion, the designs produced in this way being formed by the removal of minute chips of glass. Around Sunderland, numerous glass rolling pins were decorated with stippled views of the Sunderland Bridge, copied from some of the numerous engravings and transfer-printed earthenwares illustrating this great triumph of engineering. In other areas spirit bottles, wine bottles and other vessels of dark green or blue glass were inscribed with names, dates and illustrations, often serving as tokens of love or friendship.

9

Decorated Floors

Throughout the north of England the floors of small houses and cottages were made from the most convenient local materials. Wherever good stone was available, especially the fine-grained sandstone of the Pennine foothills, it was split into rectangular slabs and used to provide the finest smooth wear-resisting paving. Elsewhere the floors might be of bricks laid in an interlocking pattern similar to parquet, as in the York area, while on the Wolds they could be made of chalk cobbles embedded in earth. Floors of beaten earth could still be found in the eastern parts of the region during the early nineteenth century, but gradually these were entirely replaced by cement or concrete floors of a kind made here from the seventeenth century at least.[1]

Whatever the floor was made of, great pride was taken in its cleanliness, the housewives ensuring that all the mud and dirt trodden in from outside, together with the splashes of fat and grease from everyday cooking operations, was meticulously eradicated on a regular basis. To do this, quantities of sharp sand were used, as William Smith of Morley has described: 'To minimise the effect of the dirt, which every visitor to or occupant of the house could not fail to bring in from the dirty roads of the village, handfulls of yellow sand crushed very fine were scattered over the bare floor. The hawking of sand for household purposes was then a recognised trade, and every Saturday morning the sand cart, heavily laden, duly made its appearance, with the driver as a rule accompanied by his wife who carried under her arm various wooden measures ready to fill the peck or half-peck vessel, as her customers required a 'hawporth' or a 'pennorth' of the commodity'.[2] In York, generations of elderly ladies had gained permission to take fine sand from Acomb village green, where the grassed-over remains of their workings can still be seen. The donkey-carts full of sand were then led off to be hawked around the streets of the city, with the traditional cry of 'Fine Yacomb sand', the local lads taking great delight in slipping off the halter and reins, allowing the ladies to innocently lead them through the city to everyone's amusement, while the donkeys trotted off into the distance. In some areas, such as Saddleworth, the local lads collected sand from the nearby streambeds and sold it to the village women for

Fig.71. Sand and Scouring Stone

Sand for scattering across stone, cement or brick floors could be gathered from streams or sandpits, if these were available. Alternatively stone had to be purposely crushed in a large stone mill, such as (a) this example at Sourhall near Todmorden, or (b) crushed by hand, using one of the characteristic 'bukkers' of the leadmining areas. (c) In York, the Acomb sand ladies often found the halter of their donkey-carts was slipped off by mischievous youths as they jostled through the city's bars, as seen in this woodcut of around 1811. (d) Floors could also be scoured with specially made stones, such as this block of white 'Beaver brand', or (e) with large blocks of stone fastened on to long handles to form the so-called 'idleback' or 'lazyback'.

about a penny a quart, but in other areas the sand had to be made by crushing pieces of stone.[3] A mill specially constructed for this purpose stands on the edge of the moors at Sourhall, near Todmorden, its huge vertical millstone rotating in a wide circular trough in which the local gritstone was rendered down to a coarse sharp sand. The same operation was performed in the leadmining areas of Yorkshire and County Durham by means of a 'bukker', a heavy square-headed hammer purposely designed for crushing ore-bearing rocks.

Having acquired the sand, the housewife could scatter it at random over her floors, but in the Yorkshire Dales it was carefully strewn in graceful freehand patterns, passageways having looped zig-zags drawn through with a brush, while doorsteps were given scrolled patterns in two colours of sand.[4] In the East Riding, meanwhile, the floors of brick or of beaten cement marked out in rectangles to resemble flagstones were washed with rud-coloured water to give them a deep red surface. Over this, the sand was shaken out through a cullender to produce a series of beautiful yellow patches about a quarter of a yard apart. When combined with whitewashed walls, red-painted woodwork and yellow-ochred door-steps, these agricultural labourers' cottages presented a particularly bright, clean and neat appearance, and it is not surprising to learn that houseproud mothers readily scolded any youngster who disturbed one of the sand patches before six in the evening.[5]

The sand strewn across the floor was regularly swept out to keep the room clean, but there were other methods of keeping the stone-flagged floors smooth and white. One of these was the idle-back, a rectangular block of stone usually fastened by an iron socket to a long wooden handle so that it could be used with water to scrub the floor. 'Idlebacks, fessened tul t'end of a long stail. There's nowt licks a gooid stooan used bi t' hand, wi' sum elber-greease', explained Joseph Baron.[6] Another was scouring stone, small pieces of friable stone or similar material with which the flags were rubbed immediately after being washed clean. It came in a variety of materials and colours, brown, yellow-ochre and off-white stones occurring naturally being collected by the housewife as required, or purchased from hawkers who obtained them from local quarries. For a purer white, pottery-mould was used, this being broken sections of the plaster-of-Paris moulds used in all the numerous pottery factories of northern England. It was also manufactured commercially, firms such as E. Whalley and Company of Ashton-under-Lyne grinding powdered stone from Northampton and Wigan with water, cement and a bleaching agent until it was rendered down to a smooth paste. Having been pressed into a mould, cut, stamped and air-dried, it was then sold off to the hawkers in large batches, this firm alone making some 2½ million blocks

Fig.72. Sanding Patterns
The upper patterns (after Dorothy Hartley) show how sand was strewn in the Yorkshire
dales: (a) with one hand down a passageway; (b) with two hands and two colours of sand
on the doorstep; and (c) with two hands down a passageway. The bottom pattern (d) was
made by shaking yellow sand from a cullendar in a regular pattern over an East Riding
cement floor washed with red rud.

every year in the 1930s. It was usually known by its brand name and the trade-mark stamped into its upper surface, 'Donkey stone' being one of the most popular, while Whalley's products bore a lion. The demand for these stones in the West Yorkshire and East Lancashire area has continued up to the present day, market traders such as John Fowler of Huddersfield still selling up to twelve dozen a week in the 1970s.[7]

All stone surfaces where cleanliness was required and pride in house-keeping could be publicly demonstrated were decorated with scouring stone. Inside the house, the whole floor, or a border around its perimeter, was scoured while outside the edges of the paving flags, the toilet floor, the window sill, the 'bink' or stone bench on which the milk pails were put to dry, and even the doorjambs were brightened with scouring. It gave a clean and fresh appearance in rural surroundings, but perhaps looked best in the long terraces of the great industrial conurbations, where its colour gave relief to the dark brickwork and soot-laden atmosphere. The most important areas to be scoured, however, were the doorstep and the hearth. In addition to being the main focus of attention for both family and visitors, these were the key areas through which, by tradition, all evil influences could enter the house. Throughout the North, as in other parts of the British Isles, there was a belief that decorative designs scoured across the doorstep and hearth averted 'the devil', 'witches', or 'the evil eye', while others thought that it brought good luck, especially if worked in a continuous entwined scroll pattern. The antiquity of this practice is suggested by a discovery in the first century B.C. Glastonbury lake village, where a hearth of clay was decorated with parallel rows of impressed circles,[8] while as recently as the 1940s, floors in Huddersfield were still being scoured in all-over patterns of continuous circular lines to ensure good fortune. In most parts of Yorkshire and Lancashire, the hearths and doorsteps were usually scoured all over, or just around their edges, but the degree of decoration tended to increase towards the northern counties, interlacing loops, S-scrolls and wave-and-dot patterns first appearing in the north of Yorkshire, while the finest and most ornate patterns were to be found in County Durham.[9] In some instances, the scouring patterns also served as a useful means of working out complicated designs. When George Beever returned home each evening from Sandford Mill to his cottage at Cartworth Fold, Holmfirth, he used to work out his new textile designs in ruddle, white, and Barnsley blue on each flag in turn, the whole floor being re-scoured and re-decorated each week. This was in the 1860—1880 period.

In most areas, the practice of scouring continued to be a weekly chore through to the 1950s and 1960s, but then, along with so many aspects of traditional domestic life, it succumbed to the increasing demands for

Fig.73. Scouring Patterns

These scouring patterns were used to decorate doorsteps and flagstones in the following locations: (a—f & i) at Ebchester, Consett; (g & h) at Helmsley; (j) at Newton-on-the-Moor; and (k) at Ashington, where the central space was left for the doormat. The borders (l) (m) and (n) were used in Jesmond Vale, generally throughout the north-east, and at Ashington, respectively.

higher standards of living and more labour-saving devices. It was soon
discovered that a single coat of cream gloss paint could preserve the
appearance of fresh scouring, except that it was permanent, and need
not be replaced, thus saving an enormous amount of time and trouble.
Scouring ceased to maintain its role as the outwardly visible indicator of
good housekeeping, and went into a rapid decline. Today it continues in
some rural areas, however, doorsteps and the edges of window sills still
being finished with the white or yellow stones of their particular locality.

The stone-flagged or cement floors of most working-class homes were
usually left quite bare except for a few rugs or mats arranged in front of
the hearth or around the table. Old sacks could be used for this purpose,
but it was much more common for their hessian to be interlaced with
strips of woollen cloth to make them much thicker, warmer, more
comfortable and colourful. The process of making a rug started with the
collection of the necessary materials. The basic rectangle of hessian was
either salvaged from an old sack, or purchased from a roll of new
material stocked at the local hardware shop, market stall or Co-op. It was
neatly hemmed all round, marked out, and then mounted on a rug
frame. This frame consisted of a pair of long wooden bars or rails, each
being pierced with a mortice or slot at each end, and having a length of
strong webbing securely tacked down one edge. Once the ends of the
hessian had been stitched to the webbing with coarse string, all but some
eighteen inches of its length was wound around one of the bars, this then
being stretched by having a pair of flat wooden splints threaded through
the mortices in the bars so that they could be pulled apart and held in
place by pegs inserted into holes in the splints. By this arrangement, a
strip across one end of the mat was kept taut and flat ready for the
insertion of the strips of cloth and, when this section had been completed,
the splints could be withdrawn, another section of hessian rolled into
place and stretched once more, this process continuing until the whole
rug had been completed.

In some households, rug makers preferred to work with frames of a
different type. A vertical framework standing on sturdy feet was fitted
with a pair of horizontal rollers mounted between its uprights, so that the
hessian could be rolled off one, over a working area at the top, and then
down on to the other as work progressed. I have seen this type in use in
the Holmfirth area of West Yorkshire. Other households might prefer to
work with an unstretched hessian, held loosely over their knees, but it
was very difficult to produce good-quality results when working in this
way.

The woollen cloth used in rug making came from old clothes collected
throughout the year, although it was quite usual to buy separate pieces of

Fig.74. Hearthstone Patterns
The hearthstone patterns shown here come from: (a–c) the Yorkshire Dales; (d) Gateshead; (e) Ebchester, Consett; (f & g) the Lake District; (h & k) the North Yorks Moors, and (i) from a bedroom hearth in Morpeth, which used sandystone mixed with red ochre for the poppies, green distemper for the leaves, and gentian blue indelible pencil for lining out. The border patterns (j & k) are from Staindrop and North Yorkshire respectively.

Fig.75. Rugmaking
In the most common method, (a) 'prodding' or 'pegging', etc., short lengths of cloth were pushed through the hessian (b−d) using a variety of simple pointed implements (e) while working from the back of the stretched rug. (f) For hooky rugs, long strips of cloth were looped through the hessian (g & h) using hooked tools.

cloth whenever a particular colour was required. In Leeds, for example, some of the sergeants in the cavalry barracks used to carry on a lucrative trade in old uniform jackets, since these were essential for the customary narrow red lines which bordered each rug. Once sufficient cloth had been acquired it was cut up into strips, their size and shape being determined by the type of rug to be made. For the most common variety, the 'brodded', 'prodded', 'proddie', 'proggie', 'stobbie', 'peg' or 'clip' rug, the strips measured some one and a half to four inches in length by half to three-quarters of an inch in width, their ends usually being cut at 45° to prevent them fraying in use. To start rug making, a wide hole was formed in the hessian by forcing a sharp-pointed 'prodder' into its open weave. The prodder could be specially made by the blacksmith in the local smithy, factory or shipyard, its rounded ball or ring terminal fitting comfortably into the hand, but others were carved from pieces of wood or bone, or adapted from old screwdrivers or even bullets brought home as souvenirs from the First World War. Once the hole had been made, one end of a piece of cloth was threaded through the hessian, the other end being pushed down into a second hole made a short distance to the side of the first, so that it was effectively stapled in place, its ends protruding on the underside to form the pile of the completed rug. In some areas the end of a second piece of cloth was threaded down the second hole, and this process continued across the hessian to produce consecutive strips of closely-spaced prodding. It was much quicker, however, to insert each end of a broad piece of cloth into its separate hole, but the resulting rug was often relatively flat, coarse, and shabby. The designs used with rugs of this type were usually quite simple, a broad dark border made from old suiting, coats or blankets, perhaps edged with a narrow inner border of red, frequently enclosing an area of multi-coloured prodding, with a diamond-shaped or circular centrepiece. These were particularly common throughout Yorkshire and Lancashire, but were also made in other areas throughout the North. Individual rugmakers did make rather more interesting designs, but even these are very plain when compared with those produced by hooking in Cumbria, Northumberland, County Durham and Cleveland.

To prepare the cloth for making hooked or 'hooky' rugs, it was cut into long strips about half an inch wide, or, if it was very thin, an inch wide so that it could then be folded double. In areas such as the industrial section of the Tyne valley, this task was often carried out by the menfolk, who squatted on their 'hunkers' at the back doorstep in the summertime, cutting the strips and rolling them into balls which were then stored in cardboard boxes ready for the rugmaking sessions of the long winter evenings. Once the hessian had been stretched on the frame, a hole was

Fig.75a. Rugmaking
In Yorkshire prodded rugs were also made on vertical rug frames on which (a) the hessian was stretched over a series of staples, (b) the Brown's Registered Rug Needle was then (c) thrust between the staples, where (d) it was gripped by a piece of cloth, so that (e) it could be pulled back into place. This frame was used by Mrs Jarvis of Great Howden near Barnsley in the inter-war years.

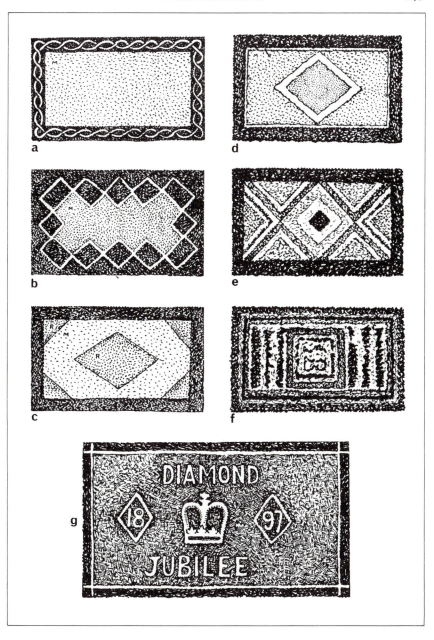

Fig.76. Prodded Rugs
Usually these rugs have fairly simple patterns, as may be seen in these examples: (a – c) from Fryup in the North Yorks Moors; (d) from West Yorkshire; (e) from Mrs Agar of Sleights; and (f) from Sheffield. The Diamond Jubilee rug (g), pegged in purple and light fawn on a dark mixed background within a black border, was collected in the Carlisle area.

poked through it at one corner using a hooked tool. Holding the strip beneath the hessian, one end was pulled up through the hole and held firmly while a second hole was poked through a quarter of an inch to one side of the first. As the hooked tool was withdrawn from this second hole, it pulled up a half-inch loop of the strip to form the pile of the hooked rug, this process being repeated until the whole rug was complete. This technique was particularly suitable for making patterned rugs, since it was capable of achieving sharply-defined lines and borders, as well as solid areas of single colour. The commonest designs for hooked rugs were based on the simplest ways of dividing up their surfaces in a geometric manner: parallel lines, concentric rectangles, squares, triangles or diamonds. All-over designs were also made by dividing the rugs into random black-bordered shapes filled in with various colours and textures, or by series of convoluted lines worked in parallel bands of contrasting colours to produce a wildly marbled 'mizzy-mazzy' surface. Throughout the four northern counties individual rugmakers made up their own decorative designs using a variety of household utensils as patterns for borders, centrepieces, and flowers, while others copied the designs of the factory-made rugs supplied by local furnishers. In Cumbria, however, the rugmakers developed a highly characteristic pictorial style, with accurate yet colourful representations of farm animals, domestic pets or local scenes.

For those who found marking out their rugs a particularly difficult task, shops such as the Co-op began to market pieces of ready-printed hessian from the 1920s. From around the same period companies operating in the major textile areas, including Walter Berry and Sons of Deighton Mills, Huddersfield, supplied fourteen-pound bags of clippings made up from scrap ends of cloth, which were sent out by mail order along with marked-out lengths of hessian and the necessary tools. The designs of the rugs made up from these kits follow those of the manufactured examples of the same period, most having symmetrical arrangements of flowers and foliage for their centrepieces and borders.

The third method of rugmaking, 'lamb-lug', or 'luggy', differed from the first two, in that the cloth was not threaded through the hessian. Instead, it was cut up into two-inch squares, which were then folded so that two adjacent sides could be sewn together to form a hollow conical shape. Having been turned inside-out to conceal their seams, these cones were next sewn down on to the hessian backing in a series of overlapping rows to produce a very attractive effect, almost like an ornamental tile roof reproduced in fabric. This method was largely restricted to Westmorland and the western dales of County Durham.

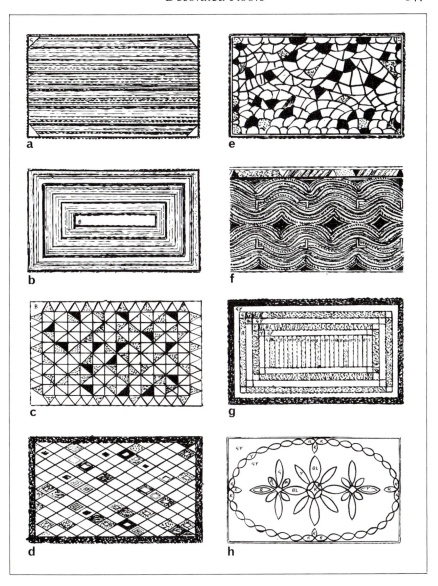

Fig.77. Simple Hooky Rugs

In the simplest designs, each strip or small area was made with a different colour in order to allow random pieces of material to be economically used up: (a) by Mrs Martin of Coxhoe around 1940; (b) by Mrs Ethel Richardson of Ashington around 1960; (c) by Mrs Green of Stanley, County Durham around 1936; (d & e) County Durham; (f) by Mrs Blacklock of Stanhope; (g) by Mrs Wilkinson of Stanley, County Durham, around 1980; and (h) from Dyehouse, Steel, near Hexham. The last rug is particularly fine, hooked with twelve loops to the inch.

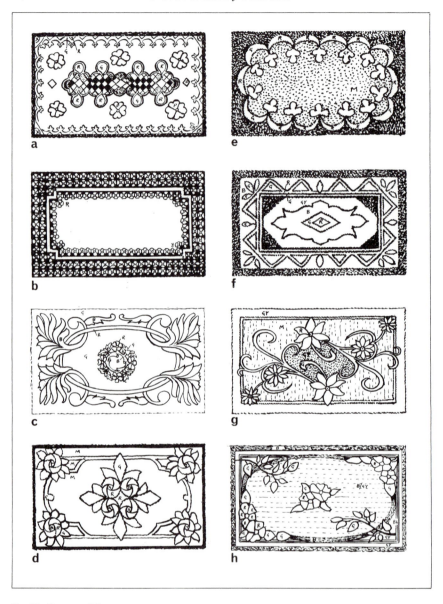

Fig.78. Patterned Rugs
Marked out at home using a variety of simple objects as templates, these rugs were
made (a) by Mrs Platter of High Spen near Blaydon; (b) in the Jarrow area around
1936–7; and (e & f) from County Durham. Lengths of hessian already marked out were
sold through Co-ops and similar outlets. Their designs usually include floral motifs similar
to those of commercially-designed factory-made rugs. These examples were made up: (c) by
Mrs Corker of Greencroft around 1926; (d & g) in County Durham; and (h) in
Sunderland.

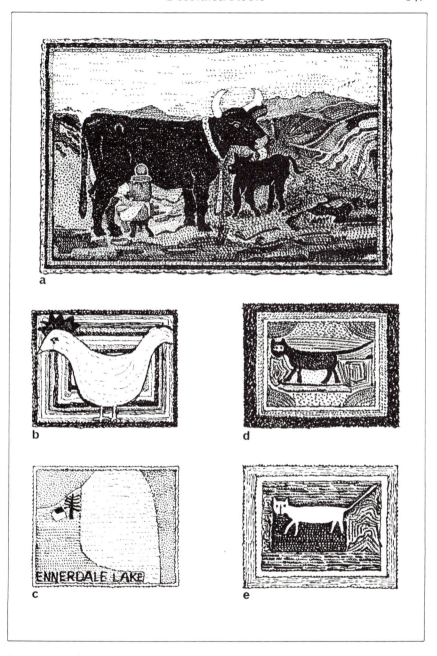

Fig.79. Pictorial Rugs
Cumbria is the main centre for the production of pictorial hooked rugs, as may be seen by
these rugs: (a) in the Museum of Lakeland Life and Industry at Kendal; and (b—e) from
the Cockermouth area.

Fig.80. Lamb-Lug Rugs
In this method two-inch squares of material (a) were folded, (b) sewn, (c) turned inside out and sewn onto the hessian, as in this rug (d) made by Mrs Tom Watson of East Nettleport, Lunedale. The floral hooked rug (e) was made as a wedding present from Mrs C. Parker by Mrs Lattimer of Nenthead in 1904.

From the 1960s the tradition of making rugs for use in the home went into decline as standards of living improved. The introduction of electric washing machines meant that the kitchen/living room did not have the weekly soaking as dripping laundry was transferred from the wash-boiler to the peggy-tub, from the peggy-tub to the blue tub, and across to the mangle. This meant that large squares of carpet or cocoa-matting could now permanently cover the flagged floors. Similarly the introduction of electric vacuum cleaners meant that carpets could be cleaned very quickly and efficiently, especially when compared with the process by which the old rag rugs, often of considerable weight, had to be taken outside and either banged against a wall or placed over a clothes line and soundly beaten, perhaps having rinsed tea-leaves rubbed in with the foot beforehand to loosen the dirt. Now most hearthrugs were bought ready made, unless a particularly deep soft-piled woollen rug was produced from one of the kits of patent hooks, specially woven canvas and bundles of thick colourful yarn, already cut to length, as supplied by 'Readicut' etc. By the 1970s the traditional forms of rugmaking had almost completely died out in many areas, such as industrial Yorkshire and Lancashire, but further north they continued, the floors of some households still being covered with numerous hooked rugs. Now, in the 1980s, they are actually going through a period of revival, and the small pictorial rugs in the Cumbrian tradition now command good prices when sold through craft shops and similar outlets.

10

Quilting

Quilting is a type of needlework in which two layers of cloth separated by a layer of soft padding are sewn together by a series of running stitches, which usually form an ornamental design. It is of great antiquity, evidence from Egypt suggesting that it was already well developed some 3,400 years B.C. In England, however, it has a continuous tradition going back to the thirteenth century, when it was used to produce both quilted bedcoverings and the quilted jackets worn by soldiers either beneath their armour or as protective garments in their own right. One of these jackets, reputedly associated with John of Gaunt, still hangs in the vestry of Rothwell Parish Church near Leeds. Made of strong coarse canvas, firmly padded with three-quarters of an inch of wool and quilted with coarse twine, it is probably the earliest example of quilting to survive in the north.

Up to the end of the eighteenth century fine quilting was considered to be a genteel accomplishment, the wives of the aristocracy and gentry producing bed quilts, petticoats, and sets of baby clothes for Christenings etc., all worked in expensive silks and satins. From around 1800, however, quilted garments rapidly went out of use in fashionable circles, but, as in other aspects of traditional culture ranging from eating habits to dance, the practice of quilting was continued and developed by the ordinary working communities of the region. Up to the years preceding the First World War, for example, quilted petticoats were still worn by women on the farms of the Yorkshire wolds, and by those living in the fishing villages spaced along the east coast from the Scottish border down to Yorkshire. Similarly, the making of bed quilts has continued up to the present day, especially in County Durham and its surrounding areas.

In many parts of the north, and particularly around Allendale and Weardale during the nineteenth and early twentieth centuries, the quilting frame was to be found in most households, where it was used to make the family's bedcovers and, in the earlier periods, their petticoats too. Often it was a solitary occupation, the wife working on her own except for the assistance of her daughters, but communal quilting parties gave the opportunity to speed the work forward in a homely convivial atmosphere. In the 1830s, for example, 'it was an awful sight to the male

Fig.81. 'The Wedding Quilt'
A detail from Ralph Hedley's painting of 1883.

inmates of the house to see the quilting-frame erected on the Monday morning, with many of the gossips in the vicinity set down to their highly important labour. The whole attention of the mistress was given to these lady-stitchers; nothing else was properly attended to as long as this

important labour continued. The best of creature comforts were provided for them; not omitting a drop of the bottle; for as they gave their labour without a fee or reward the choicest fare was expected. Amongst the improvements of our day, the poor man may thank his stars that quilted petticoats are no longer in fashion . . .' Similarly in the hilltop settlement of Almondbury above Huddersfield, the Rev. Easther noted in 1883 that 'when a woman had patched a bed quilt, she invited her neighbours to help quilt it, for which purpose it was stretched with its lining on a long frame and sewn across. Sometimes they drew figures with saucers, oyster shells, etc. In later times tea and cakes were given; formerly a cold posset consisting of new milk, sugar, currants and rum (or beer). When they could get it, the milk was taken warm from the cow and milked fast into the 'piggin' so as to froth it'. In the same year, Ralph Hedley of Newcastle recorded one of these events in his painting 'The Wedding Quilt', in which the women work around a frame stretched between the window sill and the arms of a Windsor chair. By his skilful observation and portrayal of their expressions and attitudes, he gives us a unique insight into the importance of the quilt in North country society of the late nineteenth century.

Communal groups based on chapels, Women's Institutes, etc., would also quilt together, the quilts made in this way then being sold off or raffled to raise money for some particular purpose. In one of its most interesting forms, this activity produced turkey red and white patchwork coverlets on which various individuals would sign their names on payment of a suitable donation, the signatures then being embroidered in contrasting colours to produce a large and permanent record of the fund-raising event.

The process of making a quilt started with the sewing together of lengths of material to form the top, usually one full width for the centre, with a half width on each side. The quilts from the more rural areas might be made of homespun and home-dyed woollen cloth, but the most popular materials included calico, sateens, particularly Roman sateen, taffeta, silks, paisley, cotton twill, and fine poplin. The top was then spread over a large table and marked out with the pattern to be worked in the quilting stitches, a cobbler's awl, a sharp needle, or tailor's chalk being used for this purpose, although the Allendale quilters preferred to stamp out their designs in blue pencil. This process required a high degree of skill, both in geometric and in freehand drawing, but most of the border patterns and rosettes were built up by using specially-made templates cut out of wood, tin, card or celluloid, while plates, saucers, cups or wineglasses would also be pressed into service as convenient templates from time to time. Some quilters would save time

Fig.82. Album Quilts
These centrepieces come from quilts made in Turkey red and white cotton squares embroidered with individual names as a means of fundraising at a Pickering Sunday School in 1888 (above) and at a Lanchester Methodist chapel in 1902 (below).

by drawing a quarter of their design on to a sheet of tracing paper, then pricking it through on to the quilt top.

Once the top had been marked out, it was put into a quilting frame, very similar to those used for making rugs, but over ninety inches wide in

order to accommodate the full width of the quilt. The bottom of the quilt was kept taut by being wound around the back rail of the frame, the top and the padding material being loosely pinned over the back rail so that no distortion occurred between the layers as quilting proceeded. For the same reason, tension across the quilt was maintained by taping its sides around the side-rails of the frame. The edges of the quilt were only finished off after the entire quilting process had been completed.

The quilts made and used in northern England show considerable variation in their style and quality. The very simplest, such as those I remember in everyday use in my grandparents' home, were squares made up of a few layers of old blanket material covered in patchwork formed by piecing together odd-sized rectangles of contrasting cotton prints left over from dressmaking, curtains or cushion-covers. These were very warm and practical in use, but had little to commend them in the way of skill or beauty. In complete contrast, the quilts made for weddings or for best use were magnificent examples of needlework, their elegance and quality reflecting their aristocratic origins. In the 'hammock' pattern of Allendale, for example, we can clearly see the 'swags' of classically inspired eighteenth-century architecture and decorative art.

Most quilt makers acquired their skills from within their own families, mothers passing their own patterns and high standards of needlework on to their daughters. For some two hundred years, however, the craft has benefited from the services of a series of professional quilters who were particularly adept at designing and stamping out quilts for others. One of the earliest of these was Joseph Hedley (c. 1745–1826), better known as 'Joe the Quilter'. Having been apprenticed as a tailor, he made his reputation as 'a man who had attained a greater proficiency in quilting than any ever known in the north of England' from his ability to devise intricate designs delineating flowers, fruit and figures. Stamped out quilts were supplied from his lonely cottage in Homer's Lonnin, near Warden, overlooking the North Tyne, to many northern households, some even being sent across to Ireland and America. Today very few examples of his work can be positively identified, but those which do survive show his use of trail, worm, and fan motifs, together with baskets of flowers and floral centrepieces. It is probable that a number of early patchwork quilts bearing a central square of chintz printed in bright colours with a basket of flowers within a floral wreath were also made by Joe, these squares being specially produced for this purpose between 1800 and 1816.

From the 1880s, George Gardiner began to revolutionise the northern quilting tradition by introducing a completely new range of designs. From his village shop at Mill Cottages, Dirt Pot, Allenheads, he initially

Fig.83. Quilting Patterns

Most of the border and rosette designs used in north-country quilting were marked out using templates cut out of wood, metal, card, or celluloid. Here the shape of the template is shown in solid black: (a) chain; (b) trail; (c) Weardale chain; d) twist; (e) plait; (f) worm; (g) running feather; (h) hammock; (i) double tulip or bell; (j) bellow; (k) square diamond; (l) lozenge diamond; (m) double diamond; (n) wineglass; (o) rose; (p) rose; (q) leaves; (r) pineapple.

Fig.84. Quilt by Joe the Quilter
This quilt was made around 1820 by Joseph Hedley (c.1745–1826) of Homer's Lonnin near Warden in the North Tyne valley. It shows the trail, worm, fan and flower-baskets typical of his work. The lower detail is known as 'Old Joe's chain'.

developed a local reputation for decorating ladies' hats, then moving on to stamping out quilts in his distinctive style, which was widely adopted in Weardale and throughout Northumberland. Their borders usually consist of a series of hammocks terminating in fleur-de-lis or roses, all set against a row of stylised oak leaves, the point of each corner being filled

Fig.85. Quilts by George Gardiner
These quilts both show the distinctive combination of templates and freehand designs introduced by George Gardiner of Allenheads during the last quarter of the nineteenth century. The upper quilt was stamped by him in 1903 and was completed by Mrs Harriet Adamson of Rookhope in Weardale in 1921.

by a rose. Each corner of the central area, together with the centrepiece itself, is composed of feathers, roses, fleur-de-lis, and the delicate running patterns of scrolled tendrils and foliage at which he excelled. This fine tradition was continued by George Gardiner's pupil, Miss Elizabeth Sanderson (1861–1934) of Fawside Green Farm, Allenheads. For her most characteristic designs, she built up the main elements in patchwork and appliqué — usually in pink or turkey red cloth on a white background — then stamping the lines for quilting within the areas defined by each separate colour. Eight-pointed stars or all-over basket patterns were amongst Miss Sanderson's favourite devices, her borders including twists, plaits, Weardale chain, and long scroll patterns enriched with leaves, tendril scrolls and roses reminiscent of those of George Gardiner. Their corners, meanwhile, were filled either with roses, or with areas of square diamonds. Miss Sanderson's designs were so popular that she was able to take on apprentices to help her meet the great demand for her work, these including Mrs Coulthard of Wearhead, Mrs Mallaby of Stockton, and Mrs Peart of Juniper Farm, Allendale. In her turn, Mrs Peart took pupils too, one of whom, Miss Mary Fairless, still marks quilts and cushions in Allendale today.

Towards the close of the nineteenth century the craft of quiltmaking still flourished in most parts of the northern counties, but the twentieth century, and particularly the years following the 1920s, saw it go into a period of rapid decline as mass-produced candlewick bedspreads and eiderdowns became much more popular, and as more housewives began to go out to work rather than spending all their time in the home. In 1928 Mrs Mavis FitzRandolph was commissioned by the Rural Industries Bureaux to explore the possibilities of encouraging quilting in the north-east, as a means of enabling women to bring income into the region during the depths of the depression. This scheme proved most successful, an exhibition in London together with other promotional activities producing a good demand from both private customers and the major retailers in the capital. Classes were organised to train experienced quilters, while through the Women's Institutes Mrs Alice Armes stimulated a much greater interest in quilting. The Second World War produced a shortage of the time, materials and the customers necessary to produce good-quality quilts, but since then, and particularly since the founding of the Quilters' Guild in 1979, there has been a great revival of north country quilting, although it is now seen as a craft in its own right, rather than as a means of producing a warm, utilitarian bedcovering.

Many of the finest northern quilts, including those produced in Allendale described above, were made with plain material, on one or both sides, relying entirely on the design and quality of their needlework

Fig.86. Quilts by Elizabeth Sanderson
These quilts with patchwork and appliqué in red on a white background were stamped by
George Gardiner's pupil Elizabeth Sanderson (1861–1934), the star and the basket designs
being amongst her favourites.

for the effect. They usually have an elaborate centrepiece, corners, and a
series of borders around their perimeter, the remainder being infilled
with a diamond or a wineglass pattern. Other quilts have their tops made
up of long, broad strips of cloth of contrasting colours sewn together to

give a 'strippy' effect, plain turkey red, blue or green alternating with white being the most common, although floral or striped prints or even patchwork strips could be included. Usually the reverse was quite plain. For these quilts the quilting frequently took the form of running border patterns occupying the full width of each strip. Striped quilts were also made in the Isle of Man, but here the colours were quite different, dark blue, red, black and green strips being quilted with an all-over diamond pattern.

Patchwork either on its own as a coverlet, or padded and backed to form a quilt, appears to have achieved popularity in England towards the end of the seventeenth century as a means of using up spare pieces of brightly coloured and finely printed imported calico. It was at Levens Hall near Kendal that the earliest known patchwork quilt in England was made from this material around 1708, but the majority of those surviving today are of nineteenth-century date, their patches being made of popular floral designs, spot prints and chintzes left over at the end of dressmaking etc. Their patterns are many and varied, but they may be broadly divided into three main groups. For all-over designs, geometric shapes such as squares, stars, hexagons, or diamonds which would readily tesselate enabled a great number of vivid and lively patterns to be produced, including the 'tumbling boxes' where series of light, medium and dark-toned diamonds gave a striking three-dimensional effect. Alternatively series of patches of all manner of irregular shapes and sizes could be sewn together to make crazy patchwork. In the late Victorian period these were frequently made of rich silks, velvets and satins, their seams being oversewn with herringbone or similar decorative stitches. Medallion quilts had a central motif surrounded by a series of concentric frames or borders, and these were particularly popular in the region during the early nineteenth century.

Designs based on pieced blocks were made by building up series of identical squares in patchwork, which were then sewn together to make the top of the quilt in the American manner. It is probable that the pattern for these quilts originated in the north of England, before being carried across the Atlantic.

In addition, a particularly fine group of patchwork and appliqué quilts was made in the Pennine hills of Westmorland and County Durham from the mid-nineteenth through to the early twentieth centuries. Its chief characteristic was the use of startlingly bold turkey red motifs on a white background, some examples also incorporating foliage and decorative motifs in green. Occasionally their quilting follows the shape of the appliqué panels, in others it has a simple over-all pattern, whilst the finest have the ornate quilting usually found on plain quilts.

Fig.87. Wedding Quilt
The wedding quilt shown here was made about 1825 at Walbottle, Northumberland, probably by Annie Heslop, its diagonal squares corresponding to the patchwork chintz of its top. Lovers' knots formed the traditional centrepiece of wedding quilts, the details here coming from this quilt (left) and from one made in West Cornforth about 1870 (right).

It is clearly beyond the scope of this chapter to give anything more than the very briefest introduction to the rich quilting tradition of this region or to describe its techniques, designs and development in the full detail it deserves, but fortunately this has already been undertaken by writers

Fig.88. Quilt by Mrs Stewart
This quilt in cream sateen within a printed border of gold, blue and green floral sprays was
made about 1910 by Mrs Stewart, a widow who made her living by quilting and by running
quilting clubs in the village of Bowburn, County Durham.

such as Averil Colby in her books on *Patchwork* of 1958, on *Patchwork
Quilts* of 1965, and on *Quilting* of 1972. Mrs M. FitzRandolph's
Traditional Quilting of 1953 is still the standard work on this subject,
while Rosemary Allan's *North Country Quilts and Coverlets* of 1987,
with its excellent range of colour plates and full catalogue of the Beamish

collection, the finest in the British Isles, is essential reading for anyone interested in the quilts of this region. For quilting in the Isle of Man, meanwhile, Miss L. S. Garrad has published the definitive article in *Folklife* XVII (1979).

Fig.89. Strip Quilt
Made by Mrs Phillipson of Rispby in Weardale some time before 1855. It is made of alternate strips of pink floral and plain blue material which correspond to the quilted design.

Fig.90. All-over Designs
Some of the most effective and interesting patchwork designs were based on arrangements of numerous small identical units, the examples here including: (a) square patches; (b) tumbling boxes; (c) Irish chain; (d) hexagonal patches; (e) crazy patchwork; (f) small diamond patches.

Fig.91. Appliqué Strip Quilt
The top of this quilt has a bold appliqué design in Turkey red on white. It was made by Mrs
Goldsborough of Pelton for the wedding of Isabella Levitt in 1895.

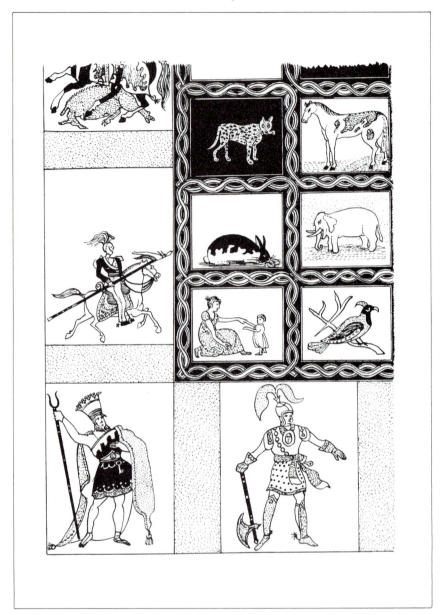

Fig.92. *Appliqué Panel*
This panel, collected in the Leeds area, bears the arms of the Merchant Tailors' Company,
and was probably made by a local tailor around 1850. Its numerous panels, only a few of
which are shown here, feature soldiers, sailors, dramatic characters copied from theatrical
tinsel pictures, and animals based on the illustrations from Bewick's *Quadrupeds* or similar
early nineteenth-century illustrated books.

11

Albums

From the end of the medieval period literacy has slowly progressed down the social scale, the old-established grammar schools, the church schools, the National and Lancasterian schools, the mill schools and eventually the local authority board schools, each in turn expanding the number of people who could read and write. Since writing provided positive evidence of academic achievement, it came to be recognised as an art-form in its own right, the quality of its calligraphy becoming almost as important as the information it conveyed. During the seventeenth and eighteenth centuries the highest standards were achieved by professional writing masters and their pupils, their elegant scripts being embellished with florid decoration to clearly demonstrate the superiority of their penmanship. Perhaps the finest example of this type of work to have survived from northern England is a small album in the collections of York Castle Museum. As its title page states, it was completed by one William Lamb in 1722. The bottom of the page contains a further inscription in code, together with the key:

A	E	I	O	U		L	M	N	R
1	2	3	4	5		6	7	8	9

Using this, the following translation is revealed:

W 3 6 6 3 1 7	6 1 7 b	3 t	3 s	7 y	8 1 7 2
W I L L I A M	L A M B	I T	I S	M Y	N A M E

1 8 d	2 8 g 6 1 8 d	3 s	7 y	8 1 t 3 4 8
A N D	E N G L A N D	I S	M Y	N A T I O N

S c 1 W t h 4 9 p 3 s 7 y d w 2 6 6 3 8 g p 6 1 c 2
S C A W T H O R P I S M Y D W E L L I N G P L A C E

1 s d	c h 9 3 s t	3 s	7 y	s 1 6 5 1 t 3 4 8. 1 7 2 2
A N D	C H R I S T	I S	M Y	S A L V A T I O N. 1 7 2 2

Thus we learn that it was written in the village of Scawthorp, two miles north-west of Doncaster in South Yorkshire. Each of the succeeding pages bears a moralising verse prefaced by a large capital letter in gothic script, progressing through the alphabet from A to Z. These are richly illuminated in black and red inks, with flowing scrolls, tendrils, flowers and foliage, all spangled with geometric motifs and small birds, being converted into human faces, while more faces can be found amid the swirling penwork. The upper margins, meanwhile, bear full alphabets of Italic capitals, above which run borders of freely-drawn calligraphic birds and hounds. The strong, robust and lively character of William Lamb's work appears to be quite exceptional, and, were it not for its sound provenance, its style alone would suggest that it originated in central Europe rather than the north of England.

During the eighteenth and nineteenth centuries great improvements in papermaking and printing technology enabled books to come into much more widespread use throughout society. Now the elaborate freehand capitals which had decorated earlier texts were largely replaced by penwork imitations of printers' typefaces, the Egyptian and Bodoni fonts being particularly popular. This is clearly seen in the volume of Manx carvels composed and written by John Kelly of Ballaquine, Braddan, between 1839 and 1846.[1] The library of the Manx Museum houses a number of similar manuscript carvel books, containing the carvels or carols in English and Manx verse composed for the traditional service of Oie Vie held in the churches each Christmas Eve, but his is unusual in the quality of its lettering and illumination. Each verse is neatly written with its title and capital letters either textured with penwork dots or painted in a variety of colours. The most interesting pages are fully occupied by drawings in ink and watercolour, including one of the Baldwin preaching house, where the service was to be held, and others showing a fashionably dressed couple. Beneath them an inscription in code mischievously gives no clue as to their identification when the key

A	E	I	O	U	Y	T		N
1	2	3	4	5	6	7		0

is used:

```
3 ' m   1 4 7   7 4   7 2 L L   6 4 5   2 H 4   7 H 2 6   1 0 2
I ' M   N O T   T O   T E L L   Y O U   W H O   T H E Y   A R E

J 4 H O   K 2 L L 6
J O H N    K E L L Y
```

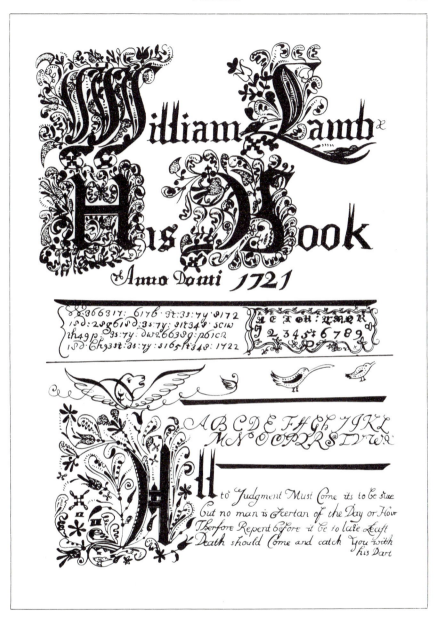

Figs. 93 – 5. William Lamb: His Book
Between 1721 and 1722 William Lamb of Scawthorp near Doncaster completed the illumination of a book composed of twenty-seven pages of paper, measuring around 7½ x 6¾ inches. After the title page, with its coded message, he proceeded with a series of philosophical verses, each starting with every letter of the alphabet from A to Z in order to give ample opportunity for the display of his inventive calligraphic skill.

From this period, many people began to collect examples of the handwriting, illuminated and ornamental lettering, drawings and paintings of their friends and relations. To do this they purchased specially-bound albums, the pages frequently being of different colours or qualities of paper, so that the writers could choose the most suitable backgrounds for their work. Within the cover, the owner might write an appropriate inscription, such as the following, from Amy Woodrow's album of 1897:[2]

This is my album
But learn ere you look
That all are expected
To add to this book

You are welcome to quiz it
 The penalty is
You must put something in it
 For others to quiz.

Figs.96 — 7. John Kelly's Carvel Book
These pages come from a book of carvels, or Manx carols, composed between 1839 and 1846 by John Kelly of Ballaquine. They show his use of coded inscriptions, and the style of his lettering, based on contemporary printed sources.

If the owner was a member of a particular group or society, one of the first pages might be decorated with a design incorporating a number of panels in which the names and addresses of all those concerned could be entered. From there on, each contributor was responsible for making his or her own choice of entry. It might be an extract from a poem, a play or the Bible written in elegant copperplate, either neatly composed down the centre of a plain page, or surrounded by an elaborate cartouche.

Fig.98. Album Drawings

As these examples show, the later Victorian albums could include a wealth of humorous detail regarding fashions and social attitudes of the period, in contrast to the more serious material of earlier generations.

Alternatively a simple motto or sentiment could be written in an ornate script, ranging from Gothic to some of the spiky and enscrolled styles popular at this time. If the contributor had the necessary skills, drawings and paintings would be included too, views of local buildings, landscapes and flowers forming the bulk of these popular subjects. Most examples demonstrate a great degree of care and thought in their execution, but from the 1890s through to their decline in the years leading up to the Second World War, there was an increasing tendency to include far more humorous and much less competent material. A crude drawing of a loaf of bread might be inscribed

> The grub which makes the butter-fly,

for example, while

> Music hath Charms
> so do Beecham's Pills

After the war, autograph albums were continued for a short period, but, since handwriting was now commonplace, the entries were restricted to a basic signature, the beautiful calligraphy of earlier years usually being superseded by a careless, scarcely legible scrawl.

12

Garlands

The custom of making garlands of flowers and greenery to carry from house to house or to exhibit in the church is one of the most widespread and long established of all English traditions, being associated with events as disparate as Christmas celebrations and funeral processions.

May Garlands

As long ago as the fourteenth century Chaucer described the practice of going out at dawn on May Day to collect branches and 'blome' to make decorations, while in 1596 the inhabitants of Cawthorne near Barnsley were censured by the ecclesiastical authorities for taking 'towers and garlandes and other formes of thinges covered with flowers' into their parish church.[1] The church tried to suppress May Day celebrations throughout much of the sixteenth and seventeenth centuries, considering them profane, lewd and drunken affairs, but from the Restoration in 1660, they experienced a popular revival. As Oliver Heywood noted in his diary for 1667, in Manchester 'they have a foolish custom after twelve a clock to rise and ramble abroad, making garlands, strew flowers etc. which they call "bringing in the May". I could sleep little that night by reason of the tumult, the day after being May the first'.[2] In his native Halifax in 1680, he found May Day being celebrated by three groups, each of sixty or more 'men, women and big youths; they had all white wastcoats or sheets about them, with huge great garlands, flowers, branches of trees' which they paraded around the town with drums, pipes, fiddles and banners bearing red crosses as they collected money to be spent largely on alcoholic entertainment. Over the succeeding years, these customs gradually fell out of use, and by the late eighteenth century most of the towns and villages which still retained their maypoles did so out of a sense of local pride, for their real function as the centrepiece of the May day dancing and festivities had already disappeared. Within this region, the only survival of the May garland is at the triennial raising of England's tallest maypole at Barwick-in-Elmet near Leeds. Here the garlands, beehive-shaped arrangements of flowers from which hang

numerous rumbler bells suspended from coloured ribbons, are shown around the village and the surrounding countryside during the evenings in the week before Whitsuntide. They are then taken to the centre of the village and fastened on to brackets on the newly painted pole as it is raised into position at 6 o'clock on the following Whit Tuesday evening.

Rushbearing Garlands

'Manie in the countrie doe use sedge and rushes in the summer time to strew their parlours and churches, as well for coolness as for pleasant smell' quotes the *Herball to the Bible* of 1587. For centuries the earthen floors of houses and churches throughout England had been provided with this fragrant covering, cool and moist in summer, but warm and dry by winter-time. Usually the churchwardens were responsible for arranging the collection or purchase of the rushes sometime in late summer, when the field rushes or bulrushes were in their prime. The rushes were then carried to the church in a communal event which acquired the status of an annual ceremony held, where possible, in association with the feast-day of the patron saint of the parish. By an Act of Convocation of 1536, the dedication feast of every church was ordered to be celebrated on the same day, the first Sunday in October, thus reflecting Henry VIII's control of the church in every parish, in addition to ensuring that the feasts did not interrupt the all-important harvest. In 1618, however, James I proclaimed that women could now continue their ancient custom of carrying rushes to church, and since that time the rushbearings have usually taken place on the Saturday prior to the feast day, although this arrangement has been subject to considerable variation to suit local circumstances.

From being strictly utilitarian in origin, rushbearings now became one of the greatest communal festivities of the year, combining elements of the traditional church feast with those of the declining May day. Thus the garlands and maypole dancing — which had vanished from the May day celebrations, re-appeared later in the year as part of the rushbearing.

In the towns and villages of south-east Lancashire, western Yorkshire, and the adjacent areas of Cheshire and Derbyshire, the rushes were built up into a tall stack on the back of a cart to form the centrepiece of their rushbearing procession. This tradition had already become established by the early 1700s and flourished through to the mid-nineteenth century, then going into a rapid decline, becoming virtually extinct by 1900 except for intermittent revivals. The different designs of the rushcarts, their construction, decoration and attendant customs have all been

Fig.99. The Rochdale Rushcart
Here, following the reconstruction in Alfred Burton's volume on *Rushbearing*, is the
Rochdale rushcart of 1824. It was entirely constructed of bundles of freshly cut soft field
rushes.

described in a number of publications, but the following account of the Rochdale rushcart of 1824 is particularly informative:

> The rushes are laid transversely on the rushcart, and are cut with sharp knives to the form desired, in which no little art is required. The bolts, as they are termed, are formed of the largest rushes, tied up in bundles of about two inches in diameter. These bolts are, as the work of making proceeds, affixed to rods fixed in the four corners of the cart, and curved to the form required. When the cart is finished, the load of rushes is decorated with carnations and other flowers, in different devices, and surmounted by branches of oak, and a person rides upon the top. The carts are sometimes drawn by horses gaily caparisoned, but more frequently by young men, to the number of twenty or thirty couple, profusely decorated with ribands, tinsel, etc. They are generally preceded by men with horse bells about them, grotesquely jumping from side to side, and jingling the bells. Often there is a band of music, and sometimes a set of morris dancers . . . followed by young women bearing garlands; then comes the banner made of silk of various colours, joined by narrow ribbons fretted, the whole profusely covered on both sides with roses, stars, etc. of tinsel. The banners are generally from four to five yards broad and six to eight yards long, having on either side a painting of Britannia, the king's arms, or some other device . . . On the front of some carts is a white cloth, to which is attached a number of silver spoons, tankards, cups and watches tastefully displayed.

Bamford, the Lancashire poet, also described the piece of white linen mounted on the front of the rushcart, decorated with pretty rosettes and quaint compartments and borderings of all colours and hues which either paper, tinsel, ribbons, or natural flowers could supply. In these compartments were arranged silver watches, trays, spoons, sugar-tongs, tea-pots, quart tankards, drinking cups, or other articles of ornament and value, all loaned for the occasion by members of the community.

The garlands, which formed a major element in these rushcart processions, were extremely large and elaborate constructions, and normally belonged to the parish, hanging up in the church from one year to the next. Just before each rushbearing, they were stripped down and newly decorated, the one at Newton Heath having 'above a thousand bows netted in it, un' th' crown o'th 'top made out of butterflee's wings and peacock feathers, un' carried by th' warden o' th' parish, un' hung up i' th' chapel . . .'. Further details of these garlands appear in contemporary paintings of rushbearings such as Alexander Wright's *Rural Sport* of 1821, Joseph Parry's *Eccles Wakes: Racing for the Smock* of 1808 and *Eccles Wake* of 1822, or the anonymous *Lymm Rushbearing* of around 1850. The large parish garlands tended to disappear once the churches stopped strewing rushes across their floors, but smaller garlands continued to be made by people who took them round the streets in order to raise money. In Oldham in 1864 garlands of this type, made from two intersecting hoops mounted on a tall pole and decorated with fruit,

coloured paper and flowers, stood at almost every street corner, while those in Rochdale were said to have been garnished with fruit and flowers stolen from local gardens.

In other parts of the North the rushes continued to be formed into bundles variously known as 'burdens', 'burthens', or 'bearings' and carried into the church by women and girls. At Warton, near Carnforth in northern Lancashire, they cut the hard rushes from the marsh, and made them up into long bundles dressed in fine linen, silk ribbons, cut paper and flowers etc. before carrying them erect in the procession, the churchwarden's burden taking precedence. Once inside the church, the burdens were stripped of their ornaments except for their richly decorated heads or crowns which were left intact, generally over the chancel area. This was around 1820, when many communities still celebrated the rushbearing. Over the next half-century, however, the social changes brought about by increasing industrialisation, the rowdiness often associated with these events, the improved paving in churches, which did away with the need for rushes, and new railways which provided feast or wakes-week excursions to the seaside, all combined to bring rushbearings to an end except in two Westmorland villages, where they still continue today.

The construction of the rushbearing garlands used at Ambleside is beautifully illustrated in T. Allom's view of the ceremony published in 1832. He shows the long procession of women in fashionable bonnets and tight-waisted dresses and carrying a large spherical garland mounted on top of a long pole, the leading garland being particularly impressive, measuring perhaps four feet in diameter and covered with elaborate arrangements of paper swags and rosettes. Recalling the ceremonies about this time, Hannah and Margaret Nicholson stated that 'the burthens were devices of every imaginable shape made by the carpenters for the great ladies and by the skilful-handed ones at home during the winter months, covered with coloured papers and coloured flowers . . . Yards of tissue paper must have been used. Aye, we know about that, for we had to lay in a stock of blue and pink and yellow; and Mr Harrison of Scale How allowed us ten shillings to give away to the poor folk in sheets of tissue each year and we used to cut it into frills for them for the making of rosettes and flowers'. On the Sunday nearest St. Anne's day, July 26th, at six in the evening, the rushbearing procession formed up at the market cross and then, led by a fiddler, walked around the village and up the hill to the old chapel, where the burdens were put in the corners of the box pews. On returning to the cross, the carriers then received their reward of gingerbread, paid for by a subscription raised among the ladies. In the earlier years the owners collected their burdens from the church on the

Fig.100. Rushbearing Garlands
The smock displayed on the garland of pink and white roses was raced for by women attending the Eccles Wake of 1822. Here the rushcart (top) was gabled, its front being divided up into panels by rose garlands, items of silverware loaned for the occasion being tied on with blue and pink ribbons. The two lower garlands appeared in the Manchester rushbearing of 1821.

Fig.101. Rushbearing Garlands
The huge globular garland on the left was carried at the Ambleside rushbearing of 1832,
the remainder appearing at the Lymm rushbearing around 1850.

following Sunday afternoon, but around 1830, when this procedure was found to be rather unseemly for the Sabbath, they were not permitted to be removed until the Monday, when they were carried home and presumably stripped down until required the following year. As the nineteenth century progressed, the large spherical garlands gradually fell out of use, their place being taken by a variety of smaller examples which incorporated obvious Christian symbolism, such as crosses and harps of David, together with sprays of rushes and wreaths, all decorated with colourful flowers, together with tall spires of rushes bound around long poles. These are still made today, being carried in procession around the town at the rushbearing ceremony held on a Saturday in July, being raised on high after the singing of the Ambleside Rushbearers' Hymn in the market place, and then carried into the parish church where a short service is held and gingerbread distributed to the children. On the following Sunday further services are held, the ceremony concluding on the Monday with tea and sports for the children.

Ambleside's mother church, St. Oswald's, Grasmere, has the longest recorded rushbearing tradition in the Lake District, the churchwarden's accounts for 1680 noting the payment of a shilling (5p) 'for Ale bestowed on those who brought rushes and repaired the Church'. The earliest description of the actual ceremony dates from 1789 when a visitor found women and girls carrying rushes to the church, all having nosegays, except their Queen who carried a large garland. Once inside the church, this was placed on the pulpit, while the rushes were strewn across the bottoms of the pews, after which the party was led off by a fiddler to a public house for an evening 'spent in all kinds of rustic merriment'. When Benjamin Newton entered the church on July 24th 1818, he was shocked to find 'every part of the church crammed with all sorts of tawdry and ridiculous things stuck upon sticks, hoops and crosses covered with coloured papers, red, green and yellow, flowers of all sorts, roses, sweet williams, straw, etc. and made to stand upright'. However, the rector then explained how the boys and girls in the parish had brought in fresh rushes, and carrying 'a garland made after their own fancies, which they deposited in the church, fixing them up as and where they pleased, after which they were regaled, at the expense of the parish, with cakes and ale and gingerbread, and had a dance in the evening in the barn belonging to the inn'.

Descriptions of the 1860s include bearings made in the form of wreaths, triangles, shields, verses and mottos, while by the 1880s there were rush baskets full of carnations, or roses, shepherds' crooks, spires of reeds decorated with water-lilies and entwined by a snake of moss, harps and lyres made on moss-covered wooden frames all entwined with roses and

Fig.102. Rush Burdens
These rush burdens, seen in Gordon Ransom's fine mural in Ambleside parish church, were all carried at their rushbearing of 1944.

strung with reeds, shields of moss emblazoned with red crosses of geranium, stars of yellow pansies with red geranium centres, rush cradles for wax-doll 'Moses in the Bulrushes', together with crosses of rush swathed in roses, verbenas, geraniums, maidenhair fern and lilium auratum, or other examples of the beautiful garden flowers now being introduced into the Lakes by the owners of its new mansions and *cottages ornées*. In 1885 a Festival of Dedication was re-introduced and the date of the rushbearing changed from the Saturday nearest to July 20th to the ecclesiastically more acceptable date of the first Saturday after August 5th, the feast of the patron saint.

Further 'refinements' followed soon after, the processions from 1889 onwards featuring a richly embroidered banner showing St. Oswald, while in 1891 the Queen, who had not appeared in the procession for a couple of generations, was prominently restored, now being attended by two pages and four maids of honour from the village school 'bearing the sheet which had been decorated for the occasion with stag-horn moss and heather and contained within it a handful of rushes in imitation [it was claimed] of the old days. This sheet, it may be mentioned, has been spun in Grasmere by the nimble fingers of one well known for her industry, it was woven in Keswick, and we hope it may form a leading feature in the Rushbearing for many years to come'. Two years later the number of girls was increased to six, each of these 'rushmaidens' wearing a green smocked dress over a white blouse, a chaplet of wild flowers around her head, and a spray of rushes in her hand. The appearance of the sheet at this time was probably intended to help the local handspun linen industry which Albert Fleming and Marion Twelves had revived in the parish in 1884, with the full support of John Ruskin and the local clergy. It was about this time too that a 'maypole' appeared, this being a garland of two hoops mounted on a pole, from the top of which hung six or eight ribbons carried by a circle of infants as part of the procession.

Visitors who make their way to Grasmere rushbearing today will find that the range of garlands or bearings has changed little over the past century. Made by the ladies of the parish, the major bearings are of wood bound with rushes. They comprise:

1. a processional cross made of golden yellow helenium flowers mounted on a rush-bound pole.

2. & 3. rush-bound poles topped with spear-heads, laurel wreaths, white ribbons, and panels inscribed respectively 'LEVAVI OCULOS' ('I lifted up mine eyes', Psalm 121) and 'CANTATE DOMINO' ('O sing to the Lord', Psalm 98).

Fig.103. Rush Bearings
Drawn at the Grasmere rushbearing of 1987, these bearings represent: (a) the processional cross of golden yellow flowers; (b & c) rush-bound spears bearing the inscription 'CANTATE DOMINO' and 'LEVAVI OCULOS'; (d) the hand of St. Oswald; (e) 'PEACE'; (f) Hope . . . and (g) the Creed.

4. the hand of St. Oswald within a circle mounted on a pole from which hangs a purple ribbon embroidered in yellow with St. Aidan's commendation 'MAY THIS HAND NEVER PERISH'.

5. a triangular panel pierced with the fretwork inscription, 'PATER EST/FILIUS EST/ SPIRITUS SANCTUS EST/DEO' from the creed, mounted in a rush-bound frame.

6. 'ST. OSWALD A.D. 642' in rush-bound lettering within a wooden frame, recording the date of the martyr's death at the hands of the heathen Penda, King of Mercia.

7. the maypole.

8. the serpent, spiralling around a central shaft, all being rush-bound and embellished with red bead eyes and a red cloth tongue.

9. 'PEACE' in rush-bound lettering, with 'RULES A LAND EVER GREEN' embroidered in yellow on blue, all within a rush-bound wooden frame.

In addition, there are smaller bearings representing the cross, lyres, the Prince of Wales' feathers, St. Oswald's crown, Moses in the bulrushes, and circles for eternity, while further sprays of rushes are carried by the rushmaidens, choir and clergy, as well as being bound around the churchwardens' staves. The children of Grasmere still make their own bearings too, for which they receive the traditional reward of a gingerbread with the stamp of St. Oswald and a 5p piece, while proud parents convert push-chairs into marvellously colourful bearings, by binding their frames with rushes and bright floral decorations. Even though the Grasmere rushbearing includes many predominantly late Victorian features, it is still the best place in England to see garlands continuing to fulfil their traditional role, and to experience the piquant sight and scent of fresh rushes strewn across the floor of a medieval parish church.[3]

The Wassail Bough

In West Yorkshire in the week before New Year's Day, or on New Year's Eve alone, groups of girls could be seen walking around the streets carrying large spherical devices concealed beneath a large cloth, cloak or case. These were the wassailers, who made their presence known to potential patrons by singing the carol 'Here we come a wassailing, among the leaves so green', the melody and text of which were first recorded by Martin Shaw, the composer and folksong arranger, who learned the carol as a boy from his father who had often heard it in the streets of Leeds in the 1850s. After attracting attention, the cloak or case was pulled back to

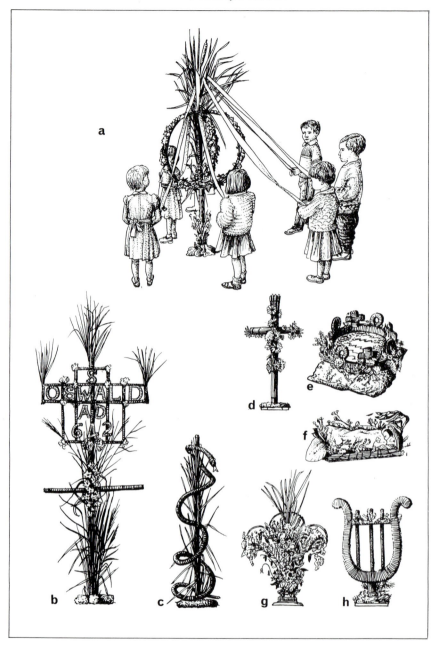

Fig.104. Rush Bearings
These Grasmere rush bearings of 1987 include: (a) the maypole; (b) St. Oswald; (c) the serpent; (d) the cross; (e) St Oswald's crown on its cushion; (f) Moses in the bulrushes; (g) the Prince of Wales' Feathers; and (h) a lyre.

show the wassail bough or wassail-bob itself. In its simplest form, this was a branch of hawthorn, yew, or holly, but more commonly it was made of two wooden hoops, perhaps salvaged from butter-barrels, each carefully wound in red and green crêpe paper, cut with fringed edges before being crossed together to form an almost spherical framework. The boughs were then ornamented with coloured papers, ribbons, tinsels, mistletoe, apples and oranges. At the centre of the bough a beautifully dressed doll represented either Joseph or the Virgin Mary, although this might be replaced with a small fir-tree, or even the figure of Father Christmas. The girls usually had their efforts rewarded with a few coins, or, if at a house door, with spice-cake and cheese too.

In addition to being used in the streets, the wassail-bob might decorate the interior of the house, hanging from the centre of the kitchen ceiling. Here it could serve as a festive chandelier, being lit up with coloured candles, or it could hold small presents for the children. These might take the form of tiny boxes filled with sweets, spice mice, or sugar pigs. Alternatively it could be hung with a series of narrow ribbons, each having a numbered gift tied to one end. Each child would dip into a box for a numbered ticket, then receiving the corresponding gift.

As an alternative to the wassail-bough, the girls or old women of Yorkshire and County Durham could carry a 'vessel-cup' or 'milly-box', the latter being derived from 'My Lady's box'. In the East Riding, the singers started their progress around the villages at Martinmas or the end of November, although the three weeks before Christmas were more usual in other parts of the north. They announced their coming with the strains of the old carols 'Here we come a-wassailing' or 'God rest ye merry Christians', and then, having received a suitable donation, lifted the lid of their basket or box to reveal a number of wooden, waxen, or pottery dolls. If there was only one doll, it represented the infant Jesus, if there were two, they represented Jesus and the Virgin Mary, while a third doll, which was only rarely used, represented Joseph. Around them, a bed of evergreens such as laurel or box was enriched with oranges, red apples, ribbons, gingerbreads, sugar sweets, or tin or blown-glass Christmas tree decorations. In the central West Riding in the 1890s, these boxes were seen to be replacements for the wassail-bough. 'The decorated holly-bush has degenerated into a herring-box', wrote J. H. Turner, while a contributor to *Notes and Queries* found that fancy soap boxes were being used for this purpose in Wakefield. A lady who lived in Stanley Road, Wakefield, around 1930 has told me of the visit of wassailers to her home at 11 o'clock each Christmas morning. The children carried a cardboard shoebox, complete with a lid, inside which was a small doll arranged on a bed of cotton-wool and surrounded by a number of

Fig.105. Wassail Boughs
This bow or 'Wesley Bob' from Midgley in Calderdale was made by intersecting two wooden hoops and then wrapping them with fringes cut from strips of coloured tissue paper. In Leeds in 1881 these girls carried their bough from door to door at Christmastime singing the local carol 'Here we come a-wassailing' and pulling back its outer cover in return for a small gift.

Fig.106. Wassail Bough
This bough, made in 1986 by Mr Arthur Wreay whose family originate in Teesdale, has its
loops of willow entwined with ivy and evergreens, and is further decorated with red apples
and sprays of holly and mistletoe.

'Wesley-bobs' as glass Christmas tree decorations had now come to be known in this strongly Methodist area. On lifting the lid of the shoebox to display their handywork, the children were given an apple, an orange, or a few pence, before they proceeded on to the next house. As recently as the 1940s Miss Dora Palmer of Whitby carried her vessel-cup down the Yorkshire coastline from Skinningrove to Robin Hood's Bay every Christmas, but from this time the custom rapidly fell out of use.[4]

The Wren Boys

In the Isle of Man, garlands were used in the customary hunting of the wren which took place on St. Stephen's Day, December 26th, up to the opening decades of the present century. According to local tradition, a beautiful fairy had seduced so many of the island's menfolk into the sea that its defence was in peril. An attempt to destroy the fairy failed when she escaped by taking the form of a wren, a form in which she was forced to reappear each year until killed by human hand. Thus the wren was hunted for two or three days before St. Stephen's Day by groups of youths who scoured the country armed with long sticks and antiquated guns, beating the hedges and chasing the unfortunate bird from bush to bush until it was killed. Then, on St. Stephen's morning, it was placed in the middle of a bush of evergreens decorated with gay streamers, and stuck on a long pole, and carried from house to house, where the 'Hunt the Wren' song was sung, and one of the feathers exchanged for a gift of money. There were variations in the manner in which the bush for the wren was constructed. In the south of the island a large stick like a broom handle had holes bored along one side into which pliable osiers or canes were inserted to form semi-circular bows. To these were sewn numerous long ribbons of various colours, begged and borrowed from far and near. The wren was then hung within a bunch of evergreens crowning the top of the outermost semi-circle, and the whole device was carried horizontally by two people. In the north of the island, only evergreens were used to decorate the bough.

By noon, the wren was almost naked, for the feathers were believed to ward off both witchcraft and shipwreck, and in this condition it was ceremonially buried either in a churchyard or one of the long-deserted keeill or chapel sites, a funeral dirge in Manx being sung over the grave.[5]

Fig.107. The Wren Boys
Here, on St Stephen's morning, 1904, a group of boys stand before a front door in Ramsey on the Isle of Man. In their hands they carry a garland of evergreens and ribbons holding a dead wren, one feather of which they will exchange for a small gift, thus ensuring good luck for the household throughout the coming year.

Maidens' Garlands

'Many of the Churches in the Deanery of Craven are adorned with these garlands, which were made of flowers, or of variegated coloured paper, fastened to small sticks, crossing each other at the top, and fixed at the bottom by a similar hoop, which was also covered with paper. From the top were suspended two papers, cut in the form of gloves, on which the name and age of the deceased Virgin were written. One of these votive garlands was solemnly borne before the corpse by two girls, who placed it on the coffin in the Church during the service. Thence it was conveyed in the same manner to the grave, and afterwards was carefully deposited on the skreen dividing the quoir from the nave, either as an emblem of virgin purity, or of the frailty and uncertainty of human life.' This extract from the 1828 *Dialect of Craven* gives all the essential details of the maiden's garland or virgin's crown as it was constructed and used in many parts of England from the sixteenth century at least.[6]

The earlier garlands were decorated with real flowers, such as those gathered by the crazed Ophelia in Shakespeare's *Hamlet*:

> . . . crow – flowers, nettles, daisies . . .
> There, on the bough her coronet weeds
> Clambering to hang, an envious sliver broke,
> When down her weedy trophies and herself
> Fell in the weeping brook.

Recalling the same practice, an old woman was heard to sing the following lines in Durham in 1859:

> When I am dead, before I be buried,
> Hearken ye maidens fair, this must ye do –
> Make me a garland of marjoram and lemon thyme,
> Mixed with pansy, rosemary, and rue.

The use of rosemary for remembrance, and rue, that 'preserver of chastity and preventor of lewd thoughts', would certainly be most appropriate for this purpose.

The Priest's Room up above the north chancel aisle of St. Mary's church, Beverley, houses this country's oldest maiden's garland. Made for the funeral of Elizabeth Ellinor in August, 1680, it takes the form of an open beehive-shaped framework of bent wooden strips, nailed together and provided with a stout iron staple at the top for suspension. The outer faces of the frame are decorated with floral motifs in green and red paintwork, while an inscription in black lettering around the bottom

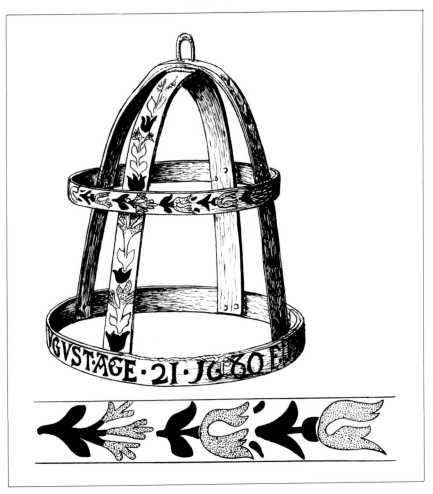

Fig.108. Maiden's Garland
Made of strips of bent wood, this frame from St Mary's church, Beverley, is the oldest
maiden's garland to have survived in England. Its painted decoration includes red flowers
with green foliage and the inscription 'ELIZABETH ELLINOR DIED YE 14 OF AUGUST,
AGE 21. 1680'.

hoop records the name, age, and date of death of the deceased. There is
no evidence of any further decoration, but presumably it was wreathed
in flowers and greenery for the funeral procession, and then stripped to
its present form when hung up in the church.

During the early nineteenth century travellers touring this region
found maidens' garlands hanging in churches in Linton in Cumberland,
in Hartlepool, Stanhope and Wolsingham in County Durham, and at

Fig.109. Maiden's Garland
Made for the funeral of Janey Levitt at Fylingdales Church in 1859, this is the finest of all
the north-country maidens' garlands. Its bows wound with strips of calico (a) are decorated
with a rosette (b), small bows made of ruched ribbon (c), and long strips of ribbon (d). A
small wooden cross wrapped in blue paper and bearing two long, broad ribbons decorated
with white gloves cut from paper (e) hangs within the bow, while a long wooden
cross (f) with bows of ribbon (g) is fitted on top to complete the whole garland (h).

Aldborough, Alne, Beverley, Bolton Abbey, Filey, Flamborough, Fylingdales, Grassington, Hinderwell, Skipton and Topcliffe in Yorkshire. Where these are described, they always include gloves cut out of white paper, inscribed with the name and age of the deceased maiden, while artificial flowers made of paper or fabric have now replaced the real flowers of earlier years. Unfortunately most of these garlands have since disappeared. A solitary pair of gloves supposedly carried at the funeral of a Miss Major about 1761 still hang in the vestry at Flamborough, while a complete garland dating from some time before 1852 is housed in the church of St. Mary, Alne. Its beehive-shaped framework is bound with strips of cotton or linen, upon which are mounted artificial blossoms cut or pinked around the edges, all now faded to a light brown, although probably having naturalistic colours when newly made.

The finest surviving group of north country garlands comes from Fylingdales Old Church, Robin Hood's Bay, where they were carried up to the mid-nineteenth century. Here it was remembered that ribbons leading from loops on the garland were each held by one of the young friends of Jenny Keld who died about 1838, so that in use it must have appeared very similar to the maypole garland still carried at Grasmere rushbearing. From visits to the church in 1982, and during the course of the conservation of these five garlands carried out by the Area Museums Service in 1983, it has proved possible to establish their constructional details. The most complete garland, carried in 1859 for Janey Levitt, is made of two intersecting hoops of split sapling tightly bound with strips of calico onto which numerous lengths of ribbon have been sewn. In addition small bows made from squares of ruched silk are sewn on to the outer faces of each hoop. A rosette of blue and cream ribbons is fixed beneath the top of the garland, and from this point hangs a small horizontal cross made of narrow wooden rods sheathed in yellow silk. This supports two lengths of broad cream silk ribbon on to which were sewn the cut-out paper gloves inscribed with the name of the deceased. Next a wooden cross made of wooden rods wrapped in pale blue paper and decorated with long muslin ribbons was fixed on top of the garland to bring it to completion. Now the fabrics are all faded but, when new, the garland must have been extremely bright and beautiful, incorporating over a hundred feet of silk and muslin ribbons, predominantly cream and brown, but also with red and blue, and many enriched with designs worked in golden yellow threads etc.[7]

The Harvest Queen

Since the whole life and prosperity of any rural community was dependent on the fertility of its lands, it is not surprising that the successful completion of the laborious annual cycle of ploughing, sowing and reaping should be celebrated in one of man's oldest and most important calendar customs. In the north, it was represented by the harvest home and the harvest queen or 'kern-baby'. Writing in 1778, William Hutchinson, author of the *View of Northumberland*, records having seen this 'Image apparelled in great finery, crowned with flowers, a sheaf of corn placed under her arm, and a scythe in her hand, carried out of the village in the morning of the conclusive reaping day, with musick and much clamour of the reapers, into the field where it stands fixed on a pole all day, and when the reaping is done, is brought home in like manner. This they call the Harvest Queen'. Henderson's *Folklore of Northern England* presents a similar account from north Northumberland, where 'the festival takes place at the close of the reaping, not the ingathering. When the sickle is laid down and the last sheaf of the golden corn is set on end, it is said that they have "got the kern": the reapers announce the fact by loud shouting, and an image, crowned with wheat-ears and dressed in a white frock and coloured ribbons, is hoisted on a pole and carried by the tallest and strongest man of the party. All circle round this kern-baby, or Harvest Queen, and proceed to the barn, where they set the image up on high and proceed to do justice to the harvest-supper'. Throughout the corn-growing lands extending eastwards from the Pennines to the sea, and northwards from the Vale of Pickering to the Scottish border, similar customs took place each harvest, although the Queen might also be set in the middle of the barn floor and danced around at the harvest home, or be set up in the stackyard to provide food for the birds over the coming winter.

In the north-west, a different custom prevailed, Cumbrian farmers taking the last sheaf cut in the field and plaiting it to enclose a large apple. It was then hung up in the farm kitchen until Christmas Day, when the corn was given to the best cow, and the apple to the oldest servant on the farm.[8]

From the middle of the nineteenth century most of these customs began to fall out of use as hand-reaping was replaced by machine reaping, and as the church introduced a new service, the harvest festival. These sober Sunday afternoon services were considered to be much more respectable and proper than the joyous harvest home, with its dancing, feasting, and drinking, even though they never acquired quite the same popular following. Except in rare instances, as at Whalton in

Fig.110. The Harvest Queen
The harvest queen or 'kern-baby' formed the centrepiece of the traditional harvest celebrations, being superseded from the 1850s by model corn stacks made especially for the new harvest festivals. The kern baby (a) was made by Mrs Harvey of Whalton, Northumberland, who, together with her mother and her daughter, have been responsible for making one for their local church for many years. The model corn stack, neatly thatched and decorated with painted sheet-iron robin and blackbirds, was made in north-eastern Yorkshire in the 1930s.

Fig.111. Corn Dollies
These are the main varieties of north-country corn dollies: the Yorkshire Chandelier (a) was made by Mrs Broadwith of Red House Farm, Kirklington, Bedale; the Durham Chandelier (b) by Mr Gibson of Sedgfield, County Durham; and the Lancashire dolly (c) by Mr Scott of Lytham St Annes. The Chalice (d), which stands around three feet high, is filled with ears of wheat, barley and rye, etc., and was made in the Vale of Pickering, while the Candlestick (e) was characteristic of the Scarborough area.

Northumberland, where Harvest Queens have continued to be placed in the back pew for the harvest festival, remaining there until replaced by their successors the following year, the whole celebration of cutting or bringing in the last sheaf soon became a thing of the past. To some extent, its symbolism was replaced by the decoration installed in the church for the harvest festival, the ladies and girls of the congregation being responsible for making appropriate arrangements of grapes, fruit and flowers from their gardens, together with moss, haws, nuts, crab apples and blackberries from the hedges and wreaths and trophies of oak leaves and brackens made at home. A sheaf might still represent the grain harvest, but in most parts of the north its place was taken by skilfully made model corn stacks, neatly thatched and finished with miniature 'dozzles' or finials.[9]

One practice which not only continued, but actually developed into a popular leisure craft, was the plaiting of straw into the form of decorative corn dollies. Made by similar techniques throughout Europe, their size and complexity varied considerably from one region to another, large 'chandeliers' made of a number of separate elements forming the basis of the northern English tradition. As may be seen in the accompanying illustration, each is based on a long vertical shaft terminating in a spray of ears of corn, all subsequent decoration being supported by wires threaded through the shaft. Both the Yorkshire and the Durham varieties have a number of hexagonal tiers filled in like a spider's web and edged with a round spiral or braid, the former having drop-shaped pendants, and the latter narrow cylindrical pendants. In Lancashire, meanwhile, a series of miniature corn dollies each hang directly from the ends of the wires, without any form of tiering. In the Vale of Pickering large chalices were made, standing perhaps a yard in height, their bases being weighted with a glass bottle in order to make them stable once they had been filled with their 'bouquet' of wheat, barley and oats. Each maker also produced a variety of other designs, ranging from simple pendants to baskets, bells, or lanterns etc., since this flexible technique allowed the greatest scope for personal experimentation in design. Anyone interested in taking up this craft should consult the two standard works, Lettice Sandford and Philla Davis's *Decorative Straw Work* of 1964 and M. Lambeth's *Golden Dolly* of 1969.

13

Found Objects

Some of the most interesting examples of folk art owe their existence to people's ability to appreciate the creative potential of a whole series of natural and manmade objects noticed during the course of their everyday lives. In some cases, including sea shells, minerals or broken fragments of brightly decorated Victorian pottery, it was the colour and beauty of the objects which attracted attention. In others, such as bones or fir-cones, their actual shape suggested a resemblance to human figures, animals, etc., while further examples, ranging from spent matchsticks to cigarette packets, were seen as useful raw materials from which a variety of structures could be made. This activity could produce items which were practical or ornamental in their own right, such as the 'mermaids' made out of thornback rays at Scarborough, while it could also provide a means of decorating some domestic article, as when side-tables were topped with a highly polished layer of copper pennies or foreign coins.[1]

The practice of converting bones into useful artefacts has been practised for centuries, flutes, apple scoops and roofing pegs all being readily produced from the shin-bones of sheep. By the nineteenth century the bones of chickens and pigeons were being used in quite a different way, however. For the most elaborate work they were drilled and wired together to form miniature chairs for display, perhaps under a glass dome, in some place of honour within the house. Their wish-bones offered further possibilities, the flat projection at the top being cut to the silhouette of a head, the features drawn in with pen and ink, and gowns fitted by gathering one end of a small cylinder of material tightly around the necks of these small dolls. If furniture of an appropriate scale was required, it could be made by cutting feathers into suitable lengths, joining them by pushing pins through the hard walls of their quills. On stylistic grounds, most of the dolls and furniture made in this way can be dated to the opening decades of the nineteenth century.[2] From around the same period, the vertebrae of large animals were carefully cleaned, dried, and then painted to resemble a preacher, the ball-joint representing his head, and a pair of rounded projections forming his raised hands, from which fell the voluminous folds of a surplice. I first found one of these serving as a mantelpiece ornament at a farm near Peel House in

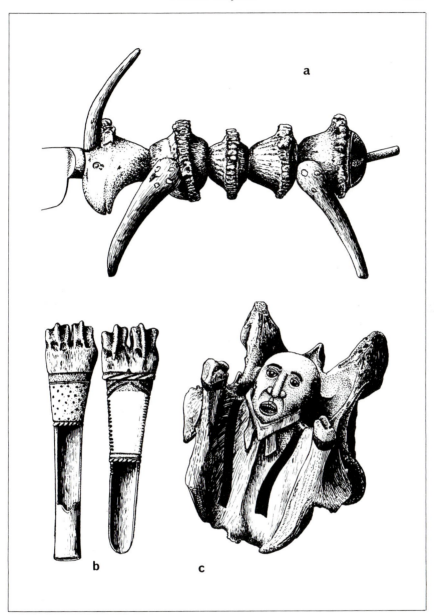

Fig.112. Antlers and Bones
The natural shapes of antlers and bones were adapted to produce both utensils and figures, as seen in (a) this carving-knife handle made at Ellins of Sheffield some time between 1825 and 1890; (b) the apple corer and apple scoop made from sheep shin-bones; and (c) the 'Wesley', made from the vertebra of a large horse, painted early in the nineteenth century.

Luddenden Dene in the Calder Valley, where it was known as a 'Wesley',
and later collected a further example, used in the same way, at a house at
East Keswick, near Leeds. Apparently they also occur in Lincolnshire,
where they were known as 'Bishop Bones' and were usually associated
with saddlers' shops. Various stories connected them with oxen, or even
with whales in fishing communities, but recently they have been positively
identified by Professor Alexander of Leeds University as the sixth cervical
vertebrae of large horses such as heavy hunters, Shires or Clydesdales,
thus explaining their appearance in saddlers' shops and farmhouses in
agricultural areas.

The natural world provided many other media for folk art. There were
the butterflies, beetles and moths which could be pinned down on to
cork-faced boards in various formal arrangements, the claws and legs of
lobsters which could be mounted as the heads and limbs of grotesque
humanoid figurines, the walnut shells ideal for making miniature tortoises,
and the pine cones which made birds and hedgehogs. Geological material
offered a particularly rich source of material too. Pieces of carboniferous
limestone sculpted into abstract shapes by the passage of water in the
rocky streambeds of the Craven district were collected to form rockeries
and ornamental wall tops, in addition to providing particularly apposite
gravestones in tranquil Dales churchyards. Water-worn pebbles were
similarly collected, to make cobbles laid in simple patterned panels, such
as those seen near the church at Arncliffe in Littondale or in the streets of
Askrigg in Wensleydale. In the Whitby area, spiral fossil ammonites were
collected from the Jurassic exposures on the cliffs and scaurs along the
coast. Here they were believed to be the remains of the living serpents
which infested the area until the seventh century A.D., when the Saxon
abbess St. Hilda turned them into stone in order to clear a site for the
building of Whitby Abbey. As the poet Surtees wrote:

> Then sole amid the serpent tribe
> The holy Abbess stood,
> With fervent faith and uplift hands
> Grasping the holy rood.
> The suppliant's prayer and powerful charm
> Th' unnumber'd reptiles own;
> Each falling from the cliff, becomes
> A headless coil of stone.

In order to perpetuate the legend and to effect the sale of specimens, the
fossil 'snakes' were improved by having heads carved on to them, some
even being fitted with glass eyes to give added realism.[3]

In the mining communities of northern England mineral specimens

were collected from the workings, and used to make carvings and models. All the coalfields in South and West Yorkshire, in County Durham, in West Cumberland and in Lancashire had numbers of men who regularly carved pieces of hard coal into the forms of small Bibles or boots. Skilled

Fig.113. Coal Carvings
These carvings come from the West Cumberland coalfield: (a, e & f) were made after the Wellington Pit disaster at Whitehaven in 1910; (b & c) after the Haig Pit explosion in the same town; and (d) from a pit near Barrow-in-Furness.

carvers might attempt rather more ambitious projects, such as human figures or miniature memorials for some of the numerous pit disasters. From the Wakefield area, I have even seen a greetings card carved from a piece of slate in the 1920s by a collier at the Parkhill Colliery. It was made as a wedding gift for the coal-owner's son, and showed the colliery, the church where the wedding took place, the liner on which the couple had their honeymoon, and places they would visit, all cut in shallow relief across both faces of a thin rectangular slab. As with many other coal carvings, this fine piece of work was completely undervalued by its owner's family, and was thrown away as rubbish after his death. It is for this reason that so few good provenanced examples of coal carving can be found today.

Some of England's most important metalliferous mines were situated within the carboniferous limestone areas of the northern Pennines. Here lead was mined in large quantities, along with fluorspar, barytes, witherite, and other gangue-minerals, the vast majority of these being extracted and processed to meet the demands of a variety of industries. Many of the minerals found during the course of mining were very attractive in appearance, their faceted crystals and highly polished glass-like surfaces reflecting and refracting the light in all directions. Particularly interesting examples were collected by the miners and cemented around the walls of cabinets made of wooden planks to create miniature grottoes called 'spar cabinets'. Pieces of mirror lining the cabinets, or sculptural arrangements of minerals in the form of arches, 'stalagmites' or 'stalactites' gave additional interest, but the exterior of the cabinet was frequently decorated too, being either glazed and framed like a picture, or built in the shape of a house. Alternatively the minerals could be erected as miniature three-dimensional obelisks etc., and placed beneath large glass domes. Some of the finest spar cabinets were produced in Laxey in the Isle of Man, where the great waterwheel 'Lady Isabella' drained the lead mines. One made here to commemorate Queen Victoria's 1887 Jubilee is a particularly good example, the different colours and textures of crystals being combined to form armorials, regalia and inscriptions.

Manmade materials, the byproducts of industry, were occasionally used in a similar manner, great crystal-like lumps of green-tinted clear glass from the glassworks being used as mantelpiece ornaments, or, along with redundant glass-pots, to provide lustrous settings for plants in urban rockeries. The Butler family of Kirkstall Forge even encrusted the medieval library of Kirkstall Abbey with chunks of iron slag in order to make it into an attractive summer house or grotto.

Other manmade waste, from the domestic rather than the industrial world, provided useful creative media. Lollipop sticks could be glued

Fig.114. Spar Cabinets
Pieces of fluorspar, galena, and other crystals were collected by the hard-rock miners of northern England and mounted within cabinets to form miniature grottoes: (a) comes from the Isle of Man and (b) from the Lake District, while the gate-posts at Keswick (c) show an interesting variation on this theme. The sample core (d) was cut from the four-fathom limestone Hope Level by the Stanhope Diamond Rock Boring Company on December 28th, 1874.

together to make boxes or model log cabins, or be woven together to make circular frisbies. The wooden jaws of spring clothes pegs could be made into small rocking chairs, and turned pegs into peg dolls. Spent matches could also be collected and stuck together in vast numbers,

Fig.115. Spar Cabinets
The upper example was made at the Laxey mines on the Isle of Man to celebrate Victoria's Jubilee of 1887, hence the inclusion of the crown and sceptre and loyal inscription in addition to the arms of Man. The lower example, with its two arches and 'stalagmite', probably comes from the Yorkshire Dales.

perhaps on to a wooden or cardboard armature, to make everything from small model gypsy caravans to houses and even cathedrals of vast size. Visitors to the Bankfield Museum at Halifax can see a fine example of this type of work in a scale model of Sir George Gilbert Scott's magnificent church of All Souls, Haley Hill. It was made by the church warden, Mr Walker, in the five years preceding the church's centenary in 1959, some 800,000 matches being used in its construction. Even the corks saved from wine and beer bottles could be re-used, being sliced across or down their length to provide series of identical units for the decoration of picture frames etc.

The glossy earthenware, bone chinas and porcelains which flooded the markets during the latter half of the nineteenth century were technically and aesthetically the finest ceramics ever to come within the reach of the working population. Their bright, pure colours, their moulded hand-painted or transfer-printed ornamentation and their bands, flowers and inscriptions in glittering gold all making them particularly attractive. Even when accidentally broken into small fragments, they still possessed a rich jewel-like quality. From the 1880s at least, these sherds were collected for use in encrusting plates, jugs, boxes and other items of pottery or tinplate in a layer of mosaic decoration. First the surface was covered in a thick coating of a putty, wax or cement-like material into which the pieces of pottery, together with sea shells, coins, or medallions, etc., were pressed closely together. The decoration could then be completed by giving the neatly finished seams a coat of gilt paint, after which the finished articles were ready for hanging on the wall or placing on the mantelpiece or sideboard. Not only pieces of pottery were utilised in this way, for similar results could be obtained by embedding other hard, permanent objects into the putty background. These might include nuts, glass beads, pieces of worked tortoise-shell, jet, or mother-of-pearl, sea shells, buttons, and metallic brooches, pins, watch chains, buckles, studs, ear-rings, keys, watch hands, scissors, etc., the whole being painted in gold once they had set in position.

As technically fully-developed pottery came into widespread use for the first time in the Victorian period, so fine polychrome printing became popularly available at just the same time, chromolithography being used for advertising, packaging, greetings cards, and reproductions of works of art. Some printing, in the form of 'scraps', was specifically designed for the amateur who could use them to decorate draught-screens, valentines, glassware or albums. Most other printing was intended for purely commercial use, however, but here again its colour, design and technical quality attracted the attention of ordinary people who wished to re-use them in a creative manner. During the first half of the present century,

Fig.116. Mosaic Ware
These examples of mosaic ware both come from West Yorkshire: (a) mounted in a gilded cement on a red earthenware jug, incorporates shells, pottery, and a souvenir medallion, and was probably made in Pontefract as a memento of a holiday in Blackpool; while (b) mounted in an orange wax (?), was made in a Wakefield handicraft class to commemorate Queen Victoria's 1897 Jubilee. The snake-stone, (c) probably had its head carved on to its fossil ammonite body in Victorian Whitby.

for example, cigar bands and the labels collected from the tops of cigar boxes were being glued on to pottery cups, saucers and dishes and given a protective coat of varnish.

Very lavish results were obtained in this way, the superficial appearance of these wares resembling highly coloured and gilded porcelain. By the time of the Second World War, cigarette packets were collected for quite different purposes, those made for Player's Navy Cut being in particular demand for making decorations for the home. Each packet was carefully cut to shape and interlaced with its neighbours to produce a shallow circular plaque which was then hung up on the wall. Since that time, these plates have been largely replaced with model dogs made from

Fig.117. Mosaic Ware
This tinplate plate, covered in putty and decorated with a wide variety of small shells, glass, and metallic artefacts was collected from Hexham. A similar example from Waddington in western Lancashire is now in the Museum of English Rural Life, Reading.

Fig.118. Tobacco and Cigarette Plates
The upper example, collected in the north-east, was made by sticking cigar bands and box labels on to a pottery plate, while the lower example, collected in Leeds, was made by interleaving packets of Player's Navy Cut cigarettes perhaps thirty or forty years ago.

Fig.119. *Cigarette Packet Dog*
This dog was made by cutting cigarette packets into narrow strips which were then woven together (as in the detailed drawing) to build up the entire three-dimensional surface of the animal.

strips of cigarette packets woven together in an extremely complicated manner to produce fully three-dimensional surfaces. These are often made in public houses or gaols such as Armley where quantities of the requisite packets can be acquired. Sometimes they are made from a single brand, such as a Woodbine dog collected in York or a large Silk Cut dog, complete with its official dog-tag, seen in the Isle of Man. Others are real mongrels, with perhaps Woodbines, Park Drive and Benson and Hedges all worked together. Whatever their origins, the production of these dogs at the present time is clear evidence that innovative folk art is not yet quite dead in the north of England, in spite of the numerous pressures to which it has been subject over the past two or three generations.

Notes

Place of publication is London unless otherwise indicated.

Chapter 2

1. Guillim, J., A Display of Heraldrie (1632), 312.
2. For a full account of this subject see Newall, V., An Egg at Easter (1971), especially pp. 281–5; Brears, P., Traditional Food in Yorkshire (Edinburgh, 1987), 162–6; Rumney, A. W., The Dalesman (Kendal, 1936), 22–4, and Wilson, A., The Dalesman (Clapham, 1964), XXVI, 164.
3. Guillim, op. cit., 254.
4. Wither, G., A Collection of Emblemes, 99, 230, 237, 244 etc.
5. See also, ibid., 44 & 256.
6. Brears, P., 'Heart Gravestones in the Calder Valley', Folk Life, IXX, 84–93.
7. Wordsworth, W., The Ruined Cottage (Cambridge, 1985), 9–10 and Cuisenier, J., French Folk Art (1977), 190.
8. Wither, op. cit., 157 & 102.
9. See O'Riordain, North Munster Antiquaries Journal 1 (1936); Evans, E., Irish Folk Ways (1957), 268; O'Sullivan, J., 'St. Brigid's Crosses', Folk Life XI (1973), 60–81, and Archaeologia LII (1890), 14–15.
10. Calverley, W. S. & Collingwood, W. G., 'Early Sculptural Crosses in the Diocese of Carlisle', Cumberland & Westmorland Antiquarian & Archaeological Society, Extra Series XI, 119.
11. Nattrass, M., 'Witch Posts', Gwerin III, 254–267; Hayes, R. H. & Rutter, J. G., Cruck Framed Buildings (Scarborough, 1972); Atkinson, J., Forty Years in a Moorland Parish (1891), 2nd edition, Appendix and Blundell, J., The Pendle Witches (Burnley, 1972).
12. Ibid; 1st edition, 61, 97–9, and personal communications from friends in Bilsdale. See also Dowson, F. W., Goathland in History and Folk-lore (1947), 61.

Chapter 3

1. Tweddell, G. M., Poems in the Yorkshire Dialect by the late John Castillo (Stokesley, 1878), 41. For a full account of stone heads and head cults see Ross, A., Pagan Celtic Britain (1967) and Ross, A., Grotesques and Gargoyles (1975). Some of the late Sidney Jackson's extensive survey of stone heads was published in his Celtic and other Stone Heads (1973).
2. Tweddell, ibid., 11–14 and Nattrass, M., 'Carved Stone Heads in Cleveland', Dalesman XII, 1950, 435–7.
3. Dawson, K., 'Storied Stones', Dalesman XXII, 1960, 174.
4. Keighley News, 18/6/1971 and 21/10/1971.
5. Information from Mrs K. Mason, Addingham Moorside.

6. Pontefract, E. & Hartley, M., *Wensleydale* (1936), 231–2.
7. Bradford Art Gallery & Museum, *White Wells* (1982).
8. Nussey, J., *Smithies Mills, Birstall* (Chester, 1984), 30–33.
9. Danachair, C., 'A Celtic Origin for Irish Folk Tradition?', *Anthropological Studies in Great Britain and Ireland* (Arizona, 1982), 27–36.
10. West Yorkshire Archaeological Unit, Report forthcoming, and Ross, A., *ibid.*, 104 *et seq.*
11. Wheeler, Sir M., 'The Stanwick Fortifications', *Reports of the Research Committee of the Society of Antiquaries of London* XVII, 53 (Oxford 1954).

Chapter 4

1. Opescu, G., *Peasant Art in Roumania* (1929).
2. Helias, P. J., *The Horse of Pride* (1978), 294; Baud-Bovy, D., *Peasant Art in Switzerland* (1924), 35; Holme, C., (ed.), *Peasant Art in Italy* (1913), 3; Holme, C., (ed.), *Peasant Art in Sweden, Lapland & Iceland* (1910), 20; Holme, C., (ed.), *Peasant Art in Russia* (1912), 50; Holme, C., (ed.), *Peasant Art in Austria & Hungary* (1911), 9, 42.
3. Haberlantd, M., *Osterreichische Volkskunst aus den Sammlungen des Museums fur Osterreichische Volkskunst*, 23.
4. Brears, P., 'The Knitting Sheath', *Folk Life* XX (1981–2), 16–40.
5. Hofer, T. & Fel, E., *Hungarian Folk Art* (Oxford, 1975), figs. 150 & 310–35; Cusenier, J., *French Folk Art* (Tokyo, 1977), fig. 302; Baud-Bovy, *op. cit.*, fig. 123; Holme, C., *op. cit.* (1911), fig. 105–6.
6. Chinnery, V., *Oak Furniture, the British Tradition* (1979), 179–181.

Chapter 6

1. *Country Life*, Jan. 15 (1959).
2. *Country Life*, Feb. 28 (1980), 589.

Chapter 7

1. See Sheppard, T., 'Catalogue of love tokens . . . in Hull Museum', *Transactions of the Yorkshire Numismatic Society*, II pt. IV, 109–12 (Hull, 1922).
2. See Musham, J. M., 'Coins as Media for Workmen's Tokens', *ibid.*, pt. II, 88–90.

Chapter 8

1. For general information on this subject, see Brears, P., *The English Country Pottery*, Newton Abbot (1971) and *The Collector's Book of English Country Pottery* (Newton Abbot, 1974).
2. Brears, P., *English Country Pottery housed in the Yorkshire Museum* (York, 1968), 7, and in Mayes, P. & Butler, L., *Sandal Castle Excavations 1964–1973* (Wakefield, 1983), 218.
3. Brears, P., *Traditional Food in Yorkshire* (Edinburgh, 1987), 184.
4. Vincent, K., *Nailsea Glass* (1975), 56–7.
5. Rush, J., *The Ingenious Beilbys* (1973), 155–7.

Chapter 9

1. Innocent, C. F., *The Development of English Building Construction* (Cambridge, 1916), 157–160; Davidson, C., *The World of Mary Ellen Best*, figs. 19, 59, 60 & 61; Brearley, F., *A History of Flamborough* (Driffield, 1971), 113 and Heath, R., *The English Peasant* (1893), 85–6.
2. Smith, W., *Morley Ancient and Modern* (Leeds, 1886), 98.
3. Kendrew, *Cries of York* (York, c. 1811) and Wrigley, A., *Old Saddleworth Days* (Oldham, 1920), 246.
4. Hartley, D., *Made in England* (1974), 137.
5. Woodcock, H., *Primitive Methodism on the Yorkshire Wolds* (1889), 201–2.
6. Baron, J., *T'Yorksher Lingo* (undated), 38.
7. Ferriday, A., 'The end of Donkey-stone scouring?', *Pennine Magazine*, October 1979, 20–21, and the *Huddersfield Examiner* for April 2nd, 1976, May 15th, 1978, and April 16th, 1981.
8. Addy, S. O., *Evolution of the English House* (1898), 124–5. See also Banks, M. M., 'Tangled Thread Mazes', *Folklore* XLVI (1935), 78–80; William, E., 'To keep the Devil at bay', *Country Quest*, May 1975, 34–6, and correspondence in *Country Life* (1973), 1450 and *The Countryman* LVI (1959), 549 & LVII (1960), 161–3.
9. Information on these patterns including extensive correspondence is housed in the information files at Beamish, the North of England Open Air Museum.

Chapter 11

1. Manx Museum Library, Arthur W. Moore Manuscripts 159A.
2. Abbey House Museum, Leeds.

Chapter 12

1. Boyes, G., 'An Ark of Bloom', *Tyke's News* (Ilkley, 1982), 18.
2. Turner, J. H., 'Our Customary Feasts', *Brighouse Echo*, Brighouse (April 1913).
3. For further information on rushbearing, see: Burton, A., *Rushbearing* (Manchester, 1891); Helm, A., 'Rushcarts of the North-West of England', *Folk Life* VIII (1970), 20–31; Poole, R., 'Lancashire Wakes Week', *History Today* XXXIV (August 1984), 22–29; Rawnsley, E. F., *The Rushbearing in Grasmere and Ambleside* (Kendal, 1953); Anon., *The Rushbearing in Grasmere* (Grasmere, 1985?).
4. For further references to wassailing, see: Addy, S. O., Household Tales & Traditional Remains (1895), 110; Dransfield, J. N., *History of Penistone* (Penistone, 1906), 135; Fisher, J., *History & Antiquities of Masham* (1865), 461; Fletcher, J. S., *Recollections from a Yorkshire Village* (1910), 153, 156; *Gentlemen's Magazine* (1824), pt. II, 588; Ingledew, C. J. D., *History of North Allerton* (1868), 342; Turner, J. H., *Yorkshire Folklore Journal* I (Bingley, 1888), 28 and *A Dozen Lightcliffe Romances* (Brighouse, 1903–4), 3.
5. Kermode, E., *Celtic Customs* (1885), 159–168.
6. This section is based on Spriggs, G. M., 'Maidens Garlands', *Folk Life* XXI (1982–3), 12–32; Brears, P. C. D., *ibid.*, 34–5 and *Dalesman* XXII (1960), 90, 164, 324–5, & 404.

7. Museum & Art Gallery Service for Yorkshire & Humberside, Aberford Conservation Centre, *Final Report for the Parish of Fylingdales . . . Five Maidens Garlands*, typescript (Aberford, 1983).

8. Dickinson, W., *A Glossary of the Words & Phrases pertaining to the Dialect of Cumberland* (1899).

9. Rumney, A. W., *The Dalesman* (Kendal, 1936), 182.

Chapter 13

1. A 'mermaid' of this type was housed in the Horniman Museum, accession number 24–423.

2. Examples are housed in the Castle Museum, York.

3. Bassett, M. G., *Formed Stones, Folklore and Fossils* (Cardiff, 1971).

Index